THE JOURNAL OF THE ASSOCIATION OF MOVING IMAGE ARCHIVISTS

OVINGIMAGETHEMOVINGIMAGETHEMOVINGIMAGETHEMOVIN

FALL 2006

The Moving Image (ISSN 1532-3978) is published twice a year in spring and fall by the University of Minnesota Press, 111 Third Avenue South, Suite 290, Minneapolis, MN 55401-2520. http://www.upress.umn.edu

Published in cooperation with the Association for Moving Image Archivists (AMIA). Members of AMIA receive the journal as one of the benefits of membership. For further information about membership, contact Janice Simpson, Association of Moving Image Archivists, 8949 Wilshire Boulevard, Beverly Hills, CA 90211 (or e-mail amia@amianet.org or visit us on the Web at http://www.amianet.org).

Postmaster: Send address changes to *Moving Image*, University of Minnesota Press, 111 Third Avenue South, Suite 290, Minneapolis, MN 55401-2520.

Inquiries and information about manuscript submissions should be sent to *The Moving Image*, c/o Association of Moving Image Archivists, 8949 Wilshire Boulevard, Beverly Hills, CA 90211 (or e-mail amia@amianet.org). **Do not send manuscripts before sending one-page proposal.** All manuscripts should be submitted in triplicate, double-spaced throughout, using 12-point type, with one-inch margins, parenthetical documentation with a list of works cited (using the *Chicago Manual of Style*, 15th edition), and a file on disc in ASCII *and* Word or WordPerfect. Contact the editorial office at the address above (or phone at 310-550-1300, or fax at 310-550-1363) for further instructions on style.

Manuscripts will be returned if accompanied by a stamped, self-addressed envelope. Please allow a minimum of four months for editorial consideration.

Address subscription orders, changes of address, and business correspondence (including requests for permission and advertising orders) to *The Moving Image*, University of Minnesota Press, 111 Third Avenue South, Suite 290, Minneapolis, MN 55401-2520.

Subscriptions: Regular rates, U.S.A.: individuals, 1 year (2 issues) $30; libraries, 1 year $75. Other countries add $5 for each year's subscription. Checks should be made payable to the University of Minnesota Press. Back issues are $22.50 for individuals (plus $4 shipping) and $56.25 for institutions (plus $4 shipping). *The Moving Image* is a benefit of membership in the Association of Moving Image Archivists.

Founded in 1991, the **ASSOCIATION OF MOVING IMAGE ARCHIVISTS** is the world's largest professional association devoted to film, television, video, and digital image preservation. Dedicated to issues surrounding the safekeeping of visual history, this journal covers topics such as the role of moving image archives and collection in the writing of history, technical and practical articles on research and development in the field, in-depth examinations of specific preservation and restoration projects, and behind-the-scenes looks at the techniques used to preserve and restore our moving image heritage.

REVIEWS

Editor's Foreword

JAN-CHRISTOPHER HORAK

Having just returned from the Orphans Film Symposium in Columbia, South Carolina, I can't but help writing about it here. Orphans 5 was dedicated to science, industry, and education, and although I only attended the first, fourth, and fifth conferences, I think my fellow "Orphanistas" (as Dan Streible likes to call the community he created) would agree, it was one of the best yet. Former AMIA board member Streible, who will be at New York University when this missive is published, is founder, organizer, and master of ceremonies at the four-day event, which has been headquartered at the University of South Carolina since 1999.

Bringing together an eclectic mix of independent filmmakers, moving image archivists, film and digital laboratory technicians, academics, and students, the Orphanistas screen films around a particular topic, present lectures, and discuss all manner of archival trends, historical narratives, and film genres. The day begins at 9 AM and ends shortly before 11 PM, with relatively short breaks for lunch and dinner. For those who haven't had enough, small-gauge screenings continue informally from midnight until as late as 5 AM in the hotel hospitality suite. This year the room was still packed on Friday night until at least 2 AM, with mostly the younger crowd in attendance, although a few veterans were also to be seen.

The subject was science films, industrial films, institutional films, sponsored films, educational films, advertising films, teaching films, medical films, government films, indeed all those genres broadly termed "informational" by British film documentarist Paul Rotha. The original impetus for the conference focus came from the planning and development of a database project, "Industrial, Institutional & Sponsored Films: A Field

Guide," spearheaded by Rick Prelinger, that catalogs and gives descriptors for more than a thousand titles. A whole session was in fact dedicated to a theoretical and practical discussion of the guide, which has now been published.

Around that core, Orphans 5 developed a model for institutional cooperation in our field, involving the National Film Preservation Board, the Andrew Mellon Foundation, and other funders for financial support; numerous moving image archives, including George Eastman House, Nederlands Filmmuseum, the United States Holocaust Museum, and the Library of Congress, that made film material accessible; laboratories such as Film Technology, Cineric, Colorlab, Summit Film, and Haghefilm that conducted pro bono lab work; and a motley crew of presenters who introduced their research or, in the case of filmmakers, their creations. The very heterogeneity of this critical mass guaranteed that the outcome would interrogate issues involving film technology and preservation, history, the creation of canons, media accessibility, and the sociology and political construction of producers and audiences.

At this year's Orphans symposium there seemed to be a palpable sense of excitement that the event was really onto something new. Although the genres in question have been with us since moving image collection and preservation began, it is equally true that they have been and still are sorely neglected: within the archives, because they were often 16mm and thought either nonarchival or "just" projection prints; in academia, because many of them were considered propaganda or merely educational, not having the cultural cachet of either Hollywood or film art. The nonexistence of reference works complicated both archival and academic progress. It has always been with a strong sense of frustration that I have conducted research on industrial films, attempting to identify

archival material with incomplete credits or to write about a particular producer of indus-
trials, given the almost total absence of reference works for industrials and other spon-
sored films. The nontheatrical 16mm educational film catalogs published by Penn State
and Indiana Universities in the 1960s through the '80s, among others, were some of the
few sources available. The Internet-based "Field Guide" promises to deliver some relief.

Second, as Don Crafton described it, industrials, sponsored, and institutional
films offered a heretofore unmined field, rich in intellectual content. The sheer vastness
of the subject, penetrating history, economics, sociology, political science, technology,
science, education, media, medicine, intellectual history, and aesthetics, guarantee that
serious inquiry will yield seismic changes to film and media studies. More than one par-
ticipant predicted the opening of a whole new field, comparable to the sea change
brought about by the FIAF Brighton Conference in 1978, which gave birth to early cinema
studies. Indeed, there was a sense at Orphans 5 of history in the making, of pioneering
a new era, just as Brighton had done. But, having experienced the Brighton conference
firsthand, I can say that those of us who attended lacked a similar consciousness of
being the avant-garde for a future movement: that would come later. Whether Orphans 5
in fact enters into the mythology of film historiography remains to be seen, but right now
the bet that it will seems pretty good.

The integration of laboratories into the discourse of film preservation as prac-
ticed at Orphans 5 is given theoretical underpinnings in the first article of the feature sec-
tion in the present issue. **Andreas Busche**'s piece asks whether the methodologies of
fine art preservation and restoration hold any value for moving image restoration and
preservation. In "Just Another Form of Ideology? Ethical and Methodological Principles in
Film Restoration," Busche reworks a chapter from his master's thesis, successfully sub-
mitted to the University of East Anglia. Although the relevance of art-historical method-
ologies has been rejected out of hand by some film archivists, Busche draws on the work
of Cesare Brandi and others to suggest that another look at these older disciplines may
help moving image archivists codify archival restoration procedures and methodologies,
which in turn will help construct our evolving professional identity.

A completely different form of film restoration comes to the fore in **Nathan Car-
roll**'s discussion of the perceived cultural value of "lost" films, rediscovered absences,
and their electronic dissemination. Noting that the Mitchell and Kenyon films were not
"lost," because no one knew they were missing, they are nevertheless now celebrated as
a unique discovery, impacting the general public as much as film history. Carroll argues
that the creation of a film restoration's cultural value is ultimately imbricated in archival

discourses, citing an article about the Mitchell and Kenyon Collection in *The Moving Image* 3, no. 2, as a primary piece of evidence.

Not a theory of moving image archiving but rather the history of moving image archives in the United States is the subject of **Janna Jones**'s contribution, "The Library of Congress Film Project: Film Collecting and a United State(s) of Mind." Looking beyond institutional history, though, Professor Jones questions how collections were constituted in the national interest, what forces formed and resisted such development, and which ideologies thereby constructed our collective cultural memory. Jones, who previously published a feature in *The Moving Image* 4, no. 2, thus continues the dialogue on the history of our field that began six years ago with our very first issue.

With **David Orgeron**'s essay *The Moving Image* picks up a discussion on the importance of amateur film that initially made its appearance in the journal's first issue and has continued in virtually every issue since. In particular, Orgeron is interested in amateur travel films, in the collection of such travel films, and in the way travel films collect images of places for middle class consumers. The glue holding together the disparate spaces of these travel films is the family on display, unified both in the production process and in the film's exhibition, where familial memories are forged.

Our Forum section begins with a personal memoir by **Rick Schmidlin**, detailing the discovery of previously "lost" elements of the Erich von Stroheim estate. If archives can create cultural value, then here we have a prime example. Schmidlin describes not only the detective work, which led to the discovery of a veritable treasure trove of von Stroheim memorabilia, but also the way cooperation between private collectors, archival institutions such as the Margaret Herrick Library of the Academy of Motion Picture Arts and Sciences, film festivals, and museums can secure for posterity our film-historical patrimony.

The remainder of the Forum is dedicated to a special section, edited by Anna Siomopoulos, detailing the *Within Our Gates* Project at Ithaca College. Since its preservation and rediscovery, Oscar Micheaux's 1920 film, considered lost for decades, has been the subject of much scholarly activity involving the recuperation of an African-American film history. However, the focus of the present project is a completely different form of recuperation, namely its exhibition for contemporary audiences. This special section thus presents a specific case of archival film exhibition, just as *The Moving Image*'s only previous special section (in 4, no. 1) interrogated general issues of film programming for today's viewers. With essays by **Anna Siomopoulos**, **Patricia Zimmermann**, **John Hochheimer**, and **Grace An**, and an interview with the composer of *Within Our Gates*'s contemporary

music score, this special section both discusses methodological issues of the film's exhibition and presents models for contextualizing an archival film for audiences.

Book and film/DVD reviews follow as usual, the latter now edited by Michael Baskett, who comes to us from the University of Kansas. A special thanks to him for taking up this editorial role, and another thanks to the rest of the editorial team these six years, including Laura Rooney, Greg Linnell, Alison Trope, and Dan Streible.

It is not a coincidence that I have referred the reader again and again to past issues of the journal and to continuities within these first twelve issues. Having spent more than seven years founding and then editing *The Moving Image,* I have decided to step down from my duties as editor to pursue other projects. Now, in the *Variety*-speak of the mainstream Hollywood film industry such a phrasing usually connotes that the person in question is not exiting of his own volition. However, in this particular case, the move is purely voluntary and necessary. Much as I have enjoyed organizing this public forum for moving image archival discourse, I have also realized how much of my time has been swallowed by editorial imperatives. As a result, I have not been able to focus on a larger publishing project of my own. It is now time for me to return to my own work, secure in the knowledge that this journal will continue to thrive along with our Association of Moving Image Archivists.

JUST ANOTHER FORM OF IDEOLOGY?

ANDREAS BUSCHE

Ethical and Methodological

Principles in Film Restoration

Since the 1980s, a serious debate about the ethics of film restoration has existed among archivists, historians, preservationists, and restorers. Numerous motion pictures have disappeared completely or survive only in a fragmentary or corrupted form. As a result, the urge to restore this lost or distorted history has become a main concern in archives and museums. However, film restoration still struggles to establish a binding professional code, comparable to those already in place in fine art restoration and heritage conservation such as the ICOM Code of Ethics, the AIC Code of Ethics, UNESCO's Memory of the World Guidelines, or the ECCO Professional Guidelines.[1]

Every profession that aspires to technical vocational recognition sooner or later faces the necessity of developing codified guidelines for professionals working in the field.[2] Such an intellectual framework is essential, determining parameters for maneuvering and serving as a reference point for an ethical conduct. A professional code establishes the basis for a professional self-conception and encourages a permanent critical assessment of work produced in the field. Hence, a professional code constitutes a concise framework of the discipline: its *raison d'être* as a profession (and science), its theoretical and ethical principles, its historical conception within a broader cultural and social context, its service to the public, and, last but not least, the methodology that brings these intellectual considerations effectively into practical application. A profession without such a codification ultimately lacks the basis for conducting its work in a responsible manner.

This article's foremost concern is to discuss a theoretical and ethical framework for film restoration and, consequently, propose a methodological approach toward some very specific, well-defined practical problems. The methodological principles derived from this discussion can only focus here on a narrow aspect of film restoration, namely the restoration of a black-and-white silent film from positive prints. Actual film restoration entails far more complex issues than discussed here. My purpose is to demonstrate that certain methodological principles are indeed useful. Ideally, my examination will lay a foundation for more elaborate methodologies. Discussion of an ethical and theoretical framework ultimately constitutes the first crucial stage for developing a consistent methodology. Such a methodology is an integral part of a professional code, since it constantly negotiates between the theoretical and the practical. Hence, a starting point is a careful examination of concepts such as ethics, restoration theory, methodology, and practice and how they interrelate for the establishment of a professional code.

Before I continue, however, it is necessary to briefly outline my definition of restoration and distinguish it from preservation, duplication (or reproduction), and reconstruction. This step is particularly important, since a binding terminology has not yet been established. This ambiguity is a prevailing problem in the conservation profession

where, in 1984, indifference toward definitions of restoration and conservation forced the International Council of Museums (ICOM) to coin the rather awkward term *conservator-restorer* as a compromise.[3]

The distinction between restoration and preservation in film preservation is slightly easier to determine but nevertheless still causes dispute. We can refer to Paul Read's and Mark Paul Meyer's general statement that the term *restoration* (in contrast to *preservation*) is used when "differences are created between the materials you start with and the materials you end with."[4] This definition seems to make perfect sense, but, unfortunately, it is not so simple. In relation to film objects (or film artifacts, as I prefer to call them: a print, a negative, a dup positive, or even a sound negative), the lines between restoration, preservation, and duplication are blurred, because every duplication—supposedly a "neutral" process—inevitably introduces qualitative changes in photographic information: a generational loss of quality and changes due to timing.

To reach common ground, we have to mind our terminology.

According to Read and Meyer, restoration encompasses the "whole spectrum of film duplication, from the most simple duplication with a minimum of interventions up to the most complex ones with a maximum of manipulations."[5]

To specify the term *restoration,* I want refer to Paolo Cherchi Usai. Cherchi Usai defines restoration as "a set of technical, editorial, and intellectual procedures aimed at compensating for the loss or degradation of the moving image artifact."[6] In general terms, a restoration involves a range of interventions: the removal of alterations or uninformed additions, the improvement of image quality and aural content (an integral aspect I will have to neglect in this essay) as close as possible to its "original" state, and the elimination of mechanical damages (always in respect to "minimal interventions"). It is important to stress that Cherchi Usai uses the term *restoration* exclusively in relation to the integrity of the artifact, not in relation to the integrity of the motion picture as such. I will return to this concept later.

If the term *restoration* refers to all processes that safeguard the integrity of a mutilated film artifact, a *reconstruction* aims at reestablishing a filmic "text." It involves material from different sources and is above all an editorial procedure, aspiring to retrieve a particular version.

The objective of a reconstruction is to create a version that is as complete as possible, based on the best film elements available.

I will not deal in too much depth with the concept of preservation, but some general remarks are necessary. Preservation ultimately aims to arrest an object in its present state, stabilize its condition, and ensure its survival for future generations. These goals imply that preservation is nonaltering, an assumption we have to treat with care. Two preservative treatments exist: passive preservation encompasses storage and climate control; active preservation can be achieved by duplication.[7]

ETHICS AND THE ROLE OF THE RESTORER

Having outlined different concepts of restoration, preservation, duplication, and reconstruction, I now turn to the role of ethics in relation to a restoration methodology. The film restorer faces the most urgent challenges in the space between theoretical evaluation and practical application. Her practical tools are basically the film laboratory. However, her reasoning differs significantly from work in a commercial laboratory that mainly duplicates prints from negatives. Film restoration requires a strong theoretical foundation and a keen awareness of goals. If we assume that film restoration is as much intellectual work as a craft—and therefore dedicated to scientific methods—the restorer must understand (a) what constitutes a film as art and/or historical evidence and (b) the physical characteristics of film, in order to define what is to be retrieved. Retrieval of this loss is the restorer's goal, but there are various paths to achieving it. And not all are acceptable.

Astute awareness of the ethical implications of their work keeps practitioners from making decisions that could compromise quality or even cast the profession in a negative light. Ethics play an integral role, particularly in disciplines that strive for social recognition.

A restoration might affect our understanding of an object or the cultural identity of a group of people.[8] A restoration improves the readability of a work of art or its historical significance (which are not necessarily mutually exclusive) in its full complexity. Consequently, the restorer must avoid falsification at any cost.

Ethics are therefore integral elements of an overarching professional code; they enable the restorer to reflect critically on the quality of his conduct.

It is not the purpose of ethics to establish a fixed set of rules. Ethics "do not instruct the profession about the difference between right or wrong but ... provide a

point of accepted reference to be used when dealing with ethical complexities." They "support the reasoning" rather than "explain what to do."[9] However, ethics can challenge accepted notions and thus improve outcomes or quality. Since ethics are fundamental for a professional code, a concise methodological framework has to be based on those principles. If we accept this notion, we have to ask ourselves, how can we articulate ethical principles that allow us to derive a methodological approach to film restoration?

Film is a relatively young medium, its historical perspective comparatively limited. Film restoration still lacks the necessary perspective to elaborate a self-referential restoration theory, particularly when it comes to ethical questions. Due to its technical reproducibility, there is still indifference among restorers toward the film artifact. I will tackle this problem later.

Out of necessity, film restorers have commonly referred to ethical discourses in fine art restoration. Unfortunately, they have often done so without the necessary methodological rigor. Adopting ethical principles from fine art restoration has to result in a consistent methodology if it is to provide guidance for film restoration. If we want to explore how film restoration can benefit from other restoration disciplines, it is crucial to understand the historical dimension and the reasoning behind these principles. Naturally, this article cannot accomplish such an ambitious goal; it merely proposes a methodological framework for film restoration.

ART RESTORATION AS A REFERENCE

The role of the restorer is still widely neglected within existing debates on film preservation philosophies.[10] FIAF congresses in Canberra (1986) and Berlin (1987) were the first dedicated to film restoration. Since then, discussions have proliferated, without general consensus or an agreed-upon theoretical and practical framework. In that respect, Mark Paul Meyer's and Paul Read's *Restoration of Motion Picture Film* (2002) represented a benchmark as the first publication dealing with the technical side of film restoration. That publication, however, still fell short in addressing ethical and philosophical questions. A coherent restoration methodology still does not exist as an indispensable part of a professional code for film restoration.[11]

Published writings on these issues in any language are surprisingly scarce. One of the first texts addressing the necessity for a methodological framework for ethical film restoration was Raymond Borde's "Film Restoration: Ethical Problems." Borde summarized the practical problems (and institutional limitations) archives were facing with

their collections of fragmented, often mutilated films. Borde's observation of the lack of critical reference was particularly striking: "[The archivist] has had no theoretical platform, nor has he been able to count on artistic advisers to direct him in his task."[12] Borde noted that archivists in charge lacked the historical knowledge and/or the technician's practical experience. Historians knew history but had only a rough idea of preservation and often no technical expertise. The laboratory technician, on the other hand, was a craftsman barely informed by ethical reason or restoration theory. Luckily, this situation has changed in the past decade. Today, it is taken for granted that the work of the restorer combines a wide range of tasks and requires practitioners with broad expertise.[13]

In recent years, examples from fine art restoration increasingly have served as a reference point for film-theorizing restorers discussing ethical issues.[14] While by no means original, my aim is to take some suggestions to prove further the usefulness of such an application. For the sake of my argument, I will focus on one specific problem common in fine art restoration: the treatment of damages and physical losses (such as the flaking of color pigments) commonly referred to as lacunae (Latin for "holes"). The adoption of the concept of lacunae for film will help me to qualify the various kinds of damage to motion pictures and the complex considerations the restorer must evaluate.

Before we can proceed to translate ethical and methodological principles from fine art restoration into film restoration, I must make two pivotal distinctions. The first is obvious: Whilst in fine art restoration, the restorer works on the object itself, in film restoration, the "original" object (a dubious term at this point of my discussion) serves only as the source. The restoration itself is conducted in consecutive intermediate stages on duplicate elements (copies). The "original" functions as a master element but remains unaltered. The second is historically significant: By mid-1980s, when film restorers began to look to fine art restoration for guidance, fine art restoration ethics had been a subject of discourse for more than two hundred years. The historical processes and cultural advances forming this body of knowledge are an integral part of modern conservation theory. This historicity is consistent with a particular practice. Hence, it is important not only to examine how far a particular fine art restoration principle is applicable to film restoration but also to comprehend the historical reasoning behind it. Historical consciousness in film restoration, by contrast, is comparatively narrow. A restoration methodology that derives its conception from such a highly refined body of knowledge will be merely a synthesized theory, empirical at best, if it fails to address problems specific to the nature of film and its historicity.

RESTORATION AS A CRITICAL DISCIPLINE: BRANDI'S THEORY OF RESTORATION

It is not easy to determine "at what precise moment people [started] to conserve and re-store works of art."[15] The earliest accounts date back to 400 BC.[16] In his encyclopedia *Natural History,* Pliny the Elder (23–79 AD) reported on some restorations Pausias of Sikyon (c. 360 BC) had conducted on paintings by Polygnotus—although he remarked that Pausias had not completely succeeded in duplicating the quality of the original.[17]

The awareness that man-made objects are subject to decay and the motivation to safeguard them for intellectual enrichment are as old as the arts themselves.

In that respect, R. H. Marijnissen is right when she writes that the birth date of ideas on conservation is largely irrelevant; much more interesting is when restorers actually began to develop an understanding of restoration as a critical act rather than a merely practical activity. Discussions among art historians, connoisseurs, artists, and restorers about the nature of a restoration and the relationship between the restorer and the art object are so rich and diverse that we will of necessity confine our focus to one particular "school." Admittedly, more in-depth examinations are required, so my approach should be con-sidered experimental.

The focus of my experiment rests primarily on the theories of art historian, phi-losopher, and restorer Cesare Brandi, whose groundbreaking *Theory of Restoration* (1963) was the first published work that dealt exhaustively with philosophical, theoreti-cal, and practical issues and, thus, brought intellectual dignity to the profession.[18] In par-ticular, his writings on the treatment of lacunae offer, to date, the most comprehensive systematic approach to a practical problem in restoration. Brandi's impact on modern conservation theory is invaluable. Today, many principles in his *Theory of Restoration*—besides the treatment of lacunae there are the reversibility of interventions and the his-toricity of the object—are widely recognized among professionals and incorporated into international charters.

Brandi's theory revolves around ontological and phenomenological questions regarding the nature of a work of art and the complex relationship between the work and the restoration. For Brandi, the recognition of an object's artistic significance presupposes a restoration, while, in turn, only a restoration can reestablish the status of a (fragmented) work as true "art." This dialectic already demonstrates what immense importance Brandi

ascribes to the intellectual act of restoration. Crucial to Brandi's theory is his differenti-
ation of two instances regarding the object's disposition: its aesthetic value and its his-
torical value.

The aesthetic value corresponds to the artistic achievement of the work of art.
In contrast, its historical value is defined by its existence as a product of a human activ-
ity in relation to a time and place and to the passage of time until the moment it reaches
the restorer. It is the restorer's responsibility to examine these values thoroughly in her
assessment of the object. According to Brandi's theory, no value should take precedence
over the other, since only together do they constitute the object's status as a work of art.
Brandi's rather narrow scope stressed these two instances as crucial solely for the defi-
nition of "works of art." I would however argue that they can be extremely useful for the
assessment of all works, since they establish categories that can qualify the cultural
value of materials, such as documentary film, without being constrained to the instance
of artistry.

Two of Brandi's ideas about the conception of a work of art are particularly
striking. Brandi acknowledged that every piece of art constitutes a "whole" rather than a
sum of various parts. This "oneness," as he calls it, is indivisible since the components
of the object do not inhere in the artist's creative spirit and, therefore, have merely a
generic value. In turn, Brandi concluded that if a work of art no longer existed as a "whole,"
but only as a fragment, each fragment would contain a "potential whole." It is this "poten-
tial whole" the restorer has to preserve in his attempt to "develop the original potential
of oneness held within each fragment."[19] Brandi's acknowledgment of a "potential one-
ness" implicitly stresses the integrity of the fragment as premise for a truthful approach
to the historical evidence passed down to the restorer. "A treatment that seeks to recover
the original oneness by developing the potential oneness of the fragments of that *whole*
(which is the work of art), should be limited to the evidence of the original that is implicit
within the fragments themselves, or retrievable from reliable sources."[20]

Brandi derived a couple of fundamental principles from his concept. The most
important is that "any intervention must always be easily recognizable, but without
interfering with the oneness that it is designed to re-establish."[21] This principle touches
on the idea of "visible restorations" as an integral aspect of the treatment of lacunae.
According to Brandi, a physical intervention must be made visible to prevent historical
falsification.

After all, a restoration is a critical interpretation, not an artistic enhancement of the object.

Another important principle puts restoration into historical perspective and leads us to the second central idea in Brandi's philosophy: "A restoration should not prevent any future restoration but, rather, facilitate them."[22] This principle constitutes the basic notion behind the concept of reversibility and the object's (dual) historicity.

Throughout its lifetime, every work of art is subjected to numerous personal tastes and current fashions that have a long-lasting impact on its "oneness."

These "fluctuations," as Brandi calls them, "are certainly not beneath the notice of history; indeed, they are history and history of culture."[23] They shape the object's "oneness" and, therefore, after a thorough examination of their quality, must be respected as integral parts of the object. Brandi concludes that the act of restoration cannot develop surreptitiously or in a manner unrelated to time. It must be emphasized as a true historical event and made a part of the process by which art is transported to the future.[24]

While the artist's intention takes precedence over interventions done over time, Brandi considers elapsed time as organic and irreversible, and thus advocates a more historical approach toward restoration. That certainly does not mean "everything that has happened to the object can be considered equally significant. What makes history is the meaning of the event, the meaning that we recognize in a particular context."[25] A critical examination of the object leads to adequate judgment of "the moment that marks the insertion of the work of art into historical time, in order to define which of these moments offers the conditions necessary for that special intervention entitled 'restoration.'"[26] Brandi calls an ahistorical approach that tends to erase the passage of time by recreating an original state a "restoration by fantasy."[27]

Brandi's concept of lacunae is directly linked to his discourse on fragments and "potential oneness," however, with a different approach. Brandi defined lacunae as "an interruption in the figurative fabric."[28] From his point of view, filling a lacuna was synonymous with reestablishing the unity of the image. The appearance of unity is strongly linked to human vision and perception. Based on empirical findings from Gestalt psychology, Brandi developed a set of principles that are still considered valid in fine art restoration. The concept of lacunae primarily references paintings and murals, and it is in this context that Brandi's theory has proven to be most valuable.

On the other hand, I don't want to build my argument solely on Brandi, since his theory has suffered from a number of false presumptions. Katrin Janis, for example, has emphasized the problems that emerge from Brandi's neglect of "minor" works, e.g.,

mechanical objects, whose historical value are mainly defined by function.[29] Brandi rele-
gated the restoration of artistically inferior works to mere craftsmen. Another reservation
was that even though Brandi aimed at a universal restoration theory, his methodology
falls short when applied to three-dimensional objects.[30] In practice, his conceptual divi-
sion of the material properties in "structure," the carrier of the visual manifestation, and
"appearance," the actual *imago* that gives a pattern or shape to the raw material, inevitably
raises problems. In particular, his axiom "only the material form of a work of art is restored"
has been proven unsustainable in modern conservation theory.[31] Still, I want to highlight
that it is possible to translate this dual conception into film restoration, if we can inter-
pret the terms *appearance* and *structure* in accordance with the physical characteristics
of film.

THE CONCEPT OF THE "ORIGINAL"

There is still no agreement on what exactly constitutes the integrity of the moving image,
a term that is clearly adopted from the fine arts. While in fine art restoration, *integrity*
refers to the physical condition as well as the historicity of an artifact, the film restorer
usually applies this term solely to the image content. This misappropriation has become
increasingly problematic with the emergence of digital cinema. Paolo Cherchi Usai has
already criticized the growing tendency among archivists to consider film a medium that
no longer depends on a physical carrier.[32] This critique exemplifies a fundamental gap in
the conception of film restoration: the relation between the actual film artifact and the
cinematic experience that constitutes our memory of film history. The *FIAF Code of Ethics*
recognizes that the original negative or the oldest surviving element has to be protected
for future reference.[33]

**But the historical value of a film artifact is still widely underappreciated. We need a concise def-
inition of *integrity* which incorporates the material characteristics of the film artifact as well as
the film content. The cinematic experience and the physical constitution of the film artifact cannot
be separated from each other.**

The attempt to apply principles from Brandi's *Theory of Restoration* to film is
not unproblematic. It is therefore necessary to look beyond mere principles and examine
what exactly justifies a comparison between handcrafted objects and technically repro-
ducible artifacts. Concepts of "the original" and "authenticity" certainly deserve closer

attention. Furthermore, it will be crucial to examine the so-called physical properties of film in order to come to grips with the still-vague term *integrity*. The recognition of these "physical properties" is a fundamental step in the assessment of the film artifact, helping us to determine those characteristics that have to be safeguarded in the restoration process.

In the past, the technical reproducibility of moving images has spurred a lot of misunderstandings — from Walter Benjamin's influential statement that films and photos ultimately lack the "aura" of unique works of art to the widespread attitude among archivists that film artifacts are merely carriers of information.[34] While traditional concepts of the "original" are irrelevant, each film artifact has specific aesthetic characteristics shaped by its material constitution (such as the film stock, the chemical composition of the emulsion, or the exposure values and the processing time that are both inscribed in the emulsion and therefore contribute to the visual appearance of the image). Since every photochemical duplication step unavoidably causes a visible loss in quality, those characteristics are indeed unique and not reproducible.[35] This dilemma, in a perverse twist, also echoes the common notion in fine art restoration that "a completed restoration represents not a former but another state."[36]

The fact that a film artifact is not perfectly reproducible stresses the importance of best-quality copy. "Concepts of quality," as Read and Meyer call it, are mainly determined by physical condition and photographic quality. The best-quality copy is in most cases identical to the oldest surviving film element — although sometimes it may be partly composed of lower quality master materials.[37] Additionally, the quality of dup film elements can differ, according to the printing and processing setups of a laboratory. Such factors make a methodological assessment of the film artifact and rigorous quality control standards in film restoration even more critical. The best-quality copy provides the material for a restoration, but is nevertheless far from being an original. As Cherchi Usai puts it, "the 'original' version of a film is an object fragmented into a number of different entities equal to the number of surviving copies."[38] Even more so than in fine art restoration, the "original" state in film restoration is, to use Giovanna Carbonara's words, a "mythical endeavour."[39] The commercial distribution of film copies has caused a massive proliferation of versions that all refer to the same "original" but have most certainly undergone drastic changes. Considering this proliferation of film versions, Cherchi Usai's theorem that every copy is a "unique object" is no exaggeration.[40]

It is therefore the responsibility of the restorer to make very clear which version he is aiming for. In her article "Some Principles of Film Restoration," Eileen Bowser proposed five practical models for film restoration that are still accepted today.

1. restoring the film as it was handed down to the archivist

2. restoring the film as it was seen by the first audiences

3. restoring the film as it was intended by the director

4. restoring the film to a version that "plays well"

5. a rework by a contemporary artist (in this case archives usually do not speak of a restoration any longer)[41]

To this list we could add a sixth model, as Read and Meyer suggest: the restoration of a version as it was seen by later audiences.[42] This version is relevant since it might be the version that has earned a place in history books and is therefore significant even if it is by no means the "definitive" version.[43] When it comes to film reconstruction, it is common practice to aim for the version seen by the first audience.

Martin Körber rightfully noted that today the term *film restoration* is widely devalued, due to general misuse.[44] Cherchi Usai has an even more drastic opinion of film restoration than Körber, regarding it as just "another form of ideology." The restorer imposes his ideas upon the object, while Cherchi Usai prefers a "non-ideological" approach that protects what the archivist finds.[45] This attitude is not only consistent with Brandi's philosophy but to some extent with the general conservation principle that a restoration ends where speculation begins.[46] Furthermore, Cherchi Usai clearly aims for the recognition of the film artifact as historical evidence and, as such, eligible for restoration in its own right. His line of argument is more consistent with traditional notions of fine art restoration: each artifact is treated as an original. Today, the use of copies or replicas is quite common in museology and heritage conservation. Furthermore, in some cases, copies themselves have taken on the status of originals. Dominique Païni gives the example of the sculptor Primaticcio who in 1540 made a series of casts from antique statues in the Courtyard of the Belvedere in the Vatican. Today, the bronze copies made from these casts have become highly appreciated works of art and are widely praised as an "essential stage in the diffusion and appreciation of antique statuary."[47]

It is therefore necessary to challenge the traditional concept of the "original" and find a more practical definition in the context of reproductive arts. Even in the museum world, "the relative significance of the original and the 'authentic'" is now widely accepted.[48] This notion strengthens my argument that the application of principles from fine art restoration to film turns out to be very useful if archivists and restorers recognize the film artifact as an object of historical evidence. Film artifacts show characteristics of

traditional works of art in a sense that each has unique aesthetic qualities that cannot be reproduced (without loss); at the same time, considering their historicity, films are products subjected to wear and tear. In this respect, film artifacts represent the very link between works of arts and utility items that Brandi's restoration theory failed to recognize. The "relative significance" of the "original" is underlined by Rudolf Arnheim's statement on duplicates in a museum: "Properties of the work of art reside in all its various embodiments."[49]

Looking into art history, we can find a comparable case with engravings. Many prejudices toward engraving sound all too familiar in the context of moving images. In the early 1700s, William Hogarth's contemporary George Vertue (1684–1756) complained about the low prestige of the engraving profession among other arts, merely because it was a reproductive rather than an original art form.[50] From a technical point of view, the similarity between engravings and moving images is striking: both are manufactured from a matrix that in itself has no aesthetic value. The engraver's plate and the photographic negative come close to the traditional concept of the "original." However, both are simply templates used to create as many prints as possible.

What, on the other hand, distinguishes both from the traditional notion of the "original" is that neither can serve as an absolute reference. As Körber emphasizes with regard to film restoration, the photographic negative provides only the "raw material" that can be "interpreted" in various ways in the printing and processing stages. "In the case of the positive print, the light values, for example, are already determined in the material. The duplication process is already an interpretation of the material. However, with the negative, the restorer starts from scratch."[51]

This observation perfectly underlines how schizophrenic the concept of the "original" is in the context of reproductive arts. Both matrix and print embody original qualities that together constitute the work's integrity.

The rising popularity of engravings ran parallel with the emergence of the consumer society and mass culture in the eighteenth century. William Hogarth (1697–1764) was the first renowned artist who capitalized on the rapidly growing print market with his highly acclaimed series *The Harlot's Progress* (1731). Hogarth proudly distinguished himself from the majority of professional engravers by manufacturing his own prints, which were based on his own works. This idea of "the author's hand" as an immanent, intangible value of a work was still strongly linked to this idea of originality. In 1744, Hogarth announced he would produce another edition of "The Harlot." However, for the second

edition he solely manufactured the copper plates and commissioned a local printmaker to execute the printing job. The prints were sold as originals, too, as a reaction to the thousands of pirate copies of "The Harlot" that flooded the streets.[52]

Other factors apart from originality come into play for the assessment of mechanically and technically reproduced artifacts; characteristics that are no longer intrinsic to the material. Païni, for example, names the "valeur d'ancienneté," the value of ancientness, as a defining value of every man-made object, whether art, reproduction, or utility item.[53] This value increases if the object is the last surviving object of its kind.

In film restoration, the camera negative, the origin of all subsequent copies, comes closest to the traditional concept of the original, but it still remains, as Körber rightfully pointed out, "raw material" in the hand of the technician. Païni's example of the Primaticcio casts clearly shows that copies can take on the status of originals.

Such a "migrating" concept of the original would suggest that ancientness and uniqueness— apart from originality—have to be recognized as other crucial factors for the assessment of cultural artifacts.[54]

AUTHENTICITY: THE FILM ARTIFACT AND VIEWING EXPERIENCE

The general indifference toward a conceptual understanding of the term *original* represents one of the oldest problems in film restoration. What is "original" about the cinematic sensation? Or, as Nicola Mazzanti asks, "Where exactly is the film experience? Is it on the film, or in the projector, or on the screen? And precisely how do these many things interact with one another?"[55] The opinions vary. While for Cherchi Usai, the integrity of the film artifact takes precedence in restoration, the restorer João Socrates de Oliveira's aims for the restoration of the "original" viewing experience. For de Oliveira, the cinematic experience is a visceral event that develops "on the screen."[56] De Oliveira makes an interesting point: one cannot separate the viewing experience from the technical apparatus that constitutes the sensation. Such an approach would completely defeat the purpose of safeguarding the authenticity of a film. Hence, we have to understand the authenticity of the film as a duality: it is defined by the object *and* the mode of presentation. In terms of authenticity, a digital projection, for example, represents something "other" than a traditional 35mm projection. This argument seems to diffuse into the realm of phenomenology but, in fact, today it is a widely accepted notion that "authenticity also encompasses function."[57] The authenticity of "running systems" such as clock-

works or computers is determined by the fact that they are actually "working."[58] Looking at a film print cannot arouse the same sensation as its projection. In that respect, de Oliveira's approach is convincing: the authenticity of moving images is strongly linked to the viewing experience.

It is however technically impossible to recreate the "original" viewing experience. The general restoration objective to restore a film "as close as possible" to its original state does not take into account that modern projection equipment generates very different results from a 1920s projector.[59]

No restorer can bridge the temporal distance between the "original" state and the present, nor can she claim to recreate the "original" viewing experience. Cherchi Usai goes so far as to completely dismiss the term *restoration* as applied to film. Instead he prefers, particularly with the emergence of increasingly accomplished digital restoration tools, the term *simulation*.[60]

This is exactly de Oliveira's approach.

What de Oliveira aims for is "the original impression that not longer exists."[61] To achieve this, he bases his restorations strictly on scientific findings. In his theory, the restoration of a silent film from the 1920s would be based on the visual impression of a projection with a carbon arc as used in the 1920s. As de Oliveira says,

> it is possible to create a correspondence between dyes, colors and color saturation in the new print that makes a projection with modern xenon bulbs look like a carbonate projection from the 1920s. The xenon lamp has a spectral distribution that is very intensive in the green spectrum and very low in the yellow spectrum. So we have to "correct" the dyes in the modern print stock in order to match them with the characteristics of the carbonate (that is very strong in blues). That way we produce a visual impression similar to the original impression once produced with a carbonate light source.[62]

De Oliveira's method takes a new approach to film restoration. His conception of restoration does not refer to the physical properties of the moving image artifact but rather to the visual appearance in projection (also an accepted lab practice with regard to the *gamma* of a film print). Hence, it is not the material object that is restored to legibility (for the "restored" print, inspected on a winding bench, would give an overall visual impression that is slightly "off") but its ephemeral manifestation on the screen. This form

of manipulation certainly does not mean that the integrity of the film artifact is simply ne-glected. It rather proves my point that the cinematic experience is conditioned by the physical properties of the artifact. The integrity of the artifact itself is respected insofar that it gives evidence of its technical history. This history is determined by physical char-acteristics such as the film stock, the aspect ratio, the shape of the perforations, or the type of soundtrack. Here, the value of the film artifact as a "primary record" becomes evi-dent. In their "Statement on the Significance of Primary Records," the Modern Language Association of America declares that

> it is crucial for the future of humanistic study to make more widely understood the continuing value of the artifacts themselves for reading and research. The advantages of the new forms in which old texts can now be made available must not be allowed to obscure the fact that the new forms cannot fully substi-tute for the actual physical objects in which those earlier texts were embodied at particular times in the past. . . . Texts are inevitably affected by the physical means of their transmission; the physical features of the artifacts conveying texts therefore play an integral role in the attempt to comprehend those texts.[63]

Simply by exchanging the word *text* for *film* we would get a concise statement on the significance of the master element (aka the "original") in film restoration. No mat-ter what we call the "restored" film artifact (copy, duplicate, new edition, or facsimile), the physical evidence of the source material has to be preserved for future generations, as it is part of the object's history. Physical clues such as the condition of the perfora-tions, the splices, or the edge numbers reveal facts about how the artifact was produced or altered; these facts contribute to the assessment of the object. Ignoring this physical evidence in the course of a restoration job would, in Brandi's terms, ultimately erase this particular history of the artifact and be, therefore, irresponsible.

PHYSICAL PROPERTIES OF THE MOVING IMAGE

If we accept as a general restoration principle that the assessment of a restoration pro-cedure necessarily emanates from the object itself, we now must take this presumption a little further. As already stressed, Brandi's conceptual division of the material mani-festation of the artifact in the two occurrences "structure" and "appearance" no longer can be maintained in modern conservation theory. Still, for two-dimensional pictorial objects, particularly moving images, Brandi's conception provides some useful guidance.

A closer examination of this structure in relation to film is therefore necessary. We can differentiate two structural elements that constitute the filmic image: the base and the emulsion, of which the latter holds the image. Both elements have a significant effect on the visual characteristics of the image, although the chemical constitution of the emulsion is by far more important.

Obviously, from a restoration point of view, the distinction between material and image does not make much sense. First of all, the film restorer—in contrast to the fine art restorer—never works on the material itself but uses it as a reference. Second, a clear separation of the visual manifestation and the material is literally impossible since the image is not just embedded in the structure, as is the case with a painting. It *has become* the structure, since the chemical components of the emulsion form the latent image of the film. Conceptually, however, Brandi's division remains useful. The chemical composition of the emulsion determines the "material properties" of the filmic image and therefore affects its visual characteristics and the overall aesthetical appearance.[64] Brandi's statement that structure and appearance "represent the two functions of material in a work of art and normally one does not contradict the other" is highly instructive in this context.[65] It is mirrored in the general notion in film restoration that the restoration of the visual impression can only be accomplished if the material structure of the film artifact is fully understood by the restorer. Here, it becomes necessary to examine the "physical properties" of the filmic image. We need to specify what exactly the filmic image is.

The filmic image is a visual manifestation within a granular structure composed of silver halide crystals. This manifestation is constituted by various factors: the light sensitivity of the silver halides, i.e., the speed of the emulsion, the exposure values used in the printing process, the duration of the stock in the developing bath, and a variety of technical tricks applied by the cinematographer, which we can summarize as the director's "stock in trade," as Ian and Angela Moor call it in their article "Photographs, Images or Artifacts?" In relation to photographs in general, the Moors emphasize that the

> recognition and understanding of these physical properties is essential, for it not only allows an appreciation of the physical subtleties inherent to individual photographic processes, . . . but also enables ethically sound preservation and conservation techniques to be formulated.[66]

Therefore, the grain constitutes an integral aspect of the image's integrity. As the restorer Robert Harris so aptly states: "Grain is not a 'byproduct' of film—it *is* the film."[67] In his criticism of contemporary efforts to decrease digitally the "disturbing" graininess of old

motion pictures, Harris compares the moving image with the impressionist paintings of Georges Seurat who composed his works solely of dots. As much as the dots in Seurat's paintings represent the visual manifestation of the image, the grain in the filmic image gives the play of light and shadow, gray scale, and density a gestalt.

Here we have the perfect analogy for the filmic image. Photographic grain is pure information: the sum and size of the grains define the resolution of the image, while the distribution of the grains controls the gray scale, i.e., the variation in density.

The removal of grain ultimately results in a loss of information; it alters crucial aesthetic characteristics and consequently corrupts the integrity of the moving image. Harris's criticism of the "over-cleaning" of moving images echoes Cherchi Usai's question about the price we are willing to pay to make motion pictures acceptable for contemporary audiences. It is not the job of the restorer to "improve" an old film with the means of modern technology. If a restoration theory for film recognizes the film artifact as an object of historical evidence, then the mode of production has to be considered as a crucial aspect of its technical history. This history has to be preserved. Therefore, in the assessment of a film artifact, the restorer must distinguish between characteristics that are integral to the moving image artifact (such as the grain structure) and characteristics that are introduced at a later stage. For example, there is a decisive difference between a picture that is unstable due to the low quality of motion picture technology at the time of production and a picture that appears unstable because of errors in a later duplication process. The first must be respected as inherent to the motion picture, the latter should be corrected.

The granularity of a moving image raises similar questions with regard to integrity. The grain structure represents an intrinsic characteristic of the filmic image, with the grain as the smallest unit of visual information. Still, keeping in mind Brandi's concept of the unity of the image, the visual impact of the moving images does not result from individual grains but from the distribution of all grains that constitute the filmic image. Ernst Gombrich has emphasized this relationship for the restoration of easel paintings.

> It may well be argued that restorers, in their difficult and responsible work, should take account not only of the chemistry of pigments but also of the psychology of perception—ours and that of the chicken. What we want of them is not to restore individual pigments to their pristine color, but something infinitely more tricky and delicate—to preserve their relationships. It is particularly

the impression of light, as we know, that rests exclusively on gradients and not, as one might expect, on the objective brightness of colors.[68]

Gombrich argues in the same vein as Brandi when he refers to human vision as a guide for the restoration of two-dimensional pictorial objects. Here, theories from Gestalt psychology become extremely valuable. The impact of Gestalt psychology on fine art restoration is particularly visible in Brandi's writings on the treatment of lacunae.[69] His methodology for the reestablishment of an image's aesthetic unity is based on the structure of our visual perception.

The main principle Brandi derived from Gestalt psychology is that the integration of loss has to be conducted in a manner that lacunae do not disrupt the unity of the image. Consequently, its treatment has to succeed in two ways: the critical intervention must conceal the interruption— without hiding the evidence.

If successful, the lacuna is "neutralized"; still visible, but in harmony with the figurative composition of the image. This harmony, however, is only partly linked to the "physical properties" of the filmic image.

Interestingly, Gestalt psychology becomes particularly relevant in the context of moving images since the concept of film is based on the phenomenon of "apparent motion" (first articulated by Max Wertheimer in 1912).[70] Motion pictures rest on the fact that the human eye cannot discriminate between individual static frames. The rapid succession of still frames creates the illusion of motion. Hence, Wertheimer concluded, the perception of the "whole," the movement, differs from the perception of each component, the still image. This is an important observation for film restoration.

It first of all emphasizes that film is a time-based medium. Our visual experience of motion pictures is strongly linked to the temporal continuum. The viewer experiences motion pictures "as time," as Körber has put it.[71] Therefore it is the restorer's job to restore the motion picture in a way that it can be appreciated again in its temporal continuity. Here, the treatment of lacunae becomes particularly interesting since, in motion pictures, lacunae can represent serious disruptions of this temporal continuity if a shot or a whole sequence is missing. The configuration of time is a critical factor in the treatment of lacunae.

Wertheimer's observation is interesting for another reason. It stresses the interdependency between still images and pictorial sequences, the "motion." Ultimately, the

film restorer does not restore single frames but a succession of images. The restoration of a filmic sequence is only successful if the relationships between its smaller units maintain a formal unity. Here, aesthetics play a pivotal role. The interpolation of frames in digital restoration is a good example for this problem.

In film restoration, interpolation is a common method of dealing with lacunae. Frames before and after a partly deteriorated frame are compared by the restoration software and a mix of them is synthesized to replace the destroyed portions. The new frame itself may look "clean" again—no scratches, no blotches, no decomposition—but the sequential transition between the damaged and the undamaged frames might create a flicker effect.

As we can see, the treatment of lacunae in film restoration raises quite different issues than in the restoration of fine art objects. With moving images, the duality of the "whole" and its components has to be recognized in its temporal configuration. The complexity of this problem still arouses a lot of discussions among film restorers. One reason is the deep gap between recognition of the technical nature of the filmic image and an understanding of the psychological implications of motion pictures. This circumstance also echoes Cherchi Usai's skepticism toward methodological tools from philology as applied to film restoration. His critique has become a little clearer now. The realization of moving images as "text" disregards the structures of human perception on which the whole viewing experience is based.

OCCURRENCES OF LACUNAE IN MOVING IMAGES

As a critical discipline, film restoration has to serve two purposes: one, the reestablishment of aesthetic unity and, two, the preservation of historical evidence as embodied in the film artifact. Ideally, the film has to become legible again as both a narrative and a historical record. To accomplish this goal, the reversal of alterations and the retrieval of losses are of foremost concern. For now, however, I will leave the problem of alterations aside and focus on losses (although I am fully aware that the distinction is not always clear; undoubtedly, an alteration can be synonymous with a loss in the case of censorship). In order to translate the concept of lacunae to film restoration successfully, we first must qualify the various types of loss and the specific treatments each requires. Only a strict classification of lacunae provides us with the information necessary to approach the problem with methodological rigor.

For my critical assessment of lacunae in moving images, I consider two questions: Can the problem be approached with ethical principles from fine art restoration?

And how does this critical conduct contribute to a consistent methodology? With these questions in mind, I can begin to categorize different instances of filmic lacunae. Two facts have to be taken into account. First is the temporal configuration of the moving image. Lacunae can affect not only the appearance of a single image but frequently also the relation between two (or more) consecutive images — and therefore temporal continuity. Secondly, in contrast to fine art restoration, lacunae in film restoration are defined exclusively as a loss of visual information. Since my discussion of lacunae is mainly based on precepts from Gestalt psychology, physical losses in film artifacts (a scratch, for example) are only a concern as a disturbance of the visual appearance of the image.

Another departure from fine art restoration is even more fundamental. While in the fine arts, the presence of the lacuna is the disruptive figurative element, in film it is frequently the absence of a whole sequence that causes an interruption of rhythmic patterns. The loss does not always appear within the frame, but *between* frames. Here, the treatment of lacunae naturally requires a different conceptual framework that is, however, still within the confinements of Brandi's theory. This circumstance indeed poses an interesting challenge for the restorer. "Hiding" a lacuna would not match Brandi's notion of a critical interpretation. The lacuna is defined as a mark of time and has to remain recognizable as such. Therefore, it is the film restorer's responsibility to make lacunae visible before he can proceed to reestablish the formal continuity of the sequence.

The reconciliation of aesthetic form with critical conduct is the restorer's most difficult task. Brandi was the first restorer who recognized the importance of consolidating both objectives in a harmonious manner. At the Instituto Centrale del Restauro in Rome, he developed a set of techniques especially designed to accomplish this goal in fine art restoration. The most common one is called *tratteggio:* a system of hatchings that models the figure on the basis of the tonal distribution. For a *tratteggio* the restorer uses mechanical brush strokes according to very precise instructions, in order to avoid the imposition of an artistic impression on the image.[72] Today, this technique is widely used in fine art restoration. In the museum world, it is referred to as the "six inch–six foot" rule: from a distance (six feet away) the *tratteggio* is not visible; the spectator has to step close to the painting (six inches) to recognize the treatment.[73]

Tratteggio is an elegant way to reintegrate lacunae in a painting, while retaining a critical rigor. Filmic lacunae, however, require a different approach. Mark Paul Meyer's statement that in motion pictures a lacuna is often not even visible is quite pertinent in this context.[74] One missing frame, unlike a damaged one, certainly has little effect on the rhythmic pattern of images and, therefore, the viewing experience. In contrast, a missing sequence of frames certainly has. Nicola Mazzanti rightly points out that "when a shot is

'dropped' it unbalances the editing of the film. . . . This could give a completely different meaning to the editing."[75] In the case of a missing sequence, two circumstances are conceivable: it might be possible that lacunae can be filled from other sources (reconstruction); if not, the insertion of black frames to indicate missing shots is a common practice. In the execution, the restorer has to apply a method that is "both qualitative and quantitative."[76] Qualitative in a sense that the position and number of inserts needs to be considered. Naturally, not every missing frame is replaced by black inserts. At the same time, the treatment has to be quantitative with respect to the length of the inserts. An insert only serves as an indication of lacunae; it does not reestablish the temporal configuration of a scene. Hence, it is not advisable to replace, for example, three feet of missing frames with an equal amount of black inserts.

A missing sequence raises a number of issues. The aspect of montage is particularly important. This problem cannot be solved merely with philological rigor. Here, the "temporality," as Tom Gunning has called it, of motion pictures comes into play.[77] This "temporality" is determined by two factors: the phenomenon of "apparent motion" (the temporal configuration of moving images) and the montage of shots that constitute the gestalt of the film. In Meyer's opinion, for example, it is not the narrative structure that should be reconstructed but the "rhythm of the film."[78] In this respect, a scrupulous treatment of sequential lacunae can be at times rather counterproductive.

In contrast, a lacuna within the image initially entails a number of ontological considerations. If, for example, the lacunae result from a mechanical damage of the artifact itself, it might be possible, depending on the extent of the damage, to recover the visual information with purely photomechanical means (wet-gate printing). If however the mechanical damage has occurred in an earlier copy and was consequently printed through, no photomechanical method is capable of dealing with the marks of time; the damages have become engrained in the moving image. Here, digital restoration remains the only solution.[79] This instance raises an interesting question about Brandi's notion of historicity: should not the restorer consider scratches historical evidence and therefore part of the moving image's integrity? No doubt the appreciation of many motion pictures has suffered from bad prints. At the same time, as Cherchi Usai points out, "it is acceptable to pay a lot of money for a sixteenth-century table which is full of scratches, and [we] have no intention whatsoever to [sic] sandpaper its surface to make it look like new."[80]

Cherchi Usai stresses a prevailing double standard in film restoration. Within a consistent restoration theory, particularly one that is derived from principles in fine art restoration, it would be indispensable to develop a critical conception of damages.[81]

Why should scratches or so called cue marks, left by generations of projectionists, not be recognized as physical characteristics of the moving image in the same way as art connoisseurs have accepted the patina of an old painting as an aesthetic feature?

De Oliveira concludes:

> A scratch that has occurred during an earlier printing process becomes part of the film. Hence, I would advise to leave it. There is the dominant idea in our times that everything should look spotless and beautiful. I do not think this is the most important thing. I have the same attitude towards colour. Even a faded print can have a unique beauty. There is an *élan*, a magic, that makes them a very interesting experience.[82]

The ethical considerations in regard to the treatment of a lacuna within a film frame differ considerably from the ones regarding sequential lacunae, because the restorer has to deal with problems in relation to the intrinsic properties of the moving image. The theoretical implications are much closer to the concepts of fine art restoration. In this context, principles from Gestalt psychology are again of particular interest. The phenomenon of "figure–ground organization," first described by Edgar Rubin in 1921, served Brandi as a guideline for his theory of the figurative composition of paintings.[83] Rubin observed that, within a group of connected forms, each component can be perceived either as object or background. Brandi derived from this phenomenon a fundamental principle for the treatment of lacunae. If the appearance of the lacuna is too obtrusive, it is most likely perceived as the figure, while the image itself recedes to the background. It is therefore the restorer's job to treat lacunae in such a way that they appear neutral, bringing the image to the fore. The image's formal unity is strongly linked to the figure–ground organization. Only if the prominence of lacunae is reduced, can the image's gestalt be perceived.

Figure–ground organization again becomes an important issue in the digital restoration of moving images. A nonsystematic retouching of single frames can result in a reversal of the figure–ground relationship between lacuna and image. If the lacuna is treated excessively in the digital domain, it might look "overcleaned." The effect is counterproductive: the lacuna appears even more obtrusive than before. This example demonstrates that Brandi's ruling principle cannot be underestimated: the degree of intervention must always be in proportion to the extent of the damage. Restraint is the greatest virtue of a restorer.

Considering the structure of human perception, we must understand that not only the size of a lacuna can affect the appearance of an image but also its location within the figurative composition.[84] The most obvious examples in the context of film are scratches that compose a regular pattern over the image. Even if the loss of visual information is considerable, the occurrence of the lacuna does not necessarily disrupt the image's legibility, since it acts rather like a screen between viewer and image. To illustrate my argument, let us imagine that a restorer replaces a shot within a scratched sequence with frames of impeccable quality retrieved from another copy. In the reconstructed sequence, the impeccably preserved frames, no matter how short, would now appear rather disturbing in contrast to the worn parts of the sequence. This instance again stresses the importance of a methodological approach. The restorer has to distinguish between lacunae that have to be reintegrated and those that should be left untouched.[85]

CONCLUSION

The temporal configuration of moving images represents the most obvious conceptual departure from traditional works of art. However, as I have demonstrated, the film restorer can overcome this conceptual difference by applying methodological principles from fine art restoration in a qualitative manner. My initial claim that fine art restoration can provide a useful methodological framework for film restoration was based on the presumption that film restoration is a critical discipline. Hence, a methodological assessment of the nature of film, as well as of its physical characteristics was a crucial step in developing a fundament for a critical approach toward moving images.

An integral aspect of this critical approach was the distinction between the film artifact as physical evidence and the motion picture as a visual sensation. Within the scope of my argument, the establishment of the film artifact as a historical document in its own right (to the same degree as an antique vase is considered as evidence of the past) was crucial for a conceptual understanding of film restoration. My brief discussion of the problem of lacunae finally demonstrated some striking parallels between two-dimensional pictorial objects (such as easel paintings) and film. At the same time, it suggested that a truthful application of principles from fine art restoration necessitates a revision of certain concepts (for example, "original" and "integrity") as they are in place in film restoration today.

The main goal of this article was to propose a methodological framework for film restoration by examining current ethical and theoretical discourses in fine art restoration. Ultimately, the methodological principles I establish for film restoration demonstrated

the usefulness of my thesis: the comparability of film restoration and fine art restoration. A number of principles Cesare Brandi articulated in his theory of restoration, although based on the very narrow of conception of "works of art," proved to be good guides. Referring back to my initial concern that film restoration still lacks a professional identity, this article aspires to establish a foundation for a consistent methodology, which is an essential feature of any professional codification.

Only a small aspect of the whole moving image restoration complex was covered. More elaborate discussions need to follow. My examination of some well-defined practical problems in film restoration simply has served to prove the usefulness of a certain methodology, derived from an already established critical discipline.

NOTES

1. ICOM Code of Ethics for Museums (International Council of Museums, 2004); ECCO Professional Guidelines (European Confederation of Conservator-Restorers' Organisations, 2002); AIC Code of Ethics (American Institute for Conservation, 1996); UNESCO Memory of the World: General Guidelines to Safeguard Documentary Heritage (United Nations Educational, Scientific and Cultural Organization, 2002). The Venice Charter (Venice, Italy: International Charter for the Conservation and Restoration of Monuments and Sites) that was agreed on in 1964 by ICOMOS (International Council on Museums and Sites) was the first international standard in the conservation of cultural heritage.

2. "One of the important distinguishing features between the craft and the professional phases is that in the latter there is an accepted corpus of principles and methods" (IIC-AG Murray Pease Report [1964], as quoted in Elizabeth Pye, *Caring for the Past* [London: James and James, 2001], 34).

3. ICOM-CC, "The Conservator-Restorer: A Definition of the Profession" (International Council of Museums, Committee for Conservation, 1984).

4. Paul Read and Mark Paul Meyer, *Restoration of Motion Picture Film* (London: Butterworth Heinemann, 2002), 1.

5. Ibid., 1.

6. Paolo Cherchi Usai, *Silent Cinema* (London: BFI, 2000), 66.

7. However, although restorative treatments are strictly determined by the film artifact, the preservation strategy must also take into account the context in which the film appears. Documentaries, artist films, home movies, and feature films of high production value encompass very different functions that have to be preserved.

8. The social relevance of conservation is thoroughly analyzed in Erica Avrami, Randy Mason, Marta de la Torre, "Report on Research," in their coedited volume, *Values and Conservation Heritage* (Los Angeles: Getty Conservation Institute, 2000), 10.

9. Gary Edison, *Museum Ethics* (London: Routledge, 1997), 13.

10. See *FIAF Code of Ethics* (International Federation of Film Archives, 1998); Ray Edmondson, *Philosophy of Film Archiving* (Paris: United Nations Educational, Scientific, and Cultural Organization, 2004); UNESCO Recommendation on the Safeguarding and Preservation of Moving Images (United Nations Educational, Scientific, and Cultural Organization, 1980).

11. Of all existing codes in the museum field, ICOM-CC's *The Conservator-Restorer: A Definition of the Profession* is, to my knowledge, the only attempt to define the responsibility the restorer as an individual rather than outlining the cultural concept of conservation/restoration.

12. Raymond Borde, "Film Restoration: Ethical Problems," in Ramon Espelt, ed., *Protection and Preservation of Films* (Barcelona: Oficina Catalana de cinema, 1988), 90.

13. I have to add, though, that in fine art restoration this development was partly reversed with the emergence of the conservation science discipline, which again widened the gap between the theorist and the practitioner. See Pye, *Caring for the Past*, 68–69.

14. See Dominique Païni, "Reproduction...Disappearance," in *This Film Is Dangerous*, ed. Roger Smither and Catherine Surowiec, 171–76 (Brussels: FIAF, 2002); Cherchi Usai, *Silent Cinema*, 44–76; Enno Patalas, "On 'Wild' Restorations, or Running a Minor Cinematheque," *Journal of Film Preservation*, no. 56 (1998): 28–38; Nicola Mazzanti, "Footnotes (For a Glossary of Film Restoration)," in *Restauro, Conservazione e Distruzione dei Film*, ed. Luisa Comencini and Matteo Pavesi, 23–29 (Bologna: Editrice il Castoro, 2001); and, finally, Mark Paul Meyer, "Ethics of Film Restoration and New Technologies," in *The Use of New Technologies Applied to Film Restoration: Technical and Ethical Problems / L'Utilizzo delle Nuove Tecnologie nel Restauro Cinematografico: Problemi Tecnici e Etici*, ed. Gamma Group, 29–38 (Bologna, Italy: Gamma Group, 1996).

15. R. H. Marijnissen, "Degradation, Conservation, and Restoration of Works of Art: Historical Overview," in *Historical and Philosophical Issues in the Conservation of Cultural Heritage*, ed. Nicholas Stanley Price, M. Kirby Talley Jr., and Alessandra Melucco Vaccaro (Los Angeles: The Getty Conservation Institute, 1996), 277.

16. Sheldon Keck, "Further Materials for a History of Conservation," in ibid., 281.

17. Pliny the Elder, *Natural History* (Cambridge, Mass.: Harvard University Press, 1961), 351–52.

18. Cesare Brandi, *Theory of Restoration* (Rome: Nardini Editore, 2005).

19. Ibid., 57.

20. Ibid.

21. Ibid.

22. Ibid.

23. Ibid., 62.

24. Ibid., 64.

25. Paul Philippot, "Restoration from the Perspective of the Humanities," in Price, Talley Jr., and Melucco Vaccaro, eds., *Historical and Philosophical Issues*, 221.

26. Brandi, *Theory of Restoration*, 63.

27. Ibid., 64.

28. Ibid., 58.

29. Katrin Janis, *Restaurierungsethik* (Munich: M Press, 2005), 28.

30. Alessandra Melucco Vaccaro, Introduction to "The Emergence of Modern Conservation Theory" in Price, Talley Jr., and Melucco Vaccaro, *Historical and Philosophical Issues*, 209.

31. Brandi, *Theory of Restoration*, 51ff; Janis, *Restaurierungsethik*, 26.

32. Paolo Cherchi Usai, in a personal interview, conducted on June 8, 2005 in Ljubljana, Slovenia.

33. *FIAF Code of Ethics*, article 1.1: "Archives will respect and safeguard the integrity of the material in their care and protect it from any forms of manipulation, mutilation, falsification or censorship."

34. Walter Benjamin, "The Work of Art in the Age of Mechanical Reproduction" (1936), in Walter Benjamin, *Illuminations*, 211–45 (London: Fontana Press, 1992).

35. Read and Meyer, *Restoration of Motion Picture Film*, 1.

36. Pye, *Caring for the Past*, 141.

37. Martin Körber, "Notes on the Proliferation of *Metropolis*," in *Preserve, Then Show*, ed. Dan Nissen and Thomas C. Christensen (Copenhagen: Danish Film Institute, 2002), 135.

38. Cherchi Usai, *Silent Cinema*, 160.

39. Giovanna Carbonara, "The Integration of the Image: Problems in the Restoration of Monuments," in Price, Talley Jr., and Melucco Vaccaro, eds. *Historical and Philosophical Issues*, 237.

40. Cherchi Usai, *Silent Cinema*, 147.

41. Eileen Bowser, "Some Principles of Film Restoration," in *Griffithiana*, no. 38/39 (October 1990): 172–73.

42. Read and Meyer, *Restoration of Motion Picture Film*, 71.

43. As Werner Sudendorf argues, even a censored version has an "original quality" that makes it eligible for restoration. Censored versions can represent a cultural or political climate and therefore serve as historical evidence. See Werner Sudendorf, "Rekonstruktion oder Restauration," in *Der Stummfilm*, ed. Elfriede Ledig (Munich: Bauer/Ledig/Schaudig, 1988), 214.

44. Cherchi Usai provided the most useful definitions of restoration and reconstruction. Cherchi Usai, *Silent Cinema*, 66–67. For further discussions, see also Read and Meyer, *Restoration of Motion Picture Film*, 1.

45. Cherchi Usai, Interview, 2005.

46. ICOMOS Norms of Quito (1967), Recommendations, Article 5.

47. Dominique Païni, "Reproduction . . . Disappearance," 175.

48. Pye, *Caring for the Past*, 59.

49. Rudolf Arnheim, "On Duplication," in *The Forger's Art*, ed. Dennis Dutton (Berkeley and Los Angeles: University of California Press, 1983), 235.

50. Ronald Paulson, *Hogarth*, vol. 1 (Cambridge, U.K.: Lutterworth Press, 1991), 53–54.

51. Martin Körber, personal interview, conducted on May 31, 2005, in Berlin, Germany. His colleague, João Socrates de Oliveira, argues similarly: "In engraving, the matrix is not the important product. It is fundamental, of course, but the print is the final product. An engraver can produce fantastic

changes with different print techniques, by using more pressure or more ink, for instance, over the same matrix. This is similar to film; you have the negative but the negative can generate very different results" (João Socrates de Oliveira, personal interview, conducted on June 16, 2005, in London, England).

52. Paulson, *Hogarth*, 308–9.

53. Dominique Païni, "Reproduction...Disappearance," 171. "Age value" is an idea first introduced by Alois Riegl (1858–1905). Riegl recognized age as a critical factor for the evaluation of cultural artifacts. See Alois Riegl, "The Modern Cult of Monuments: Its Essence and Its Development," in Price, Talley Jr., and Melucco Vaccaro, eds., *Historical and Philosophical Issues*, 69–83.

54. Jack W. Meiland, "Originals, Copies, and Aesthetic Value," in *The Forger's Art*, ed. Dennis Dutton, 122.

55. Nicola Mazzanti, "Raising the Colours (Restoring Kinemacolor)," in *This Film Is Dangerous*, ed. Smither and Surowiec, 123.

56. De Oliveira interview.

57. Pye, *Caring for the Past*, 58.

58. Suzanne Keene, "Objects as Systems: A New Challenge for Conservation," and Francis Brodie, "Clocks and Watches—A Re-Appraisal?" in *Restoration—Is It Acceptable?* ed. Andrew Oddy, 19–25 and 27–32 (London: British Museum Press, 1994).

59. Paolo Cherchi Usai, "Film as an Art Object," in *Preserve, Then Show*, ed. Nissen and Christensen, 5.

60. Cherchi Usai, interview.

61. De Oliveira, interview.

62. Ibid.

63. Modern Language Association of America, "Statement on the Significance of Primary Records," in *Profession* 95 (1996): 27–28.

64. For discussion, see Paolo Cherchi Usai, "An Epiphany of Nitrate," in *This Film Is Dangerous*, ed. Smither and Surowiec, 128–31; and Kevin Brownlow, "Preface to the First Edition" in Cherchi Usai, *Silent Cinema*, xiii–xvi. The notion that "material can influence aesthetics" is widely recognized in fine art restoration. See M. Kirby Talley Jr., "The Eye's Caress: Looking, Appreciation, and Connoisseurship," in Price, Talley Jr., and Melucco Vaccaro, *Historical and Philosophical Issues*, 5.

65. Brandi, *Theory of Restoration*, 51.

66. Ian L. Moor and Angela Moor, "Photographs, Images or Artifacts?" in *The Journal of Photographic Science* 36 (1988): 120.

67. Robert Harris, as quoted in Jeffrey Wells, "Grain, or Not to Grain?" www.moviepoopshoot.com.

68. Ernst H. Gombrich, *Art and Illusion* (New York: Pantheon Books, 1960), 54–55.

69. Brandi, *Theory of Restoration*, 58.

70. Irvin Rock and Stephen Palmer, "The Legacy of Gestalt Psychology," *Scientific American* 263, no. 6 (December 1990): 48.

71. Körber interview.

72. Brandi, *Theory of Restoration*, 57. See also Paolo Mora, Laura Mora, and Paul Philippot, "Problems of Presentation," in Price, Talley Jr., and Melucco Vaccaro, *Historical and Philosophical Issues*, 351.

73. Andrew Oddy, "Introduction," to *The Art of the Conservator*, Andrew Oddy ed. (London: British Museum Press, 1992), 11.

74. Mark Paul Meyer, personal interview, conducted on June 10, 2005, in Ljubljana, Slovenia.

75. Nicola Mazzanti, "Footnotes," 27.

76. Ibid., 27–28.

77. Tom Gunning, "'Now You See It, Now You Don't': The Temporality of the Cinema of Attractions," in Richard Abel, *Silent Film*, 71–84 (New Brunswick, N.H.: Rutgers University Press, 1996).

78. Meyer interview.

79. Giovanna Fossati, "From Grains to Pixels: Digital Technology and the Film Archive" in Comencini and Pavesi, *Restauro, Conservazione e Distruzione dei Film*, 137.

80. Cherchi Usai interview.

81. Mazzanti distinguishes three types of "corruptions": damage (a corruption, such as deterioration, that happened through the passage of time), error (editorial corruption or bad printing), and defect (technical corruption, as happened in the production process). This distinction is fairly useful but needs more clarification. See Mazzanti, "Footnotes," 26–27.

82. De Oliveira interview.

83. Rock and Palmer, "The Legacy of Gestalt Psychology," 49.

84. Albert Philippot and Paul Philippot, "The Problem of the Integration of Lacunae in the Restoration of Paintings," in Price, Talley Jr. and Melucco Vaccaro, *Historical and Philosophical Issues*, 36.

85. Paul Philippot, "Historic Preservation: Philosophy, Criteria, Guidelines, II," in Price, Talley Jr., and Melucco Vaccaro, *Historical and Philosophical Issues*, 358.

THE LIBRARY OF CONGRESS FILM PROJECT

JANNA JONES

Film Collecting and a

United State(s) of Mind

There were whispers of concern about the ephemeral nature of mo-

tion picture films and their potential importance to future genera-

tions when the film industry was in its infancy. An editorial in the

1906 industry trade paper *Views and Film Index,* for example, opined that in fifty or one

hundred years films might become vital archival documents. Suggesting that moving

images of President Roosevelt, busy street scenes, and veteran processions might be of

value someday, the editorial acknowledged that the past disappears so quickly in a cul-

ture fixated on progress that photographs and film might help to prevent the obliteration

of memory. "Perhaps the day will come when motion pictures will be treasured by gov-

ernments in their museums as vital documents in their historical archives." The editorial

urged readers to consider the cultural impact of film and its unique ability to record both

everyday life and monumental events, and it called for the country's great universities to begin gathering films of "national importance" for future students. Interestingly, films of such import included mundane scenes of city streets as well as the historic occasions of presidential gatherings. In this early view, motion picture film was viewed as a time capsule that might afford future generations the ability to see the past, a past that would presumably be wiped out by progress. Archiving motion pictures could help to cultivate cultural memory by preserving political and social histories, thereby aiding the education of future generations.

A 1915 editorial in *Motography* entitled "Can Films Be Preserved for Posterity?" pointed to the potential problems that came with saving motion picture film; namely that its chemical properties and composition might lead to instability, flammability, and the growth of fungus. The editorial's concerns about film storage and chemical instability were driven by a desire to preserve moving images of the important actions of World War I. "Now that the greatest event in world history is transpiring, so to speak, before our cameras," the editorial explained, "the historians are offered their first extraordinary opportunity to establish archives of film records, to preserve into the indefinite future the exact replicas of today's actions."[1]

The editorial's archival impulse is, in part, driven by reports of the German government filming and archiving their participation in the war. It was also motivated by the possibility that future generations could be imbued with patriotism if they were afforded the chance to see "the exact replicas of today's actions." Both the 1906 and 1915 editorials suggested that films should be collected for future generations because they were documents of significant human activity. If films were protected, both editorials reasoned, future generations would respect history and be moved to patriotism. Such early archival inclinations were centered on nonfictional moving images that could offer future generations ways to *see* history exactly. While the 1905 editorial conjectured that scenes of both daily life and the politically powerful were worth collecting, the 1915 editorial focused only on grand, national events that would foster patriotism in future generations.

INTRODUCTION

While such a collection was only dreamt about in 1915, by the forties, the Library of Congress and the Museum of Modern Art (MoMA) collaborated in creating a national collection of films that reflected the strength and character of the country during World War II. This attempt at creating a comprehensive national moving image collection is the primary

focus of this essay, and while it an important chapter in the history and development of the motion picture archive, this essay is not primarily for the purpose of recounting. Instead, I consider how acts of collaboration, compromise, and resistance shaped the collection and how these acts helped to form our cultural memory. This essay, in part, reminds us that the moving image archive, like any other historical record, is not an objective, ideology-free representation of the past.

Put simply: this collection was not born out of fear that the country's films were decomposing and disappearing. Rather, it was constructed because it was believed that a collection of moving images could be an effective tool for representing positive and persuasive views of the United States during World War II.

This essay also contributes to the interdisciplinary discourse about the nature of the archive that has interested scholars during the past decade or so. By detailing the events around the creation of this film collection, I hope to uncover the accordance but also the small disruptions and acts of resistance that occurred during its formation. Generally, the archive is imagined as a consequence; the physical representation of what influential people believe is important for future generations to understand about the past. Yet, by uncovering the archive in its creation, we are privy to struggles for meaning and history making. We discover that the archive is not necessarily blanketed by a single ideology; rather, competing forces create it; resistance fashions it. This push and pull of ideologies constructs an archival patchwork quilt.

MEANINGS OF THE ARCHIVE

"Archives—as records—wield power over the shape and direction of historical scholarship, collective memory, and national identity," write Joan Schwartz and Terry Cook, "over how we know ourselves as individuals, groups, and societies."[2] Schwartz and Cook assert that scholars and archivists have had a vested interest in understanding the archive as an objective and neutral site. However, they state that the idea of the ideology-free archive has been challenged during the past decade and is routinely met with resistance by scholars who focus their research on collective memory, historical context, and identity. "The deep suspicion of metanarratives and universals, which is integral to postmodern inquiry," Schwartz and Cook explain, "requires that we consider the historicity

and specificity as institutions, as records, and as a profession."[3] We must question what "goes on at the archive," Schwartz and Cook assert, because the lack of questioning supports the myth of archival neutrality and objectivity.[4] Richard Harvey Brown and Beth Davis-Brown emphasize that the archive is the site where memory is manufactured.

Thus, the act of archiving is necessarily political, for it is a process of constructing reality from a particular social position and point of view.

Brown and Davis-Brown explain that the "technical-rational work" of the archivist may not be overtly political, but it does shape the national public memory. They claim that the unrecognized, undetected functions of the archive must be uncovered, so that we may better understand the ideological nature of past decisions and practices.[5]

Jacques Derrida's *Archive Fever: A Freudian Impression* has influenced many researchers' understanding of the archive as both a metaphor and literal space of power. "There is no political power without control of the archive, if not memory," Derrida proclaims. "Effective democratization can always be measured by this essential criterion: the participation in and access to the archive, its constitution, and its interpretation."[6] Derrida's archival theory is, in part, based in Freudian analysis, particularly the counteractive forces of the death drive and the conservation drive, or the pleasure principal. Freud's death drive: the urge toward destruction incites "the annihilation of memory." The archive, according to Derrida, is not spontaneous or alive memory. "On the contrary," he writes, "the archive takes place at the place of originary and structural breakdown of the said memory."[7] The historical record, he says, is a negotiation between the death drive and the pleasure principal. Marlene Manoff contends that the stakes of this struggle can be quite high. "In the aftermath of the U.S-led 'Operation Iraqi Freedom,' Iraq's national Museum, National Library, National Archives and other repositories have been looted and burned," Manoff writes. "A chorus of voices has declared this a cultural disaster of immense proportion."[8] But Derrida's ideas can also help uncover the significance of other, much smaller struggles over the meaning and definition of the collection or the archive. "Derrida's work has contributed to scholarly recognition of the contingent nature of the archive," asserts Manoff, "the way it is shaped by social, political, and technological forces."[9]

Paul J. Voss and Marta L. Werner remind us that the history of the archive is an amalgam of conservation and loss that is not only shaped by determination and ideological power. They suggest that some losses and omissions are merely accidental. Other absences come about as a result of the inability to tame the archive.

> Even if the historical winds never destabilized the archives, their ultimate sta-
> bility would not be guaranteed: the archive's dream of perfect order is dis-
> turbed by the nightmare of its random, heterogeneous, and often unruly con-
> tents. The dream of those secret or disconcerting elements ("errors," "garbage")
> located at its outermost edges or in its deepest recesses defy codification and
> unsettle memory and context.[10]

While Voss and Werner hope to widen our understanding of who and what shapes the archive, they, like Derrida and others, suggest that we must take into account the contingencies that shape cultural memory.

David Greetham agrees that the poetics of archival exclusion include historical accidents, but he also argues that we cannot ignore the predictability of archival construction, which he likens to the act of book editing. Both the acts of archiving and editing, he argues, are likely to be neutral, culturally commendable, insidious, repressive, and restrictive.[11] Greetham contends that cultural conservators' practices and values are invariably rooted in exclusion and inequity, for, rather than gathering together everything, they focus on archiving what they understand to be the *best* of everything. He claims cultural collecting is both "self-referential" and "self-laudatory." He writes that, like the space probe mini-archive that was shot off into deep space, the archive is "a sort of Arnoldian 'best that was ever thought and known in the world.' "[12] Furthermore, Greetham contends that it is folly to predict what will and will not be important in the future.

> This cultural poetics is heavily dependent not only on historical accidents of
> transmission but on various types of agency that receive cultural prerogatives
> at particular times. And while the prerogatives bestowed by culture may often
> have been taken seriously *by the standards of the time,* attempts either to predict
> the archival needs of the future or to find universalist systems of classification
> are inherently doomed by the force of local prejudice. (author's emphasis)[13]

Finally, Michael Lynch aims to complicate our understanding of the ideological nature of the archive. He claims that the archives are "sites of historical struggle over the writing, collection, consignment, destruction, and interpretation of writings." Rather than a politically unified vision, the archive can or may be a site of struggle and contestation of power. Lynch recommends that scholars interested in the meaning of the archive study the "work of assembling, disrupting, and reconfiguring particular archival collections." He claims that such studies should be seen as "historical phenomena in their own right."

"Such an orientation does not negate the scholarly use of archival information; instead, it shifts attention to archives *in formation* and the localized gathering of histories."[14]

THE PRECURSORS TO A NATIONAL COLLECTION

The idea of a national collection of motion pictures did not gain momentum until the mid-1930s. In general, film scholars and the film archival community concur that the British-born Iris Barry, the first curator of the Museum of Modern Art Film Library, played a major role in shifting America's attitudes toward film in general and old film in particular.[15] Barry's primary interest in collecting films was so that they could be studied critically. Barry was conscious of the scope of task she was undertaking; she understood that to collect, study, and analyze the beginnings of the art of film was an endeavor of tremendous proportions.

> It will be the first time in history that any such first-hand record of the birth of a new art will have been undertaken: we ourselves in the Film Library [are] merely the first students in this field. And, most encouraging and most helpful, our researches are really proving successful largely because—far from being solitary workers—we represent only the American wing of a spontaneous and universal movement to preserve a record of the birth and development of the art of the cinema.[16]

Barry stressed that the Film Library's collection was for the purpose of constructing a record of the development of cinematic art by the way of "first-hand examinations."[17] Since the founding of the Film Library, Barry explained, "a much keener interest in the sociological implications of the motion picture has been elicited than its aesthetic content, and it would be unfortunate if this unbalance were to persist."[18] It is not surprising that Barry was not entirely satisfied with sociological or psychological inquiry, because she and the staff at MoMA had constructed the Film Library so film could be "studied and enjoyed as any other of the arts is studied and enjoyed." If film was to be considered a serious art like sculpture and painting, then it was critical for scholars to study it and create serious discourse about it in the same manner as scholars of sculpture and painting.[19]

While Barry wished to construct a film archive in order to bolster the artistic significance of cinema, the first attempt to create a collection of films reflecting the historic significance of the United States occurred when Will H. Hays, president of the

Motion Picture Producers and Distributors of America, discussed with President Coolidge a plan in which the United States government would preserve films. A 1926 *New York Times* article detailing a conference between Hays and Coolidge explained that both men agreed that preserving films was important for the education of future generations. In 1926, Hays announced that there was already plenty of important film to be stored in the government's vaults: McKinley's inauguration, films made during Roosevelt's administration, the signing of the Versailles Treaty, the burying of the unknown soldier, the flying of the first air machine, the operation of the first wireless, and "pictures showing the costumes and habits of peoples, all of great interest in future periods."[20] Hays's proposal, which began as a vision for a film vault in the basement of the White House, did not come to fruition, but he did contribute to the 1930 architectural plan for the National Archives, which included vaults for storing both films and sound recordings pertaining to and illustrating historical activities in the United States.[21]

The National Archives Act signed by President Franklin D. Roosevelt and passed by the Seventy-third Congress on June 19, 1934, did include a provision for motion pictures and sound recording. However, Hays's and other motion picture industry leaders' goal to have a government-sponsored national film library that would house both Hollywood and government films was not fully realized by the National Archives Act. Established as an independent agency of the executive branch, the National Archives was established for the purpose of maintaining the permanent records documenting the policies and activities of the federal government. Section 7 of the National Archives Act did specifically address audio-visual documents. It reads:

> The National Archives may also accept, store, and preserve motion-picture films and sound recordings pertaining to and illustrative of historical activities of the United States, and in connection therewith maintain a projecting room for showing such films and reproducing such sound recordings for historical purposes and study.

According to the first Archivist of the United States, R. D. W. Connor, in a 1935 *New York Times* editorial, the provision for motion pictures and sound recordings in the 1934 National Archives Act piqued considerable public interest. Connor explained that the provision was "one of the most important activities of the National Archives Establishment." Furthermore, Connor explained that the films, vaults, and projection room are for historical purposes and study. "The possibilities which motion pictures and sound recordings open up for the future historian," Connor explained, "are boundless."[22]

The inclusion of motion pictures and sound recordings as archival materials in the 1934 Act, according to National Archives historian Marjorie H. Ciarlante, was visionary. The act was written during a time when "virtually no archives were collecting audio-visual materials and when records were regarded as the written word residing on a paper-based medium."[23] Thus, the inclusion of motion pictures in the National Archives Act and the subsequent development of the Motion Pictures and Sound Recordings Division helped establish and promote the belief that motion pictures had enough cultural and historic value for the United States government to warrant their protection.[24]

The act also helped place motion pictures in a new category: objects of archival interest. Connor's claim, in the *New York Times,* that archival motion pictures would be beneficial to future historians helped to establish their significance as archival artifacts. Perhaps Connor's most radical message in his *Times* commentary was the promotion of the belief that future historians would learn truths about the history of the United States by watching motion pictures housed in the National Archives. But whatever truths future historians might learn by watching the collected films would be ones constructed by the United States government, not the ones created by the Hollywood film industry. Hays's dream of constructing a national film library that included both industry and governmental films did not materialize with Roosevelt's signing of the National Archives Act. While section 7 of the Act stated that the National Archives could accept "motion-picture films and sound recordings pertaining to and illustrative of historical activities of the United States," the National Archives Act in general established a National Archives of the *United States Government*. The Archivist, as stated in section 3 of the Act is the superintendent of all archives belonging to the government of the United States (legislative, executive, judicial, and other).

While the moving image collecting policy of the National Archives focused on cinematic images of the United States government, there was still some room for interpretation. Section 7's lack of specificity regarding the kinds of films that could be collected at the National Archives opened the door for John G. Bradley, the first head of the Motion Pictures and Sound Recordings Division, to have a broader interpretation of what sorts of motion pictures and sound recordings could be accepted. The language of section 7 enabled Bradley to have a somewhat liberal collection policy. According to Ciarlante, the Motion Pictures and Sound Recordings Division had a more inclusive collection than that of the rest of the National Archives.

What Bradley did, in a word, was to broaden the definition of "United States history" to an all-inclusive term, "reflection of the American scene," to encom-

pass all fields of human endeavor with "virtually nothing excluded." By so doing, he reopened the issue of the original intent of the law; i.e., "history of the U.S. Government" versus "U.S. history in its broadest sense," an issue upon which he refused to compromise and which ultimately forced his resignation from the National Archives.[25]

Connor and Bradley reasoned that motion pictures counted as artifacts; they could and would be useful to the historian, and they were on par with print-based records. But Bradley's wide-open collecting policy created enough tension that he resigned, and the National Archives redefined their collecting policy. Many of the non-government moving images Bradley collected were motion picture industry newsreels, portraits of United States history, and films of the country's curiosities and natural wonders. Bradley's collection included Warner Bros.' Odd Occupations and Nature's Handiwork (1935), Time, Inc.'s *Fashion Means Business* (1947) and *RKO Radio Pictures Convention* (1937), Alfred Hitchcock's *Foreign Correspondent* (1940), and the Harmon Foundation's *Negro Notables: Negro Education and Art in the U.S.* (1937).

These films, alongside the many United States government films such as the Department of Defense's *Women Mechanics Take over Men's Jobs at N.A.S. Norfolk, VA* (1942) and *Personal Freedom* (1947), create a collage of moving images that portray the United States from wide-ranging viewpoints. Bradley created a kaleidoscopic portrait of the United States. While United States government films are certainly the foundation for the collection, he peppered it with curiosities that paint a less certain and dogmatic portrait of the nation. Bradley's resistance to the law of the archive offers contemporary researchers opportunities to view cows washed and shaved in El Monte, California in *Can You Imagine?* (Warner Bros. Pictures Inc., 1936) as well as instructions for how to thrust, butt stroke, and parry in *Bayonet Training* (Department of Defense, 1938). Bradley's defiance of the National Archives collecting policy leaves us with an archival legacy that is as diverse and curious as the country it represents.

A NATIONAL COLLECTION AND THE WAR EFFORT

The Film Library at the Museum of Modern Art and the National Archives were the primary institutions that collected films and endorsed the idea that films were useful tools for intellectual inquiry. But when the poet Archibald MacLeish was appointed as the Librarian of Congress in October 1939, he made a series of decisions that helped put motion pictures on the map at the Library of Congress. MacLeish envisioned and then initiated

a plan to create a national film collection at the Library of Congress. He supported the transfer of the recently recovered paper-print collection to celluloid; he promoted the private donations of films made during the thirty-year period from 1912 to 1942 when the Library did not

Archibald MacLeish, Librarian of Congress (1939–1944), sitting at his desk. "Freedom's Fortress: The Library of Congress, 1939–1953," Manuscript Division, Library of Congress, Washington, D.C., Number 3138

collect motion pictures; he created a collaboration between MoMA and the Library (by which MoMA selected the most significant films made each year), and he created a motion picture section at the Library of Congress.

MacLeish's focus on motion pictures during his tenure as the Librarian of Congress altered the Library's relationship with motion pictures and helped push the cultural and political significance of films and their preservation into a brighter light. A poet, playwright, and political activist, MacLeish was an early advocate of the United States' involvement in the war. His view of motion pictures at the Library was shaped by both his political views and the fact that he became the Librarian a month after the European war broke out in 1939. During his tenure as Librarian of Congress (1939–1944), he held other important governmental offices that also shaped his perception of the role of motion pictures at the Library. Before the Pearl Harbor attack in 1941, President Roosevelt asked

MacLeish to head the Office of Facts and Figures. He then became the assistant director of the Office of War Information (OWI) in 1942.

As the assistant director of the OWI, MacLeish was part of a team that worked to mobilize positive images of the United States to an international audience. President Roosevelt issued Executive Order 9182, creating the OWI in June 1942. An autonomous agency, the OWI absorbed the functions of the Office of Facts and Figures, the Office of Government Reports, the division of information at the Office for Emergency Management, and the foreign information service at the Coordinator of Information. The OWI coordinated the release of war news for domestic use and launched a propaganda campaign abroad. Historian Justin Hart writes that during the early 1940s policymakers believed that the image the United States projected abroad was critical to the country's foreign policy. The "United States could best advance its own geopolitical position through selling its ideology and its way of life," Hart writes, "rather than through costly and disruptive exercises in military conquest. Simply put, Americanization became the antidote to colonization." Hart contends that the OWI became the first governmental agency to "be assigned custodial responsibility for the nation's overall image in the world."[26]

The Bureau of Motion Pictures (BMP) in the OWI acted as the intermediary between federal agencies and the radio and motion picture industries. The BMP wrote a manual entitled *Government Information Manual for the Motion Picture Industry* in 1942. A comprehensive portrait of the bureau's interpretation of the war, the manual explained the ideology of the OWI and directed the film industry to produce films that appropriately promoted its principles. The BMP distributed weekly additions to the loose-leaf manual to keep the movie industry continually updated.

Hollywood was, in effect, charged with representing American democratic ideals and the practicalities of fighting a war.

"We practical-minded Americans can easily grasp such tangible programs as sugar-rationing or pooling of cars to save rubber," the manual states. "It is a challenge to the ingenuity of Hollywood to make equally real the democratic values which we take for granted." While the manual consistently urges Hollywood to make films

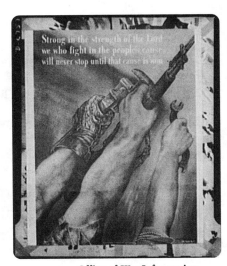

Office of War Information, 1944, Library of Congress, Prints and Photographs Division, FSA-OWI Collection, LC-USE6- D-006757

that constitute the abstract notions of American determination and goodness, it also offers Hollywood ways to practically represent and aid the war effort. America was in dire need of nurses, for example, and a BMP manual supplement explained that part of the war effort was to recruit unmarried graduate nurses under the age of forty.

> The call must go out to every woman in America. In the newspapers. Over the radio. And, most important, through motion pictures, which can make visual the heroic deeds known to us now only in words. The nurses of Pearl Harbor, of Manila and Bataan, of Dutch Harbor, are heroes, just as the fighting soldiers, sailors, and fliers are heroes. Because their stories are first-rate drama, because they constitute a shining example for young American women, they are stories that should be told—by the most effective means possible—through motion pictures.

The BMP not only suggested what should be portrayed on screen, it also voiced its approval or disapproval of films being distributed. For example, one particular 1942 film of which the BMP approved was *Casablanca*. As historians Clayton Koppes and Gregory Black explain, the BMP liked the 1942 Academy Award winner because of its "depiction of the valiant underground, the United States as the haven of the oppressed, and subordination of personal desires to the greater cause of the war—although they would have preferred that the hero had verbalized the reasons for his conversion."[27] The overarching effects of the BMP on the film industry should not be underestimated. "From mid-1943 until the end of the war, OWI exerted an influence over an American mass medium never equaled before or since by a government agency," write Koppes and Black. "The content of World War II motion pictures is inexplicable without reference to the bureau."[28]

Such an overt push to regulate the circulation of moving images in Hollywood strongly suggests that MacLeish's drive for a national film collection at the Library of Congress was motivated by World War II, his participation with the OWI, and the effort by the OWI to disseminate propaganda.

In the 1942 *Annual Report of the Librarian of Congress,* MacLeish explained that a new procedure regarding the selection of motion pictures for Library's collection was brought along in part by the ongoing war. MacLeish stated that the war "emphasized the tremendous historical and scholarly importance of much current film."[29]

One of the ways in which MacLeish planned to build a national collection was to restore the original conditions of the motion picture copyright deposit. Once motion pictures were protected by copyright laws and paper prints were no longer deposited, the Library had no way to maintain copies of motion pictures that came to the Library for copyright registration. The practice from 1912 to 1942 was to send motion pictures back to their producers within one day

Office of War Information, 1942 or 1943, Library of Congress, Prints and Photographs Division, FSA-OWI Collection, LC-USE6- D-010435

of their receipt and accept materials such as scripts, posters, or credit sheets for copyright deposit, but MacLeish overturned this agreement. He explained in the 1942 *Report of the Librarian of Congress* that the early arrangement of returning films "has now been abrogated, and one copy of every film selected for preservation will be retained by the Library." This decision, he explained, also enabled the Library to accept gifts of both old and new material.

In order to develop the national collection, the Library, the Museum of Modern Art Film Library, and the Rockefeller Foundation agreed on an arrangement whereby the staff at the Museum of Modern Art Film Library selected films released during the calendar year. The criteria for selecting the films was developed by MacLeish, his friend Robert Penn Warren, Iris Barry, John Abbott, and others at the Film Library. In 1942, the first year of the agreement, MoMA received $25,000 from the Rockefeller Foundation to pay staff to screen American motion pictures deposited for copyright and then select the appropriate films for preservation. The selected films were then stored in vaults rented by the Museum of Modern Art.

During the first year of the film selection process, the MoMA staff selected 104 of the 1400 films released in 1942. According to MacLeish in his 1943 *Report of the Librarian of Congress*, the criteria for selection were based on "those films which will provide future students with the most truthful and revealing information the cinema can provide as to the life and interests of the men and women of the period." He specifically stated five categories of greatest interest: newsreels and news-related films of probable

interest to students of the time, documentary films of probable interest to the social historian and political historian, films that mark important artistic and technological advances in the art of motion pictures, films such as certain animated cartoons that reveal the imaginative life of the period, and outstanding scientific and geographic films.

While MacLeish outlined the types of films selected, the content of most of the selected films suggest that war propaganda, as outlined by OWI mandate, steered the selection process. Of the 104 motion pictures selected, many are newsreels and documentaries directly related to the war effort. The documentaries, which dominate the list, could be best described as extended newsreels about the war: *The Fighting French* (March of Time); *Beyond the Line of Duty* (Seiler); *The Price of Victory* (Pine); *Prelude to Victory* (March of Time); and *Inside Fascist Spain* (March of Time). Nearly all of the fictional films' plots deal directly with World War II. Such 1942 films as *Mrs. Miniver* (William Wyler); *Wake Island* (John Farrow); *In Which We Serve* (Noel Coward and David Lean); *The War against Mrs. Hadley* (Harold S. Bucquet); and *This Land Is Mine* (Jean Renoir) suggest that the selection process for fictional films was also for the purpose of circulating propaganda so to aid the war effort.

While later large-scale efforts at the Library of Congress and other archives would recover and recuperate some of the motion pictures that were not included in this collection, it is clear that MacLeish's ideological position and collecting policy shapes our contemporary understanding of motion picture history during World War II.

The Film Library staff weeded out more than ninety percent of the motion pictures that might have potentially been added to the list in 1942. While MacLeish's ideological position envelops the formation of the collection, it is also our motion picture legacy.

"Archives validate our experiences, our perceptions, our narratives, our stories," write Schwartz and Cook. "Archives are our memories."[30] Making sense of how motion pictures have been collected does not merely sate our historical curiosity. It is important to understand the ideological motivation behind the formation of an archive, because we can better understand its limitations and strengths and what it can tell us about the past. Without this knowledge, the archival collection remains naturalized and unquestioned, tricking our cultural memory into complacency.

COLLABORATION AND RESISTANCE

MacLeish was firmly ensconced in governmental affairs and viewed motion pictures as visual information and a tool for distributing positive images of the United States during

World War II. But determining what films should be part of the national collection at the Library of Congress was a collaborative process that involved Iris Barry and the MoMA Film Library staff. They screened, selected, and stored the collection. Barry's purpose for wanting and creating a national film collection was different than MacLeish's. She came to the project desiring to collect and document the growth of an art form. For eight years, she had been collecting films at MoMA for their aesthetic and formal contributions. Because MacLeish and Barry came to the project with different visions, there were plenty of disagreements between them. In general, MacLeish's view of film as visual information about the war trumped Barry's view of it as an art form worthy of collecting for study and scholarship. Barry, for example, rejected the Technicolor version of *For Whom the Bell Tolls* (Sam Wood, 1943) because she felt it was bad version of Hemingway's novel. MacLeish overturned her decision.

"I am against you on *For Whom the Bell Tolls,* MacLeish wrote in a telegram to Barry, "not because I disagree with your statement, but because the film, bad as it was, throws a good deal of light on the state of the American mind during the war."[31]

But the Film Library staff created a methodology for selecting the films that complicated MacLeish's collecting plan. Like Bradley at the National Archives, Barry and her staff resisted the official collecting policy. We are privy to their methodological resistance because they published an explication of it in *The Library of Congress Quarterly Journal.* The author, Barbara Deming, who would during the 1960s become a well-known peace activist, was a member of the selection staff. Deming and her colleagues Norbert Lusk, Philip Hartung, Liane Richter, and Barbara Symmes screened 1400 motion pictures and selected the films to be included in the national collection. Deming's article, like many of Barry's essays, is a significant document of film history not only as an early example of film criticism but also because it shows how the Film Library staff members envisioned themselves as historians and critics, as well as archivists.

Deming's article explicates the method the staff used for choosing films. The general principle guiding the selection process, she explains, is to serve the student of history rather than the cinema scholar. Outlining their system of analysis, Deming categorizes films into two modes: direct and indirect. In the direct mode, films confront the zeitgeist literally and directly. But films also portray the times by representation, reflecting the mentality of a period, which is the indirect mode. She argues that all actualities and fictional films come to the viewer with a point of view that may be either directly or indirectly expressed. However if a film expresses the period's mindset, Deming explains,

it needs to provide to the historian pertinent information that could not be duplicated through some other medium.

Outlining the methodology for choosing films that are of the direct mode, Deming explains that the staff chose newsreels that illuminated the significance of an event in relation to the human experience but dismissed newsreels in which the camera work, accompanying audio, or commentator's interpretations were misleading (contradicting the early twentieth century uncritical point of view that films were "replicas of human events"). Deming admits that choosing the most significant newsreels required a certain degree of guesswork. "This man rather than that man, this speech rather than that speech, will go down in history," Deming explains. "One must, in other words, play the historian oneself, and precociously."[32]

Fictional films of the direct mode, Deming argues, are direct mirrors of a period and reveal the details of daily life and the material truths of the period. The historian can discern the spirit of an age by observing clothing, the props of daily life, language use, and even the ways in which actors sing and dance. Such films can also afford the historian a glimpse of war. She explain that a film such as *In Which We Serve* serves us well by showing the actions of men in battle, but she warns that from a psychological perspective, such a film is much less reliable. "As soon as it is human experience that is being explored, the picture that is not only a vivid picture but a true picture becomes a rarity," Deming explains. "It takes vision and honesty, and it takes art, not just scrupulosity, to depict with any accuracy the social and psychological realities to the times."[33] Deming's account of the interpretive process of the films of the direct mode seems straightforward enough, and the selection process of these films surely aligned with MacLeish's desire to assist with the war effort. But, her exposition also suggests that films of the direct mode that literally portray the battlefront may not be very useful for making sense of the social and psychological realities of war.

Deming's account, in other words, seems to question the effectiveness of MacLeish's desire to collect and circulate propaganda. Films that matter, according to Deming, are not literal representations of military struggle. Only visionary and artful films can tell us the truth.

Deming's explanation of the indirect mode is more complex, and where we see how she and her colleagues created a methodological tool of analysis and resistance. She states that interpreting films in the indirect mode requires the analyst to step through the looking glass and understand the psychology responsible for the film. Films

of the indirect mode, she asserts, may serve future historians by enabling them to see the culture's daydreams; films that reveal attitudes and beliefs not talked about but that are "felt in the bones." "Films will again and again, as dreams will, approach the same guilt feeling, trying to erase it, or approach the same anxiety, trying to relieve it, the same yen, trying to indulge it," Deming writes. "After examining the films of a period it is possible to constellate them finally in shifting groups about certain major pressure points."[34]

Deming and the staff's belief that cinema was a manifestation of an era's cultural guilt and anxiety was most likely shaped by their relationship with Siegfried Kracauer, the German film theorist who worked at the Museum of Modern Art after he immigrated to the United States in 1941. Deming acknowledges a "friendly debt" to Kracauer. She writes, "many of the thoughts expressed here crystallized after conversations with him." A contemporary of Walter Benjamin, Kracauer believed that there was a correspondence between the basic properties of film and the underlying properties of modernity. Kracauer's ideas about both film and reality were influenced by Edmund Husserl's ideas about phenomenology and his conception of *lebenswelt,* a term that referred to the more subjective meanings generated within experience that are often obscured by abstract discourse.[35]

Kracauer believed film was produced by the condition of *lebenswelt* and that film redeemed the experiential and psychological domain of life that was often buried beneath the conceptual and the conscious. In his book *From Caligari to Hitler: A Psychological History of the German Film,* Kracauer argues that, while films cannot represent the unconscious, "visible hieroglyphs" of the "unseen dynamics of human relations" can be seen within them.[36] Kracauer argues that, in periods of radical disruption, "core underlying motifs" rise to the surface and become embedded in cultural artifacts such as films.[37] Kracauer was working on the ideas of *From Caligari to Hitler,* published in 1947, while he was working at MoMA, and it is likely that his theory of German film and German national identity helped shape the method used to study and select the films for MoMA's collection during that time. Kracauer's contribution to the collection should not be overlooked, for his international perspective on cinema and national discord shaped how the Film Library staff thought about and screened the films for the United States collection.

While the films of the direct mode and their selection process more neatly aligned with the needs of building a national collection (and benefiting the war effort), the analytical process for the films of the indirect mode veered away from any such practicalities. Schwartz and Cook suggest that we need to be on the lookout for the ways archival collections have been partly formed or deconstructed by new thinkers, those

who "speak in opposition to power, or that insert irony or sarcasm or doubt."[38] The Film Library staff creation and explication of the indirect mode suggests that they resisted MacLeish's guiding principles. We know that Barry viewed films as complex art forms worth collecting for scholarship, and the explication of the indirect mode intimates that the Library staff believed films' messages were not straightforward and easy to interpret. Moving images, Deming implies, are not communication missives; what makes them interesting, what makes them art, is that they do not, perhaps cannot, convey their cultural message as if they were memos.

Deming uses the film *Lifeboat* (Alfred Hitchcock, 1944) as an example of a film that appears to have a clear and direct message about the war but actually has opaque meanings and obscure messages for the viewer (and the historian who will see it in the future). After her description of the Nazi in control of the boat while the others are playing German lullabies on a tin pipe or babbling for water, she writes:

> With this vision, one can say that another issue materializes: The issue of whether or not the democracies have any longer a foundation of living faith, a working faith that can stand up against the Nazi's ruthless logic. At the conscious level, in terms of the carefully arranged allegory, the film is nicely optimistic on this score. But at this deeper level, where it lives, the film is dubious.[39]

The Film Library staff was skeptical. They did not believe that filmmakers were even entirely aware of their own perspectives. Nor did they think that audience members could articulate or necessarily understand their responses to a film unless they were exceptionally sophisticated and well trained in the viewing of films. Thus, how was it possible to choose films that frankly expressed the nationalistic and patriotic perspectives about the United States during World War II? In a word, Deming's essay neatly unravels MacLeish's collecting mission and reveals their commitment to Barry's guiding principle of film collecting for art's sake, for the scholar's sake. Of course, most of the films collected by the staff are about the war. There was not an insurrection at the Film Library. But their acts of resistance surely added a colorful and textured dimension to the collection that is a part of our legacy. Along with films such as *The Battle of Midway* (John Ford, 1942) and *Private Smith of the USA* (Harry W. Smith, 1942), the Film Library staff added *A Shadow of a Doubt* (Alfred Hitchcock, 1943), *Saludos Amigos* (Norman Ferguson, Wilfred Jackson, Jack Kinney, Hamilton Luske, and Bill Roberts, 1942), *Ridin' Down the Canyon* (Joseph Kane, 1942), *Cabin in the Sky* (Vincente Minnelli, 1943), and *The Postman*

Didn't Ring (Harold D. Schuster, 1942) to the collection. We are bequeathed a far more knotty and multifaceted portrait of cultural and film history as a result of the Film Library staff's waywardness.

CONCLUSION

Deming and her colleagues completed the screening process at the end of April 1945. By the time they were finished, they had screened 4,398 films and had added 969 reels of film to the collection. With the millions of feet of film of enemy-produced films transferred to the Library, and the films donated by the film collector, John Allen, the Library announced the creation of a motion picture repository on June 3, 1945. In October 1946 the Motion Picture Project became a division of the Library of Congress. John Bradley left the National Archives to become the head of the division at the Library. With a staff of seventeen, it appeared that Bradley finally would be able to build the national collection he had hoped for at the National Archives. However, in 1947, the Republican Congress cut the wartime budget and the Motion Pictures Division was shut down.

Deming ends her essay by stating that films that are farthest away from the literal events of the day are the films that will tell the historian the most. "For it is these—the films which, more than most, have found an orientation among the sensed realities of the time—which demonstrate most vividly the difficulties of belief today," Deming writes. "We are, for the moment, not quite sure where we live." The same might be said for Deming and her colleagues.

Her essay is a discursive collision between two major institutions attempting to collaborate on standards for a national collection. The Film Library staff must not have been sure where they lived institutionally or ideologically; forming the national collection was surely a schizophrenic process.

Their seeming lack of conviction for the war effort did not prevent them from creating a collection laden with images of U.S. heroics. Still, traces of their resistance remain. By uncovering and interpreting their interference to the ideological order, we have a deeper understanding of the push and pull of the archive in formation. The archive is never an ideologically neutral site, but the prevailing order is not the only force that helps to form and maintain it. Archival acts of disobedience smuggle in the curious, the

outspoken, and the sullen. We must be thankful for them; they enliven our collections and enable our cultural memory to get closer to the truths of who we are and what we have been.

NOTES

1. "Can Films Be Preserved?" *Motography* 13, no. 14 (April 3,1915): 521.

2. Joan Schwartz and Terry Cook, "Archives, Records, and Power: The Making of Modern Memory," *Archival Science* 2 (2002): 2.

3. Ibid., 13.

4. Ibid., 14.

5. Harvey Brown and Beth Davis-Brown, "The Making of Memory: The Politics of Archives, Libraries, and Museums in the Construction of National Consciousness," *History of the Human Sciences* 11, no. 4 (1998): 22.

6. Jacques Derrida, *Archive Fever: A Freudian Impression*, trans. Eric Prenowitz (Chicago: University of Chicago Press, 1995), 4 n. 1.

7. Ibid., 11.

8. Marlene Manoff, "Theories of the Archives from Across the Disciplines," *portal: Libraries and the Academy* 4, no. 1 (2004): 12.

9. Ibid.

10. Paul J. Voss and Marta L. Werner, "Toward a Poetics of the Archive," *Studies in the Literary Imagination* 32, no. 1 (1999): ii.

11. David Greetham, "'Who's In, Who's Out': The Cultural Poetics of Archival Exclusion," *Studies in the Literary Imagination* 32, no. 1 (1999): 10.

12. Ibid., 10.

13. Ibid., 19.

14. Michael Lynch, "Archives in Formation: Privileged Spaces, Popular Archives, and Paper Trails," *History of the Human Sciences* 12, no. 2 (1999): 83.

15. For an insightful and thorough account of Iris Barry's contributions and legacy, see Haidee Wasson's *Museum Movies: The Museum of Modern Art and the Birth of Art Cinema* (Berkeley and Los Angeles: University of California Press, 2005).

16. Iris Barry, "The Museum of Modern Art Film Library," *Sight and Sound* 5, no. 18 (1936): 16.

17. Iris Barry, "Films for History," *Special Libraries* 30, no. 8 (1939): 258.

18. Iris Barry, "Motion Pictures as a Field for Research," *College Art Journal* 4, no. 4 (May 1945): 208.

19. Barry not only encouraged researchers to take the study of the film itself seriously, she provided a lengthy list of research questions for the potential film scholar. Focusing on issues concerning film editing, style, theme, and genre, Barry exclaimed the realm of inquiry was endless. Imploring film scholars to take advantage of the Film Library's collection, Barry wrote, "It is no longer a question of feeble conjecture, hearsay, and memory, of dead scrabbling through the inept film criticism of yesteryear: the authentic raw material for research awaits the new expert's eye." The film collection

provides the vital component for serious film scholarship, for if film is art, then film must be studied like other art forms. Its structure, composition, and other artistic elements must be studied with the eye. Memory, Barry implored, was not enough.

20. "Hays Asks Coolidge for Film Archives," *New York Times*, September 1, 1926, 1.

21. Anthony Slide, *Nitrate Won't Wait* (Jefferson, N.C.: McFarland, 1992), 26.

22. R. D. W. Connor, "New Archives to Shelter Movies and Many Records," *New York Times*, February 10, 1935, E11.

23. Marjorie H. Ciarlante, "The Origin of Motion Picture and Sound Recording Collection Policy in the National Archives," unpublished manuscript.

24. There were political conflicts that arose around the writing of the three bills that would eventually establish the National Archives and the role of the motion picture collection at the Archives. The base of these conflicts was rooted in differing views of the role of the National Archive. The commercial industry was pushing for a national film library that would house motion pictures of historical interest; which might include almost *any* film. But the role of the National Archivist, according to the National Archives Act was to be custodian of "all archives or records belonging to the Government of the United States (legislative, executive, judicial, and other)."

25. Ciarlante, "The Origin," n.p.

26. Justin Hart, "Making Democracy Safe for the World: Race, Propaganda, and the Transformation of U.S. Foreign Policy during World War II, *Pacific Historical Review* 73, no. 1 (2004): 55, 81.

27. Clayton Koppes and Gregory Black, "What to Show the World: The Office of War Information and Hollywood, 1942–1945," *The Journal of American History* 64, no. 1 (June 1977): 98.

28. Ibid., 103–4.

29. Archibald MacLeish, *Annual Report of the Librarian of Congress, 1942* (Washington, D.C.: Government Printing Office, 1943), 20.

30. Schwartz and Cook, "Archives, Records, and Power," 18.

31. Quoted in Paul Spehr, "It Was Fifty Years Ago This Month: Motion Picture Division Celebrates Its Golden Anniversary," *Library of Congress Information Bulletin* 51, no. 8 (April 20, 1992): 175.

32. Barbara Deming, "The Library of Congress Film Project: Exposition of a Method," *The Library of Congress Quarterly Journal of Current Acquisitions* 2, no. 1 (July–September 1944): 5.

33. Ibid., 9.

34. Ibid., 31–32.

35. Edmund Husserl, *The Crisis of European Science and Transcendental Phenomenology* (Evanston: University of Illinois Press, 1970), 156.

36. Siegfried Kracauer, *Theory of Film: The Redemption of Physical Reality* (Oxford: Oxford University Press, 1960), 7.

37. Ian Aitken, "Distraction and Redemption: Kracauer, Surrealism, and Phenomenology," *Screen* 39, no. 2 (1998): 128.

38. Schwartz and Cook, "Archives, Records, and Power," 15.

39. Deming, "The Library of Congress Film Project," 18.

MITCHELL AND KENYON, ARCHIVAL CONTINGENCY, AND THE CULTURAL PRODUCTION OF HISTORICAL LICENSE

NATHAN CARROLL

The lost or fragmented film is in many ways the ideal post-modern artefact, with its subversion of authorial intention and its decentring of narrative, formal, thematic and stylistic totality: the lost film, in a sense, embodies its own de(con)struction. Closure is denied, loose ends float free, the unities are blasted open. Instead of one unified production of a Great Artist, the lost/fragmented work offers a (great post-modern jargon) palimpsest of variant texts—what we have left, what was intended, what has been worked over by other hands etc. —DARRAGH O'DONAHUE, "PARADISE REGAINED: *QUEEN KELLY* AND THE LURE OF THE 'LOST' FILM"

INTRODUCTION: DVDS AND LOST WORLDS

Can the absence of cultural artifacts or their physical histories project

cultural value? In terms of lost films, cultural value is often ascribed as historical value—

a function of the power of the authoritative gaze determining a film's public position of

lostness, defined here as the capacity for being found and archived. Hence, the com-

modity value of the structured historical absence of the work makes sense only in that we

fantasize about the potential value of an unearthed archival print. It is not actual use

value in a commodity market that determines the worth of a lost film but an imagined

state of economic and aesthetic fruition, situated within a contemporary cultural sub-

junctive context of "what it will likely have meant" to retrieve an absent object. Still,

these variable meanings of lostness are never private or meaning*less,* as cultural values

of absence are normatively negotiated through public discourse.

In this sense, lostness is a sublime chaotic cultural condition that is publicly controlled, rhetorically subdued, and economically disciplined by the discourse of rescue and restoration.

What is it worth to own a piece of resurrected history? Has DVD devalued lost historical memory by rationalizing the inestimable sublime? It would seem on the face of it that digital presentation and mass distribution flattens an overwhelming mystique. For whom is a lost film valuable anyway? Collectors, historians, family of crew, critics, studio and public archives, film studies departments, and consumers are all plausible stake-holders in producing the value of a lost film. Such investor relations in missing history involve imbuing the production of collective memories with the affect of awe and virtual simulation of sublime wonder, speculating on the future historical possibilities of the lost object, if ever discovered. Missing-link theories supplement genre and auteur histories, investing discursive gaps with loaded expectations that a lost film could and should fill a hole in human knowledge, recuperating an otherwise amputated canon. Like junk bond traders, we cinephiles often let our imaginations overspeculate and run riot over these archival gaps, overinvesting lost films with an idea that we may have to rewrite history at large if indeed complete versions were ever brought to light.

In some cases this might be accurate, but I would be cautiously skeptical that an extended ten-hour director's cut of von Stroheim's *Greed* or an intact vision of Welles's *The Magnificent Ambersons* would rewrite film history to the extent we have come to expect. Rather, much of the value of a lost film is plausibly due to the fact that it is lost at all. The hype is often so inflated over such lost works that, at best, our preconceptions might be reinforced, telling us that we were right all along about a film's significance to the film canon. Still, as at least one aging filmgoer noted on a DVD extra about the famed lost Tod Browning / Lon Chaney collaboration, *London after Midnight,* we might very well be extremely disappointed at the artistic quality of the film if we ever did fully recover it.

On the other hand, it would seem proof apparent with the recent digital rescue of 826 Mitchell and Kenyon films in Great Britain that the films that really do rewrite history are quite possibly the least considered.

Prior to their discovery, filmmakers Sagar Mitchell and James Kenyon were best known for the Boer War reenactments, but after finding this wide collection of films, their re-appraised historical value seems to usurp any previous estimation. Who could guess how important fairground films, made for local working-class audiences to see themselves onscreen, would be for academics and the public alike one hundred years later? These

films were deemed so *un*important that few even knew they were lost, and certainly no one was looking for them. Rather, the value of their historical absence or quality of lost-ness could only be retrospectively attributed by archivists once the films were found a century later. In this sense, the Mitchell and Kenyon films not only rewrite how we currently think about the history of British film but also significantly gerrymander the boundaries of legitimate collective memory, retrospectively determining how we once thought about lost cultural artifacts when we did not yet even know they existed.

To this end, the concerted act of digging and archiving is productive of the surplus value of lost history, whether of films or other cultural artifacts. It is the effort exuded in archival restoration and reconstruction projects that at the end of the day produces the future value of what lost films will mean to the public — and further, what they should have meant all along. For when we recover filmic records of lost time, we are in effect constructing the parameters of what counts as acceptable memory, legitimizing the rationale for recovery through the process of reconstruction itself. DVDs index not only the contingency of time recorded in film's emulsion but, as virtual archival architecture, also provide immediate access to how a film might have been otherwise restored, spatially coordinated, and publicly remembered. In this sense, they catalog the disruptive traces of archival contingency. DVDs push the limits of archival discourse as new media by self-reflexively archiving the contingency of their own archiving practices.

What is lost and what is gained in the transfer of analog to digital history? One story goes something like this: Found in three buried drums beneath the floorboards of a building up for demolition in 1994, 826 films by Sagar Mitchell and James Kenyon, turn-of-the-century cinematographic entrepreneurs, were saved from permanent storage in garbage bins by some keen-eyed laborers. Given to a local film transfer shop, they were hence entrusted to cinephile Peter Worden, who was the first to gauge their potential historic significance. These coreless films with identifying etchings on the first frames of each film were stored in Worden's garage in an unplugged freezer, individually wrapped in cellophane and stored in seventeen ice cream tubs. In 2000, Worden donated the lost films to the British Film Institute, where they were stored in nitrate safety vaults before restoration began. Four years later, the result of the astounding find and monumental restoration effort yielded a veritable treasure trove of cultural records and has been responsible for increasing the BFI's silent film collection by some 20 to 25 percent.[1]

Several articles, a book of collected essays (with a second book set for publication in January 2007), and three published DVDs followed, making both these films *and their packaging* ripe for cultural reassessment. In the 2003 article, "The Mitchell and Kenyon Collection: Rewriting Film History," along with the wealth of essays compiled in

the BFI's 2004 book, *The Lost World of Mitchell and Kenyon: Edwardian Britain on Film*, project archivists including Vanessa Toulmin, Patrick Russell, and Timothy Neal clearly relate the stories of film rescue and restoration far more cogently and insightfully than can be attempted here. Indeed, this essay has no pretense to supplant those essential firsthand archival narratives. Rather, I understand the bulk of these writings as intended catalysts for expanded discussions of questions broached by the Mitchell and Kenyon films. It is within this robust dis-

Morecombe Boys Brigade
(1904), **Mitchell and Kenyon
Collection**

cursive trajectory I aim to stake out issues of cultural context and archival contingency, beginning with closing words from the article from *The Moving Image* noted above:

> The body of information brought together through the project will provide ad-
> ditional scope for study in a number of contexts: evaluation of early nonfiction,
> production, distribution, regionality, exhibition networks and routes, commis-
> sioning of subject materials, and their importance as sociohistorical texts.[2]

On March 11, 2005, *ABC Nightline* dedicated its broadcast to these discoveries.[3] Subsequently, the American distributor Milestone has furthered the BFI's roadshow distribution of the restored Mitchell and Kenyon films around the United Kingdom with similar theatrical screenings in the United States. The Milestone Web site states: "As the projection speed of these short films vary from 8fps to 14fps, the theatrical release of *Electric Edwardian* will be on High-Def, Digi-Beta, DVD or VHS."[4] As part of this transatlantic distribution strategy, these "local films for local people" were given domestic digital distribution in the United States on July 11, 2006, with a duplicate NTSC DVD release of *Electric Edwardians: The Films of Mitchell and Kenyon*.[5] This DVD replicates the content of the UK DVD release with the same title. Given the recent release date of the Milestone DVD, this essay primarily considers the terms of archival access by comparing the two British DVDs. As the various attempts at packaging these lost films reveal, it is one thing to find a lost world, but it is quite another endeavor to sell it.

"LOCAL FILMS FOR LOCAL PEOPLE"

The above phrase was one way that Mitchell and Kenyon advertised their work. As described in a recent essay by Tom Gunning, "Pictures of Crowd Splendor: The Mitchell and Kenyon Factory Gate Films," unlike the factory-gate films of the Lumière brothers or the lone viewers of Edison's Kinetoscope, the Mitchell and Kenyon films were shown to the working class people actually in the films, often on the evening of the same day they were filmed.[6] The immediacy of this carnival aspect, what Gunning famously coined "the cinema of attractions"[7] was a strong economic and aesthetic motivator for the production of these films, those two words often blurred in the traveling show. Gunning writes:

> The relationship between crowd and camera and, most important of all, audience and film in the Lumière productions contrasts with that seen in the Mitchell and Kenyon collection. In the Lumière films, the workers seem to regard the camera with studied indifference and were not the intended primary audience.[8]

In *The Emergence of Cinematic Time: Modernity, Contingency, and the Archive*, Mary Ann Doane considers the various roles chance and contingency play in contemporary cinematic history.[9] Doane makes the case that, as the role of contingency became an increasingly common fact of modern life in the twentieth century, we sought to control the irregularities of time more and more, through technologies such as time punch-clocks, pocket watches, and train schedules.

In this environment of contradictory impulses, film provided an archival outlet through which we could monitor and index the instantaneous succession of moments in time. Hence, at its revolutionary best, the medium of film was a chance to record the exigency of historical change.

Film provided an archive of historical contingency for consumption in public memory. For factory workers peering at themselves, friends, and family members moving through an "other" virtual space, a Mitchell and Kenyon film must have seemed proof the world had both purpose and possibilities, but, ultimately, could have been run otherwise. Within this stew of class upheaval, the technological apparatus of cinema showed an un- flinching eye for recording whatever you put in front of it. Censorship would most likely be a problem, but, simultaneously, the early political promise of cinema can be seen. Cinema

could show things others might not want you to see: yourselves and others. It could serve as a tool to enlighten the masses about world events, abuses of power, and the lengths of desire. Factory workers and laborers, including women and children, seeing themselves onscreen were given the chance to identify with their projected image as a banded community. Used further to show acts of revolution and military power throughout the twentieth century, the democratic and propagandistic potential of cinema proved extremely powerful in mass media, reaching hearts and minds in a towering format. From the Zapruder film to *Medium Cool* to C-SPAN, moving images, both film and video, have captured the historical contingency of the twentieth century. For those moments we did not and could not witness, we were shown their deadly effects, from Auschwitz and Cambodia to Kosovo and Rwanda.

In the twentieth century, life often seemed spectacular, as if staged for the camera. Everything in the late twentieth century (including the act of archiving itself) seemed potentially archivable.

In that sense, through convergent technology, everything appeared to be increasingly recordable, transferable, and accessible. In the wake of so much new archiving technology, it seemed inconceivable that so much history could be lost. Surely someone was watching somewhere and cataloging it all.

Clunky archival technologies, unstable safety stock that requires its own conservation practices, flammable archives, inadequate budgets, obsolete equipment, messy catalogs, and too little public interest too late in the game: all of these contributed in one way or another to the current decayed state of film history.

Thus, when we migrate the photochemical record stored in emulsion into binary data, we digitally record and index a frozen moment in a long history of analog decay. In doing so, we implicitly archive the cultural history of memory loss along with a film's physical history.

What gets digitally archived are the images, but also the contingent difference of time between when the film was last projected, conserved, and/or restored. Removing more than the image content, too much digital cleaning erases the physical history of the film on its journey from initial stages of production to mass digital distribution. Yet, this also threatens our memory of elapsed time by negating its visceral effects. Effectively suppressing any panic accompanying cultural amnesia, the marketing device proclaiming movies never age because cinema is immortal appeals to our paranoia that anything filmed could *and should* be restored, lest we forget about it. But this demand for timeless

art seems out of step with the lived reality of filmmaking and film going, where objects and people *do* become obsolete. The overwrought desire for timeless cinema appears to incur rather than preclude cultural amnesia. This begs the question: should we market cinema as the art of preserving timelessness or as culturally situated and historically contingent mnemo-technology?

The films of Mitchell and Kenyon were first explored in a three-part miniseries by the BBC in collaboration with the British Film Institute. This series, *The Lost World of Mitchell and Kenyon,* was first shown on BBC Two, January 14, 2005, and released on Region 2 PAL DVD January 31, 2005. Just four months later, a second DVD, *Electric Edwardians: The Films of Mitchell and Kenyon* was published in the same format. However, the differences between the two discs are striking and the discussion that follows juxtaposes them for comparison. *Lost World* is a BBC title aimed at a relatively unacquainted mass audience. By contrast, *Electric Edwardians* emphasizes the BFI aspect of the coproduction; it focuses on archival issues and presents the discussed films in a more research-friendly framework. The different audiences appealed to by each of these DVDs speak to niche marketing strategies for lost film history but also to the ways in which the British Film Institute aims to project a more popular image. It could also be argued these DVDs pitch a more archival image for the BBC, which certainly has a stake. They are government-funded coproducers of this project, along with the BFI, who aim to project particular images of British culture and popular memory. Without the legitimacy and cultural authority of

The Lost World of Mitchell and Kenyon DVD menu

these sponsoring institutions *and their provided context,* we would have a very stark and curious DVD collection indeed: more of a disinterested virtual warehouse but far less of a public touchstone. Along with an absence of supplied context, consumers would lose official consensus as to what actually happened. Thus, finding a lost world proves a substantially different task than actually convincing people it is worth buying.

THE LOST WORLD OF MITCHELL AND KENYON

The first DVD, *The Lost World of Mitchell and Kenyon,* takes an armchair historian's view of the recovered material, stringing together speculative narration as to what particular films must have meant versus the value they have now. On this DVD, cultural nostalgia is the strongest marketed contemporary value. It is hosted by the excited patriarchal figure of Dan Cruickshank, who attempts to make his narration as thrilling as humanly possible, barely containing himself at the overwhelming wonder of it all. Nevertheless, this showman hype has both warrant and merit. Although the films may not be the greatest epics ever made, they do depict people in the midst of, well, being people. Gunning explains the empathetic value of these social quirks to viewers in detail:

> They [the films] address us directly. We participate in their humanity and their spontaneity. These workers still look us in the eyes, whether expressing curiosity, good humour or smouldering anger. It is a filmic experience, and also a moment snatched from history. These films abound with broad smiles, necks craned to see the camera better, flirtatious poses, waves of hands and caps, bits of performances and attempts to attract attention, but we also find their opposites. People hide their faces behind hands or shawls, ignore the camera, regard it sullenly if at all, or stare at it without delivering a quiver of recognition. This range of reactions constitutes one of the dramas of these films, seeing how an oncoming sea of faces reacts to this elementary encounter.[10]

Throughout the DVD presentation, Cruickshank plays on this aggrandizement of everyday habit as art history by variously locating descendants of family members identified in particular Mitchell and Kenyon films. Interviews with these relatives ground us in the reality of here and now by showing exactly why these found "lost" films matter so much—because of the human stories. So we get to watch descendants looking into this historical mirror, seeing their long-deceased loved ones moving out and about for the first time. Ron Vickers, for example, saw photos from the films in a local newspaper where he recognized a mill worker as his grandfather at around age ten. Ron is featured in

Cruickshank's story watching a recording on television of his grandfather while narrating the difficult demands of a typical working day. This is quite a different hypermediated experiment from original filmgoers who may have seen themselves in a film recorded earlier that day. Instead of going to a film hall with others to watch themselves for a lark, descendents watch their forbearers at home on TV, while we watch a DVD of a film crew recording that moment for posterity. The inevitable shock of identification by these descendants is both a staged and a publicly accountable process.

As voyeuristic viewers, our treat is the intense emotional reality of this big historical "reveal."[11]

We witness and connect to Britain's nostalgic past not only because of Cruickshank's narration but through people's surprised expressions at recognizing their deceased relatives moving about in these digitally restored settings.

For British citizens, these films capture a formative moment in contemporary national identity from the turn of the century, including cultural values, class struggle, archival practices, and the habits of everyday life. Still, the message of this presentation strategy is tied to its method, implying one cannot meaningfully know history alone. Instead, it is adduced through the presentation that, as consumers (locals or tourists), we need indirect historical mediation. Through the BBC documentary we are taught that we need cultural authorities like Dan Cruickshank to witness history with us or, at the very least, to *witness us witness history* in order for it to make sense. Thus, we need third-person narrators as interpreters and interlocutors to tell us why these films are so important. Lost films that no one knew were lost require cultural tour guides to legitimately historicize the meaning of their lostness.

The architectural structure of *Lost World* is divided into three main categories (in contrast to the five or arguably six indexed on *Electric Edwardians*. "The Life and Times," "Sport and Pleasure," and "Saints and Sinners" each refer to one of three episodes shown on the BBC and situated on the DVD. The factory-gate films are, for example, discussed in the first episode, while the first match of famed football club Manchester United under that name is discussed in the second. The third, enigmatically titled episode includes official occasions such as Catholic and temperance processions, returning Boer War heroes, and police in full parade dress. In trying to keep with apparent themes, producers finally impose narratives on the material, dressing up the context to increase the significance of meaning to a mass "local" public watching them on national television or on DVD.

For example, included under the last category, "Saints and Sinners," is an unusual crime re-creation, which as *Electric Edwardians* notes, requires additional context

to make sense. In *The Arrest of Goudie* (1901), the narration talks us through a sensa-
tional murder of the time and the apprehension of the criminal. As Cruickshank walks the
same streets today, a strategy repeated across the three episodes, he correlates news-
paper accounts of the day with events and spaces unfolding in the film. Although he is
acquainting us with the contemporary world of these films' recorded spaces, the purpose
of walking us through this particular crime drama reenactment is to show the variety of
the films in the collection as well as the limits of understanding these films without
additional archival materials. So the implication is made here that "some narrative
assembly is required" because filmed history is not always self-explanatory. Through
descriptive reimagining of the conditions of Mitchell and Kenyon's "Goudie" re-creation,
historical contingency itself becomes archivally contingent, a function of how things
should be remembered rather than a sheer convulsive record of human performance.
Clearly, we are not meant to confuse this staged event or its digital restaging with "actual"
contingencies. In this respect, the transparent self-reflexive narrative function of this
DVD as an "archive of lost archives" acts as a flagged decoding device, structurally devised
for public consumption.

Each of these episodes can work as a stand-alone but also plays off knowledge
gained in previous episodes. Hence, the uniqueness of the material, the excited narra-
tion, nostalgic appeal, and thematic catharsis work collaboratively *as context* to attract
an otherwise distracted television audience. In this way, the BBC presentation finally
provided Mitchell and Kenyon with their ideal "local" audience inasmuch as their films
were presented and meaningfully contextualized as essential building blocks of contem-
porary national identity.

But why were the films of Mitchell and Kenyon lost? What did it mean for them
to be lost? What does it tell us when they were found in drums hidden under floorboards
as their archival home was being demolished? Did anybody know they were lost? Does
this change how the world thinks about emerging British cinematic identity? All these
questions might finally be missing the point. Instead of trying to nail down the cultural
significance of 826 individual lost films, maybe Cruickshank gets it right.

Maybe what we are really archiving here is a narrative sum total of lost times: accumulations of differentiated film fragments digitally assembled into narrative wholes, whose coalesced remnants map resemblance to the memory of an ever-present "lost world."

And the difference from that world to our own is arguably the history of change archived
on these DVDs—indexed lost film restorations testifying that less history could have

been lost, different histories could have been recorded and selected, and these digital memories might have been presented otherwise.

Contrasting two important functions of the Mitchell and Kenyon films, Patrick Russell explains how tensions between archaeological and historical demands are productive of different kinds of cultural knowledge:

> As archaeology, these artefacts might yield fresh insight into film technology and manufacture of a formative period; as history, their image content might — subject to good preservation choices being made — allow a clearer view (literally!) of British film-making of that period than ever before. . . . More suggestive comparisons were international: a late British equivalent to canonical, comprehensive, internally cohesive catalogues of original materials associated with Edison or the Lumières.[12]

Working from Michel Foucault's definitions, I am describing this epistemological friction in slightly different terms: between the archaeology of objects and the archaeology of knowledge.[13] My critique proposes that, far from being polar opposites, both historical perspectives shape memory as a product of taste and, finally, both often craft competing historical truths through exclusive archival practices. History and archaeology are not discrete archival processes; both react against one another but also are completely informed by the other, indebted to the respective roles each plays.

ELECTRIC EDWARDIANS

Electric Edwardians exhibits this same stress between intrinsic content and added context while also providing extensive detail on the BFI's rescue mission. With two DVD extras already devoted to this explanation, a third features an audio-visual essay with an abridged narration of Tom Gunning's essay "Pictures of Crowd Splendor." It aims to contextualize the meaning of this archival drama in terms of class mobility and cultural contingency. With respect to other structural differences, in contrast to the three narrative categories for *The Lost World, Electric Edwardians* has five divisions, along with a sixth untitled "hidden" category. These are: "Youth and Education," "The Anglo-Boer War," "Workers," "High Days and Holidays," and "People and Places." A DVD "Easter egg" or hidden feature is easily accessed by clicking on a burst icon just to the left of the "back" button on the lower left of the extras menu. A hidden menu is revealed that includes five films. These films, unlike the rest of the films on the DVD, are supplied without context,

music, group heading, or commentary. Interestingly enough, the only significant change to media access on the U.S. release of this otherwise identical DVD title is to this hidden menu. The five films composing the Easter egg menu on the British DVD are taken out of hiding and on the U.S. DVD are simply listed alongside the restoration features on the Extras menu. The five are exceptional films that, as will be discussed, are not easily contained under existing menu headings. In at least this sense, the archival content on the U.S. DVD release is more clearly referenced and more easily accessed. Further, whereas *The Lost World* DVD release included only fragments of films integrated into an arching narrative structure, the archival focus of *Electric Edwardians* is reflected in its research-friendly form. Therefore, many outstanding films only briefly mentioned in disjointed narrated bits on *The Lost World* disc are allowed a proper display in their entirety. As viewers, we can sequentially watch them all at once or access them to be played as part of the aforementioned group headings or watch them individually at our own leisure.

For *Electric Edwardians,* our narrator is no longer the excited Dan Cruickshank, but rather the calm and measured Dr. Vanessa Toulmin who delivers a low-key archival commentary for each film if you select the audio option. Even the musical score by In the Nursery seems less frenetic and more contemplative. While one could watch this disk on its own, the impression is that, if you liked the TV series and/or the *The Lost World* DVD but wanted to know more, this disc will allow you in-depth analysis of these films. In every sense, this DVD seems tailored to researchers with archival interests in the restoration of decomposing films.

Although plausibly targeted to a smaller, more exclusive niche audience, the audience aimed for here is arguably much broader than that for *Lost World*. The marketing strategy of this DVD looks beyond the national borders of Great Britain toward a potentially international audience with archival interests. The completeness of the individual films, along with the streamlined access and removable commentary with subtitles, suggests that programmers attempted to make this DVD available to a wide array of viewers with diverse research needs. Instead of showman hype, we are given stolid details regarding the wheres and whens of particular titles.

As with *The Lost World,* most films included on the disk seem chosen for uniqueness or exceptional qualities rather than generic characteristics. These exceptional choices are notable for their use value as selling points for both DVDs. They atypically depict typical regional life. In this sense, the films illustrate elements common to the time, while finally exceeding mundane reality with unique narrative and aesthetic embellishments. Hence, with a broad yet unique and spectacular public appeal, they

help bring in an audience *and* hold their interest. For example, in one of the selected factory-gate titles, *Parkgate Iron and Steel Co., Rotherham* (1901), we are first made aware of typical working-class life. Here we see class division typical of the time before the Education Act of 1902 sent children to school instead of work. Toulmin comments, "Again, the children leaving would have been half-time workers and the more smartly attired gentlemen would've been the actual management." Describing other action, Toulmin observes: "This pan shot shows the variety of workforce ranging from ten-year-old boys upwards to elderly gentlemen." In this same film, we are presented with what we are told by the narrator are comparatively rare examples of people acting badly in front of the camera. This includes an incident that Toulmin describes as a probable actual fight. In contrast to the comic fights often staged for the camera, this one occurs at a far edge of the frame and is notable for its spontaneous "roughness." In the same film we see another unusual occurrence. Remarking on a gesture equivalent to the American middle finger, the commentator observes, "Now we get the first example of a V-sign in film history." Shown waiting in line for pay, this particular worker does not take kindly to being filmed. In reacting as he does, he conflates the aggressiveness of filmmaking with picking a fight. Thus, consumer-spectators are shown atypical gestures rhetorically framed within typical narratives of cultural history.

Does this correlation between the birth of British cinema and "exploited masses" overstate the case? Not likely, as Vanessa Toulmin of the National Fairground Archive attests. In her DVD interview, Toulmin asserts at length the cultural significance of the socioeconomically subjugated working class to the emergence of both local and national cinema:

> There's no doubt that in the early 1900s the predominant audience for fairgrounds was the working class. It was their form of entertainment, it was arranged around their factory holidays, it was arranged around their wakes, their local customs and traditions. . . . When cinema came into that audience, they tried to give a kind of differentiation. So what you had is a pricing structure within the film shows. . . . Different types of films being made. Procession films, kind of films with royalty, kind of more dignified. And the camera becomes less focused on the crowd but more on the actual scene. I think when you get the introduction of cinema in 1909, 1910, a lot of the middle-class people who go to the cinema complain about the smell of the working class people. One of the most popular things in the 1910–11 cinemas were these sprays that they

could do to get rid of the smell of the working-class people. So I think, primar-
ily in the 1900s, Mitchell and Kenyon's audience was working class.

The working class of turn-of-the-century England was indeed massive. As one film title
shouts, *20,000 Employees Entering Lord Armstrong's Elswick Works, Newcastle-Upon-*
Tyne (1900). The remarks explain, "this film shows the industrial importance of the fac-
tories to local Lancashire cotton and woolen communities. Over 20,000 employees were
supposedly working for Lord Armstrong's works." Toulmin suggests that Mitchell and
Kenyon literally "bring the world to you" by "cramming the frame" with worker's faces.[14]

The typical/exceptionalist dialectic quality to the DVD described thus far is fur-
ther emphasized by the hidden menu, which consists of unique films of interest appar-
ently outside the prestructured categories. Thus, in contrast to the "nonfiction" films
pervading the collection, we see *Diving Lucy* (1903), mentioned first on the BBC series
DVD. Although *Electric Edwardians* provides no commentary, Cruickshank speaks about
the film on *The Lost World* in terms of its international stature, it having reached Ameri-
can box-office success. In this comic farce, mischief makers set up a lone "Bobby" to
edge out on a plank and retrieve the ankles of what looks like a drowning maiden. How-
ever, when "Lucy's" legs are pulled, so are his, so to speak: the grasped ankles are
merely wooden decoys. The locals who have been holding the plank hence release it,
consequently dunking the policeman in the water while the mischief makers run away
from his inflamed temper.

In contrast to the mantra "local films for local people" the international signifi-
cance of this hidden group of uncommon Mitchell and Kenyon films is further demon-
strated by titles that, although made with local people, were probably not necessarily
shown for the express purpose of showing locals onscreen. For example, the football and
cricket matches on the main DVD menus include extensive crowd shots with obvious
plants in the crowd to stir up vigorous audience response to the camera. In contrast, the
film *Race for the Muriatti Cup, Manchester* (1901), is primarily focused on recording the
central personalities involved in the race itself. Posing for pictures are trophy winners in
motorized tricycle races.

Situated third in this hidden grouping of five films is *Comic Pictures in High*
Street, West Bromwich, 1905. Shown only as a fragment under "Life & Times" on *Lost*
World, the film on *Electric Edwardians* is a compilation of several short takes of young
boys mugging for the camera. This includes staging mock fights directly for the lens as
participants and onlookers laugh throughout the proceedings. Of special interest is the

self-reflexive shot common to both DVDs concerning amused street crowds passing in front of a large billboard that reads:

Hall West Bromwich

Pictures We are Taking

Shown Monday Jan 13th

During the Week

Presumably, this scene is *more* comic due to the self-reflexive, transparent inclusion of their contingent archival practices within the film's diegesis. Archiving the humorous promotion of recording, the filmmakers become part of their own actuality. Through self-effacement of archival contingency, showmanship, new technology, and their historically limited situation, the comic content is finally subject to new levels of ironic appreciation across time.

The last two films in the hidden group, *Royal Proclamation of Death of Queen Victoria, Blackburn* (1901) and *Bradford Coronation Procession* (1902) exchange a fleeting focus on the working class for recording transitional historic events. These are national films with local people self-consciously concerned with archiving events. Seemingly out of place with the primary narrative categories, these DVD features are apparently excised from the primary architecture because of their exceptional status. They are situated as more historically important than the vast majority of films in the sense they record and archive important events (versus people) in British history. For the first time on these DVDs crowds gape at more important events than the presence of the camera. Instead of meeting the camera's eye, civilians assume its archival gaze and look *with* the camera at the unfolding historical action. Queen Victoria's death procession and the subsequent coronation are ultimately less about shifting royalty than the community performance of cultural ritual. As consumers, we have no reason to believe these hidden films were any more lost than any other film in the collection or that the grouped items were any more difficult to restore. Whether they are relegated or privileged as Easter eggs is a matter of perspective, but clearly they are exclusively situated as exceptions to everything else on these DVDs, exceeding the limits of the predesigned narrative categories.

Films in the *Electric Edwardians* Mitchell and Kenyon DVD collection are no less immune to the influence of context than those on the more popularly oriented *Lost World* collection. Substituting for heavy-handed narration, the categorical expansions, exclusions, extras, menus system, as well as the removable commentary all combine to deliver

a structural context for this digital architecture. The way items are displayed, including what they are juxtaposed to and the variety of methods by which you can revisit the same object, provide a virtual map for the aesthetic and economic priorities of particular archival perspectives.

In the DVD extra, "Road to Restoration: Mitchell and Kenyon and the National Film and Television Archive," Ben Thompson (the section leader for image quality) elucidates some of the cultural contingencies in archiving, while describing the image grading process. Working on a computer in a media studio, Thompson demonstrates what needs fixing and how those fixes will be made. Of course, from another angle, he is also showing us what will not be fixed, which implies the application of particular archival values. As an occupational hazard, Thompson treads a thin line between optimal exhibition and overcleaning the image. Hence, dynamic human error becomes part of the archivable in preparing digital presentations. But does this level of intervention really matter? Darragh O' Donahue thinks so:

> It is in the areas of archiving and film history that the battle against the lost film has been waged, and much brave and exhaustive work has been done on re-creating vanished art, whether through the restoration of existing films, or reconstructions of missing footage with reference to screenplays, stills and studio records. But even this task has something Sisyphean about it, as witness the fraught history of *Metropolis* (Fritz Lang, 1927) and its many versions, or even a recent George Eastman House restoration of *The Lost World* (Harry O. Hoyt & Willis O'Brien 1925), which excised politically incorrect material. Recreating the silent era is further impeded by controversies over projection speeds and the loss of most contemporary music scores.[15]

As O'Donahue remarks, there is an ethical dimension to archival practices that involve making exclusive decisions affecting the projected legacies of taste, public memory, and film history itself.

Along with technical contingency in archiving, there is a real variable for contingencies in decision making. Exclusion is as important as inclusion in determining ethical and aesthetic priorities of archives.

Still, the purpose in pointing this out is not to excoriate the George Eastman House for excising primary material but to show how *every* archival decision made in DVD design reflects the contingent interests of local power structures.

Suggestive of more than just archival contingency, the films of Mitchell and Kenyon, reflecting the life of their times, also depict a great deal about the existential contingency of the human condition. For example, in some films we see brigades of young boys training for World War I trenches. These boys' only brief moments on film stand as ghostly monuments to the nationally felt loss of an entire generation. Toulmin concludes, "And you see the films of the Boys' Brigades. You know that within years those children are going to war—you know that many of that generation's lost. What Mitchell and Kenyon captures for us is the lost generation."[16]

Thus, more has been found here than archival contingencies for lost films. Once again the empirical archaeological interests of film archives intersect with human nostalgia and public memory.

In this respect, the films of Mitchell and Kenyon do not provide us with neat answers to old questions by showing us the lost-and-found box of historical truth. Instead, *they archive the difference in time between two key events: the recording and the restoration—and the memory gaps between.*

For their part, the DVDs of these lost films finally archive repressed cultural memories, including memories about the loss of memories. As new-media theorist Lev Manovich argues, "digital media returns to us the repressed of cinema."[17] On DVD, this historical difference is sold as a replenished digital archive of fading and otherwise lost cultural memories. Within this new context, Russell surmises that, if around today, Mitchell and Kenyon would probably be most surprised to find their local films "could be consumed both as *documentaries* and as a moving *aesthetic* experience." However, in recognition of the cultural memory gap productive of such differences, Russell concludes that "Such revaluations are inescapable. . . . Hindsight adds emotional depth—the shock of our realisation that the Collections' many camera-friendly young boys will often have died together on the trenches."[18]

WATCHING PEOPLE WATCHING

While the Lumière films trumpeted, "Bring the World Within Your Reach," the same ultimately could be said about the spectacle of local films and instant archives brought to consumers on these DVDs.[19] Following the end credits on the *Electric Edwardians* DVD, a short appeal sutures the national interest in familial nostalgia marketed on *Lost World*

once more to the promise for future cultural archives, stating, "If you can see your family, your grandparents on screen, please contact the British Film Institute. We would be eager to have any stories that you believe would help with the dating and contextualisation of this collection." With this final statement we can see how the memory contents of private citizens are hailed by the state and rhetorically interpellated into the culture industry of the national archives vis-à-vis the contextual representation of lost films.

Family members reconnect by video with Lt. Clive Wilson of the Boer War (from *The Lost World of Mitchell and Kenyon*).

Hypothetically, through the power of digital media, individuals' memories could be metonymically transposed to stand in for an otherwise incomplete public database. History becomes histories — public amalgams of personal memories. What is publicly lost to recorded knowledge might be conceivably substituted with the rhetorical power of personal memory and collective nostalgia.

Similarly, it is allegorically inferred on these DVDs that a citizen recognizes their great-grandparent in the way an entire country recognizes its hidden past. Under this rhetorically strategic production of empathetic context, history becomes a transparent archive of fragmented stories, constantly revealing and concealing the conditions of its own archival contingency — familial history narrated for cultural purposes. Russell writes, "But this story is less about things than about people. Film-makers and showmen rescued from cinema history's margins. The dead photo-chemically resurrected, their faces crammed into seemingly every frame. The faces of their descendants delighted and awed at screenings."[20]

It is this diligent ambivalence toward both uncovering and producing the truth through context that dialectically marks this contingent mode of historicizing as an ongoing cultural project. The stakes in national identity supersede the interests of any single story, and hence it is through the accumulation of narrative differences that the cultural force of the archive will be judged. The ability to internally manage these rhetorical dif-

ferences and meaningfully incorporate them into existing archival categories speaks to the technological efficacy, performative flexibility, and discursive power of national identity.

Objects, lost and found, arrive to cognition first by faculties of sensory perception. If we empty our educated minds completely of noise and attune to the object of aesthetic attention as the Enlightenment philosopher David Hume argued in his seminal essay "Of the Standard of Taste," we arguably get no closer to an objective autonomous standard of digital critique. Nor are these DVDs deductively reducible to universal kernels shaping a single global standard for digital representation. Rather, what we mean by material content is perhaps more accurately rephrased as the accumulation of disparate cultural contexts.

While digital content may have an ontological and intellectual life discrete from the supplied context, these two categories are functionally inseparable from the dialectical influence of the other—both economically and aesthetically. At the very least, content and context are encoded in the same format and situated next to each other on DVDs. At most, the context supersedes and conceivably negates the significance of the primary marketed content. However, most often, content and context converse fluidly. Each serves to accent, supplement, and even conflict with the other as part of the normal digital dialogue of a film presented on DVD. The aesthetic ambivalence between context and content, contingency, and systematicity has helped propel the DVD market. While DVDs may not transfer the full 35mm contingency of big-screen flicker into our living rooms, they do simulate archival uses of space. DVDs arrange supplementary materials in a fashion available for convenient, instant nonlinear access on the part of the discerning viewer. If film archives ultimately protect historical contingency, then DVDs structure in the contingency of competing archival perspectives by denoting performative differences between them. Put another way, *DVDs exploit the consumer market for easily digestible versions of archival contingency.* Moreover, DVDs situate historical perspectives as functionally contingent intersections of lost time within digitally contrived spaces. Thus, the spatio-temporal archival transparency of DVDs highlights new avenues in the economic flow of knowledge: how elements of historical memory are culturally sifted, discursively mass produced, and generationally disseminated through transference to "new media."

Much as negative space countershapes the painter's frame, I am suggesting that lost films (and their contemporary recuperations), as particular rhetorical articulations of cultural history, provide sublime windows on dominant archival perspectives. For

it is the archival process of digital rescue itself, including both budget and effort, that is finally productive of the bulk of cultural value attributed to films hidden from the public eye. Lost films like those of Mitchell and Kenyon, by virtue of absence, simultaneously threaten and support the discursive architecture containing them; they perpetually reveal the repressed lack of self to the cinematic canon as if in a mirror. Yet, their meanings are negotiated and shaped within the dominant archival framework. As both empirical objects and elements of knowledge they threaten to be rediscovered at any time and like the lost films of Mitchell and Kenyon, rewrite history.

Taken together, aesthetic and rhetorical functions define *lostness:* a displaced artifact's cultural capacity to be found and archived. Therefore, given the structural significance of asystematic contingency central to the cinema nuanced by Doane, it may not be desirable to try to fill in *all* the potholes of film history with digital epoxy.

Instead of eliding historical disruptions, it might finally be more suggestive to *mind the gaps* between the archivable and the anarchivic.

Critically, we should endeavor to respect context, salient cultural differences, and local archival principles, for what is lost to history need not be found to have meaningful cultural importance. Multiple histories of films can be evocatively archived through a wide range of contextualizing practices. Consequently, once lost films now arrive on DVD as libraries of complex analog/digital differences, disciplining contingent archival gaps, *indexing how history could have been remembered otherwise.* Listening for digital difference is thus imperative for discerning *how* we are being told *what* to see in particular cultural contexts.

NOTES

1. Patrick Russell, "Truth at 10 Frames per Second? Archiving Mitchell and Kenyon," in *The Lost World of Mitchell and Kenyon: Edwardian Britain on Film,* ed. Vanessa Toulmin, Simon Popple, and Patrick Russell (London: BFI, 2004), 14: "Implications for that canon were sure to reach further. The Collection's scale alone justified the publicity claim that it would 'rewrite film history' itself. Adding 800 new titles to the Archive's UK holdings for the period would increase them by perhaps up to twenty percent, decisively altering the shape and meaning of this portion of the collection." Also see Vanessa Toulmin, Patrick Russell, and Tim Neal, "The Mitchell and Kenyon Collection: Rewriting Film History," *The Moving Image* 3, no. 2 (Fall 2003): 2. In this article the number is cited as "25 percent."
2. Russell, "Truth," 16.

3. Hillary Profita and the *Nightline* Staff, "Nightline Tonight," (republished announcement), March 11, 2005, http://www.imponderables.com/archives/000194.php.

4. *Electric Edwardians: The Films of Mitchell and Kenyon*, http://www.milestonefilms.com/movie.php/electric.

5. The opening scroll for *Electric Edwardians* reads, "The films of Sagar Mitchell and James Kenyon were commissioned between 1900 and 1913 by touring showmen in the days before purpose-built cinemas. Advertised as 'Local Films for Local People,' they were screened at town halls, village fetes and local fairs."

6. Tom Gunning, "Pictures of Crowd Splendor: The Mitchell and Kenyon Factory Gate Films," in *The Lost World of Mitchell and Kenyon: Edwardian Britain on Film*, ed. Toulmin, Popple, and Russell, 49–58.

7. Tom Gunning, "The Cinema of Attractions: Early Film, Its Spectator, and the Avant-Garde," *Early Cinema: Space, Frame, Narrative*, ed. Thomas Elsaesser and Adam Barker, 56–75 (London: BFI, 1989).

8. This quote is from the abridged DVD version of Gunning's essay, "Pictures of Crowd Splendor," narrated by actor Paul McGann, on *Electric Edwardians: The Films of Mitchell and Kenyon* (BFI, 2005).

9. Mary Ann Doane, *The Emergence of Cinematic Time: Modernity, Contingency, and the Archive* (Cambridge, Mass.: Harvard University Press, 2002).

10. From Gunning's abridged essay, "Pictures of Crowd Splendor" on the *Electric Edwardians* DVD.

11. The effect is not unlike those on reality makeover shows, which often feature "reveals" for dramatic purposes.

12. Russell, "Truth," 14.

13. Michel Foucault, *The Archaeology of Knowledge*, trans. A. M. Sheridan Smith (New York: Pantheon Books, 1972), 131: "[Archaeology] designates the general theme of a description that questions the already-said at the level of its existence: of the enunciative function that operates within it, of the discursive formation, and the general archive system to which it belongs. Archaeology describes discourses as practices specified in the element of the archive."

14. Interview with Vanessa Toulmin of the National Fairground Archive, *Electric Edwardians* DVD.

15. Darragh O'Donahue, "Paradise Regained: *Queen Kelly* and the Lure of the 'Lost' Film" (July 2003), http://www.sensesofcinema.com/contents/03/27/queen_kelly.html.

16. Interview with Vanessa Toulmin, *Electric Edwardians* DVD.

17. Lev Manovich, "What Is Digital Cinema?" (1995), http://www.manovich.net/TEXT/digital-cinema.html.

18. Russell, "Truth," 18.

19. Gunning, "Pictures," 52.

20. Russell sums the project as "the journey from ice-cream tub to lost world" ("Truth," 19).

MOBILE HOME MOVIES

DEVIN ORGERON

Travel and *le Politique*

des Amateurs

AMATEUR CINEMATOGRAPHY AND MOMENT COLLECTING

This article examines the post–World War II travel films of two American families. One family documented their travels (mostly in the United States) in the late 1940s and early 1950s, and the other family, the Weiss family, was especially mobile (and internationally so) in the early to mid-1960s as U.S. involvement in Vietnam was escalating.[1] The films themselves are part of a larger collection acquired by the author at estate sales in and around Silver Spring, Maryland, and Washington, D.C., between 1997 and 2001. Several of those years were my "dissertating years." Haunting people's basements on the weekends, which started as a diversion, quickly became something more when at one of these sales I bought a dusty Kodak Brownie 500 projector and a big box of mysterious-looking fifty-foot Kodachrome films, most of which were labeled simply

with a year and a geographical referent.[2] This particular sale was professionally run; some are run by surviving family members, and some are simply indoor yard sales.

That the items themselves in this case were "professionally" priced at ten dollars — a surviving family member, in fact, "threw" the Weiss family film collection in with the projector, the item that justified the price tag — indicates the low esteem our culture has for what Patricia Zimmermann has called a "part of a suppressed and discarded film history."[3]

As a student of moving image history and technology, my attraction to this particular strain of popular culture made sense; this, at least, is the argument I like to use when I grow weary of defending or denying what is also quite clearly a form of voyeurism — a fascination with the ways objects, especially these objects, reverberate nostalgically. So, while I should perhaps repress my own voyeurism, my own fascination with a time that, in most cases, I never knew personally, or with people to whom I certainly had no personal connection, I want here to unmask my violation of these academic taboos in the hope of complicating them and, to some degree, unraveling how such desires not only form the organizational backbone of "the collecting impulse" but are also strategies implicit in the amateur cinematographer's task, which is, after all, to look longingly, to remember fondly.

Writing of his own difficult-to-reconcile fervor for the written word, his own collections of books and of quotations, Walter Benjamin suggested that "to renew the old world — that is the collector's deepest desire when he is driven to acquire new things."[4] Benjamin's words are magnificent, in part, for their own quotability — a state of affairs, I suspect, he would have found delightfully comical. Susan Sontag, buoyed by Benjamin's observations, draws the connection between the collector's and the photographer's twin enterprises. This connection inspires her to open her seminal 1977 book *On Photography* with the aphorismatic position that "the most grandiose result of the photographic enterprise is to give us the sense that we can hold the whole world in our heads — an anthology of images. To collect photographs is to collect the world."[5] Sontag also closes her book, in homage to Benjamin, with her own collection of quotations on photography. Between these Benjaminian bookends, Sontag offers a critical statement upon which the present examination pivots. Continuing in the photographer-as-collector vein, she writes that,

Like the collector, the photographer is animated by a passion that, even when it appears to be for the present, is linked to a sense of the past. But while tradi-

tional arts of historical consciousness attempt to put the past in order, distinguishing the innovative from the retrograde, the central from the marginal, the relevant from the irrelevant or merely interesting, the photographer's approach — like that of the collector — is unsystematic, indeed, anti-systematic.[6]

Although Sontag's analysis deals specifically with still photography, its implications stretch into the realm of amateur cinematography, especially travel and vacation cinematography, which was driven by the same impulse to "collect the world" and to resist, sometimes defiantly, the systematic or the "orderly" as it was being defined. My interest in the notion of the amateur cinematographer as "moment collector" is fed in part by a desire to make sense of an unusually consistent aesthetic logic running through these films, one guided less by the rules of narrative continuity as those rules were being prescribed within the pages of instruction manuals and guidebooks, and more by a shifting relationship to both time and space that was fueled by the emergence of the 8mm camera as consumer recording device and by the postwar convenience and popularity of road and air travel.[7]

Indeed, as the growing body of scholarship on amateur filmmaking continually demonstrates, few activities were as "collectible" or as cinematographically inspiring as travel.[8] Although it is confronted more explicitly elsewhere in her study, in the excerpt above, and indeed throughout *On Photography,* Sontag simply assumes the still camera's mobility, its *worldliness.*[9] Where Sontag wishes to emphasize the manner by which her roving photographers embarked upon their world-collecting missions linked umbilically to the past, however, I wish to emphasize the amateur image maker's interest in a temporal category Sontag only glosses: *the future.* From his or her vantage point behind the lens, the family cinematographer, like the family still photographer, has a complicated relationship to the present moment stemming from a perceived need to preserve it, a need to can personal or familial history, presumably for future exhibition.[10]

The preservational awareness of a personal and global world *in transition* frequently expresses itself in images of families *in transit,* families moving between geographical and temporal poles. That the motion picture camera is capable of recording the details of this mobility is obvious but centrally important.

As much as the destinations or landmarks announcing themselves to be the "goal" of each of my focus families' travels, those aforementioned geographically specific

labels, the amateur cinematographers explored here are also curiously drawn to the various modes of transportation that make such travel possible. Moving beyond the two collections addressed here, postwar American amateur travel films appear to be a celebration of automobiles, the road, the shiny prop-driven airplanes of the 1940s, locomotives, and boats of all shapes and sizes. As the camera's operator is drawn to these various vehicular subjects and their routes, the very aesthetic principles these cinematographers appropriate begin to take on bizarrely transportative qualities themselves. Chiefly, I am interested in the emergence of a dialectically rhythmic editing structure that finds the amateur cinematographer *moving*, at times within the very limited narrative space of a fifty-foot reel, between images of *difference* (typically glimpsed voyeuristically) and images of *familiarity* (typically captured nostalgically). Sometimes familiar images occur at the literal level, in travel films punctuated by images of home. More frequently and more intriguingly, however, they appear metaphorically, in travel films that search for "homelike" qualities away from home.

As I've indicated, these decisions move well beyond mere object choice and form the basis of an amateur travel aesthetic; an aesthetic working in complex ways within the space between the requisite "Welcome to . . ." sign to the end, not of the road or ride, but of the reel. In-camera editing, for the most part, is the only editing to be found, though sometimes reels from different legs of a trip or footage from separate annual trips are not-so-artfully spliced together to create longer, though apparently chronologically assembled, compilation reels.[11] There is in these films an apparent respect for the linear integrity of the journey itself and a fear of compromising that linearity. For this reason, the *details* of travel—the minutiae amateur handbooks warned these photographers to overlook—remain wonderfully and fascinatingly intact.[12] This self-imposed linearity, however, is complicated by a dialectical structure capable of shuttling the viewer back home. In short, these films challenge what many understand to be the very notion of the home movie. For, while they were certainly screened at home, and while I eventually found and paid for them in the basements of some of these homes, their thematic interests stretch far beyond the domestic site, even while that site is constantly and quite visibly acknowledged. The home's mythic *stability*, in other words, is acknowledged precisely by repeatedly disavowing its *stasis*.

As objects with clear ties to the aura of their producing families, home movies force us to consider their contextual meaning both within the domestic space and well beyond it. Walter Benjamin writes that "the phenomenon of collecting loses its meaning as it loses its personal owner. Even though public collections may be less objectionable socially and more useful academically than private collections, the objects get their due

only in the latter."[13] A product of mechanical reproduction though infrequently repro-duced *multiply,* the family travel film is a complex object, and its connection to ideas like "the personal" and "original" are murky to say the least. Although its indexical relation-ship to the events and geographies it records is illusory, for a fraction of its life it does enjoy a potentially privileged position as "original" and, one might add, a narratable ob-ject in and of itself. Functioning like other records of familial existence, it is part of a larger *meaningful* "collection" of family history. This designation is interrupted at the point of sale, donation, or disposal; or perhaps even earlier, at the point when the im-ages themselves (for reasons having to do with technological change, historical distance, convenience, and so on) fail to resonate for the original or, as Benjamin would have it, "personal" collector/creator (i.e. the represented family).[14] The object, in other words, is stripped of its aura, its temporal, geographical, and personal specificity that, of course, was tenuous to begin with. Typically only semi-articulate in the best of conditions, in their often mildew-ridden boxes or vinegaring cans, on other peoples' projectors, on the Internet, these films are even further "removed," are rendered increasingly opaque.

Dredging up the historical context in which these films were made begins to illuminate the degree to which travel home movies, in particular, defy the era's prescriptive logic as it was being promoted in how-to manuals and instruction booklets. Travel appears to impose its own order, which runs counter to the logic being sold to the amateur enthusiast.

DISCONTINUOUS SUBJECTS: AMATEUR CINEMATOGRAPHY IS NEITHER HERE NOR THERE

Anyone who has had the opportunity to examine a significant body of amateur 8mm films, travel or otherwise, will tell you that, more often than not, they leave something to be desired technically; something to be desired, that is, if Hollywood continuity is your frame of reference.[15] In spite of a great deal of ink spilled both in the instruction manu-als packed with 8mm camera outfits and within the pages of amateur cinematography magazines, where a fascinating notion of amateur artistry was being pitched, many of the films fail, upon surface inspection, to move beyond the categorization of moving snapshot.

Patricia Zimmermann, in her influential 1995 study of amateur film, *Reel Fami-lies,* has provided perhaps the most comprehensive attempt to unravel the complex dis-course surrounding amateur film practice. Her work, which promises to examine the

shifting dynamic of this enormous body of literature, however, ultimately underscores its consistency. The changes that occur across the decades she surveys are marked principally by escalating degree. Important moments such as the creation of otherwise-inclined and highly active amateur movie clubs and occasional defenses of amateurism are overshadowed by a pervasive call to professionalize and homogenize. That most amateurs not-so-systematically ignored this advice is acknowledged both in Zimmerman's work and elsewhere. Less explored, however, are the systems that developed instead.[16]

An article entitled "Make Your Movie Tell a Story" illustrates this drive toward Hollywood homogeneity. This very sensibly written article by regular contributor Frederic Foster appears in the January 1944 issue of *Home Movies*. *Home Movies,* which billed itself as "Hollywood's Magazine for the Movie Amateur," frequently ran reviews of major Hollywood pictures and seemed to think of its pages as a sort of informal film school for a generation of potential Hollywood cinematographers trained in the classical continuity style. Their goal, in other words, seemed to have been to take the amateur *out* of amateur cinematography:

> The best amateur movies are first planned on paper, in scenario or "shooting script" form. . . . When such advance planning is not feasible, as with many travel and vacation films, we can at least keep in mind what we are going to do with the shots after we have made them. By keeping one eye on continuity this way, we often can pick up connecting or "fill-in" shots as we go along that can be used at editing time to knit our picture into a reasonable continuity.
>
> To the amateur to whom continuity is yet an untried technique, we suggest this procedure: construct your film or your shooting script, if you will, just as you would a letter covering the very subject you wish to film, with the same attention to detail and progressive steps of narration. In writing a letter about a trip to California, we would not jump from a description of our experience in Chicago to that of our stay in Los Angeles without mentioning how we got there and give an interesting account of things that happened to us between the two cities.[17]

The fact that the piece is written during the Second World War should alert us to the practical reasons behind its largely conservative appeal: film was a scarce material, not something to be wasted. The author's particular attention to the travel film and its wasteful and discontinuous potential is taken up a bit later in the article in a manner that even more aggressively promotes the Hollywood model. Foster writes,

The public has become quite conscious of what constitutes good continuity from long and regular attendance of motion picture theatres. It has learned to anticipate action and is impatient to see the action it has anticipated. Many actions of everyday life have become so commonplace that everyone takes them for granted. Hence, it is not necessary to show them on the screen. A person steps into a car and drives away. It is wholly superfluous to show the intermediate steps of starting the motor, releasing the brake, shifting the gear lever, etc. Audience imagination fills in these familiar details.[18]

Written in 1944, the piece indicates a degree of industrial confidence in "the public" at a pivotal moment in film history, a moment toward the end of Hollywood's most lucrative four-year period and just before the end of the war when the "long and regular attendance" the author speaks of began to taper off.[19] In spite of its titular implications, in fact, *Home Movies* during this period in the mid-1940s appealed rather directly, both in its columns and in its advertising, to a group of amateur cinematographers who were not yet *home,* who were still *over there*. Home, however, loomed large in these appeals and sealed the domestic preoccupations of amateur cinematographers.

In fact, within the pages of *Home Movies* from this period, between its articles and between the lines, can be glimpsed the basis of a pervasive aesthetic logic running through the postwar travel film. This logic turns on a belief in small-gauge equipment's ability to bring the world home and in its related ability to bring or find elements of *home* in the world. Although the basis of this rhetoric can be found elsewhere, its momentum builds during the late-war period as notions of the world and the home were being hotly contested.

A selection of advertisements and feature lead-ins helps illustrate the point. In Figure 1, the Universal Camera Corporation addresses itself directly to the soldier, touting their equipment's communicative abilities. For those servicemen who brought or were sent their equipment overseas, the camera is depicted as a mechanism by which to stay in visual contact with one's family, with one's home.

The camera's connection to epistolary forms here is both foregrounded and significantly exaggerated, as the advertisement evinces a unidirectional form of communication. Amateur equipment, in other words, is sold as bringing "over there" home in all of its "exciting" and "exotic" splendor.

Equally critical, nontheatrical equipment is elsewhere imagined as bringing "home" to the soldiers in the form of transportable and familiar film programs. A richly

Figure 1: This March 1944 advertisement in *Home Movies* for the Universal Camera Corporation is hinged on the balance between the exotic and the domestic (96).

imagined and cheerily cartoonish 1944 advertisement for the Victor Animatograph depicting a group of seated and visibly entertained soldiers watching Mickey Mouse on screen goes so far as to claim that even "Death pauses for Mickey Mouse." The text continues, suggesting that "for a little while, war is far away...the lovable little creations of Walt Disney are a breath of home and peace...a great morale force are these 16mm Projectors bringing entertainment and laughter to our boys at the most advanced outposts."[20]

Additionally, for the emergent enthusiast and for those who left their cameras behind, amateur equipment became one of a handful of reasons to long for home, figured, along with the wife, the child, the home itself, and the automobile as celebrated symbols of the "America" these young men needed to believe they were fighting for. The illustration accompanying the earlier referenced "Make Your Movie Tell a Story" is fascinating precisely for the "story" it tells. A smiling serviceman, still in uniform, is greeted by wife, child, and camera, creating a deliberate and very timely homecoming story.[21] The bottom half of Figure 1 imagines a similar scenario, tempting the soldier stationed in the South Pacific with the promise of new technology, images of domesticity, and, critically, its filmability. Amateur equipment at both the production and exhibition sides of the equation, in other words, was establishing its liminal existence, its historical function as bridge *between* spaces.

The end of the war capitalized on these qualities. As the literature focused squarely on the importance of postwar hangovers of exoticism and action, it tempered these concerns with the joys of the familiar, the domestic.

Both of these notions of *America* coalesced in the postwar era, and evidence of their mingling can be traced across the surface of many families' 8mm attempts at capturing both the spirit of *family* and *home* as they traveled inside and outside of U.S. national borders. The official and unofficial marketing of wartime amateur cinematography, then, worked to establish the dialectical aesthetic that governed the mostly in-camera editing of these films.

Writing specifically of the disconnect between discourse and practice from 1923 to 1940, Zimmermann writes,

> These films illustrate how out of touch with the contingencies of actual amateur-film production these experts were. . . . Their makers were obviously content to settle on their rushes as the final product, equating production with the finished product for exhibition, if they were even shown at all after they were made. Amateurs clearly harbored a different agenda from that of Hollywood advice columnists.[22]

Remaining "out of touch with the contingencies of actual amateur-film production" coupled with the push for professional polish by the late 1940s might be viewed as defensive strategies designed to maintain the illusion of Hollywood superiority and

perfection and to win back an audience that was increasingly contenting itself with other leisure-time activities. High on this newly organized list of activities were travel and home movie making, pastimes that were similarly hinged on the pleasures of display and observation but, more than the cinema, could be consumed by the newly emerging and soon-to-be-ubiquitous family unit. Hollywood, in fact, would not rebound from its slump until the 1960s, a cinematic decade that borrowed from European sources, to be sure, but was as indebted to the illusion of immediacy fostered by a period of unrivaled interest in amateur media.[23]

Attempts to "professionalize" the amateur, however, were as persistent as the amateurs' alternate agenda. In the late 1950s, in a book entitled *Story-Telling: Home Movies: How to Make Them,* Leo Salkin notes the degree to which mean-spirited jokes and anti-amateur cinematography cartoons were marring the hobbyist's reputation as they repeatedly depicted "the hapless and unsuspecting guest (who) is coerced into look-ing at home movies against his will, against his better judgment, and to his complete dis-comfort."[24] A few lines later, revealing his goal, which is, of course, to improve this state of affairs, Salkin writes that "these cartoons would not be funny, that is, they would not strike a responsive chord in the reader, if there was not a large grain of truth in them."[25] Kodak, in their widely circulating publication *How to Make Good Movies,* was similarly

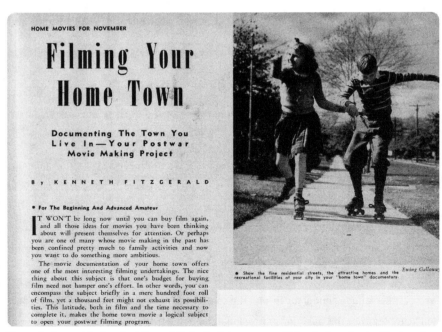

Figure 2: One critical and oddly mobile half of the postwar dialectical aesthetic, filming the local, is foregrounded here (detail from "Filming Your Home Town" by Kenneth Fitzgerald, *Home Movies,* November 1945, 473).

concerned, warning the amateur, for instance, not to "Panoram" on stationary landscapes, a cinematic sin leading to the boredom Salkin laments.[26]

And while it is surely a mistake to assume that all hobbyists (or even my selected amateurs) read all or any of these bits of advice, the fact that they ventured fearlessly and so consistently in their travel films into the much discussed danger zones of panoramic shots, shots from moving vehicles, still or "action-free" compositions, and the dreaded "post-card" aesthetic, indicates that something much stronger than a fairly convincing attempt on the part of the industry and its experts to standardize and professionalize amateur cinematography was at work. This "something," this "different agenda," I want to suggest, has much to do with the postwar American family's desire to narrate their newly mobilized domestic comforts.

VEHICULAR SUBJECTS: GETTING THERE IS MORE THAN HALF THE FILM

A 1949 trip from Maryland to California is an ideal case in point. The film ("#2: California Trip, 1949" available for viewing at http://www.archive.org/stream/home_movies_misc/ metal_2_ca_256kb.mp4) is part of a collection of eight reels purchased together in a grey steel case marked "Brumberger" capable of holding twelve such reels. Of these eight reels, seven are edited, labeled, and numbered in semi-chronological order. The collection also includes a small, unlabeled, unedited reel on a flimsy paper spool containing shots from a slow-moving boat or canoe, and of a child (Ray Jr. of the labeled reels) playing in the snow, presumably around the holidays (a forlorn and semi-dismantled Christmas tree serves as a prop toward the film's conclusion), in the backyard of the home where, nearly fifty years later, I purchased the films. Of the seven labeled reels, only two are nongeographically identified: reel "#4: All Ray Jr. from Christening to lawn mower scene aged 2 years 1953, 1954, 1955" and reel "#5: All Miscellaneous 1947, 48, 49, 51, & 53." These two reels, along with the unlabeled short reel, contain extensive domestic footage, shot largely outdoors. The remainder of the reels are travel or vacation reels, though both reel "#2: California Trip 1949" and reel "#6: FLA, 1955 & 1957" are punctuated by scenes of the home. I will return to this idea as it is key to understanding how the films themselves and their ideas of mobile domesticity function.

"#2: California Trip, 1949" is, I think, most exciting for its timing. One hundred years after the California Gold Rush, this Silver Spring, Maryland, family makes its own journey west. We soon become acquainted with our cast of characters who are, we quickly learn, somewhat democratic in sharing time behind the camera. We will be traveling with a couple, presumably husband and wife, and her mother. The older woman

they travel with bears some resemblance to the young woman and their playfulness together, their familiarity, seems to suggest more than a legal relationship.

At one point, an elegant pan from the utterly barren road they've traveled together and the similarly desolate landscape it traverses lands on the wife, neatly gesturing at the unfamiliar in a manner that frames it. Visible over her shoulder, mother stoops to examine the desert floor and, as she does so, the young woman sets up to playfully and familiarly spank her on the rear.

The action is not allowed to resolve, however, as a perfectly placed cut to the mother composed alone in the frame preempts the point of contact.

The film, in fact, begins by breaking the rules of "good" amateur cinematography by panoramming somewhat dizzily on a stationary landscape remarkable to this family, no doubt for its barrenness, its *difference* from their native terrain. These shots are followed by a pause at the Duncan Hines–recommended La Siesta Motel, which is subjected to the same panoramic treatment. The oddity of the natural landscape, its emptiness, its inhospitable surfaces are, for a moment, compensated for by its opposite: a well-populated theme motel, complete with the requisite density of signage, convenient parking, and a service garage: all of the highly contrived conveniences of home.

Richard Chalfen, who has written extensively on the sociological and anthropological significance of home movies, has pointed to this tendency toward "sign-language." He writes that "home moviemakers, like snapshooters, may occasionally include written identifications of place ('welcome to Yellowstone Park') and time in the form of road signs, town markers, or historic signs."[27] And, while this family is interested in markers of touristic significance, it is their lingering over markers of mobile domesticity that is critical here. The story this family's images tell, in other words, becomes a story of lodgings, reminders of and temporary replacements for home. This is most fascinatingly apparent in reel "#1: Maine Trip, 1947" (http://www.archive.org/stream/home_movies_misc/metal_1_maine_256kb.mp4) where, en route to what is apparently the husband's family home, the young couple pauses to shoot "Silver Spring Lodge," a series of low-lying bungalows that attracts our young couple's cinematographic attention for its familiarity in name, if not place; they are, we recall, from Silver Spring, Maryland.

In "#2: California Trip, 1949," a rather rapid pan to the right establishes our group's narrational sensibilities; as if to remind themselves and the viewer of their journey's deliberate timing and its historical significance, the first sign visible in this camera movement advertises the Golden Nugget. As they journey more deeply into the desert,

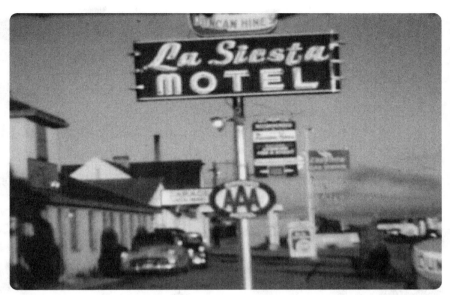

Figure 3: At home on the road.

our cinematographer offers us a composition that has become a staple of the American Western and, some years later, the American road movie: a narrow road receding into the dusty landscape. Further developing their domestic automobility, this shot is followed almost immediately by another motel shot, this time closer and with the automobile even more clearly foregrounded. Our family is establishing in this film a fascinating rhythmic structure that follows them on their various journeys, alternating between images of emptiness and "difference" and images of "civilization" and familiarity. This rhythmic structure has little to do with the cinematic or narrative instincts of the family, little to do with the industry's attempts to nurture or create those instincts, and everything to do with this family's display of domestic mobility, which, perhaps in spite of itself, keeps searching for signs of stability.

After a visit to what appears to be a family-run fruit orchard and a series of poses capturing both families, the remaining California footage is fairly standard: drive-through rock formations at the entrance to the redwood forest; dramatic pans up on the redwoods themselves; footage taken from high above San Francisco; images of the Golden Gate bridge from afar and, against the instructions found in the manuals and magazines, from their moving vehicle (Figure 4); Hoover Dam; another motor lodge; and a parting image of Gregg's Trail (probably taken in New Mexico), again, with its Gold Rush implications, acknowledging the centennial timeliness of their journey.[28] That their San Francisco visit passes by so quickly (one minute and thirty seconds of the film's total twelve minutes) is rendered all the more peculiar by the images that close the film. Back

Figure 4: Transitory images move against the grain of the advice manuals.

at home in Silver Spring, Maryland, probably hoping to spend the last two minutes of film before sending it away to be processed, we switch between images of our couple formally dressed and emerging from their tidy brick home, to images of the wife in a sundress, playing on the lawn with their cocker spaniel.

Although the manuals instructed amateur travel cinematographers to tell stories, to dispense with the unnecessary, and to allow audience imagination to fill in the "familiar" details, the "story" this film tells in spite of (or because of) its structure is one of a family interested in showcasing their mobility but equally seeking out signs of home, hurrying, in fact, toward home.

The family's twin journeys to Florida, captured on Reel "#6: FLA 1955 & 1957" (http://www.archive.org/stream/home_movies_misc/metal_6_fla_256kb.mp4) do not include the wife's mother but feature the couple's newest edition, Ray Jr., here about two years of age. Fifteen minutes in length, the reel is composed of about five fifty-foot reels edited together in apparent chronological order, not to tell a story but presumably to make family viewing time longer and less disjointed. The reel's organization is similar,

however, to the California reel. Both are interested in the details of transport, and both foreground the family's liberty to participate in public displays of roadside tourism as well as their desire to luxuriate among and point to signs of the familiar.

The reel begins with images of two women fishing off of a bridge—one of these women is the wife from the first film. The film cuts to a man who is clearly the husband (and presumably the frequent cinematographer) participating in the same behavior, followed by an inelegant but lengthy pan across the water into which his line has been dropped. Perhaps even more than their other journeys in the collection, this one foregrounds traditional modes of leisure activity (like fishing), no matter their noncinematic nature (because, with apologies to the *Outdoor Living Network*, what could be more excruciatingly boring to watch than fishing?). This footage is followed by images of a shirtless Ray Jr. playing with geese (his own leisure activity) so leisurely edited to the next footage that Kodak's processing perforations can be glimpsed on its tail end.

Our cinematographer here, in the pan prior to the boy-with-geese footage, returns to the automobile, as he does throughout the collection. Lack of onscreen action or movement, it seems, is countered by the implied, potential kineticism of the vehicle. In the footage that follows—which compositionally rhymes with the boy-with-geese segue, with its road-based vanishing point—that cardinal rule of amateur cinematography is broken: *never shoot from a moving vehicle.*

My incomplete survey of amateur travel films, however, would indicate that this shot is what links all of these filmmakers. It is, it seems, an inevitability. The rule is broken here, but beautifully and in a manner that points up the absurdity of the rule to begin with and, once again, reaffirms the amateur cinematographer's desire to account for the insulated intricacies of both geography and duration.

In-camera jump cuts move us dramatically from one point on the bridge's expanse to the next, and there is an interesting logic to the cuts so that some semblance of beginning, middle, and end (the journey's critical components) is maintained.

The aesthetics here are intriguing because they are both subversive, moving as they do against the "how-to" literature, and normative, subscribing as they do to a highly privileged notion of the American family's easy mobility. This confusion prefigures a similar aesthetic logic that would occupy international modernist cinema, especially as it was concerned with the idea of the journey and its relationship to notions of the domestic.

From Michelangelo Antonioni, to Jean-Luc Godard, to Dennis Hopper and Monte Hellman, to Wim Wenders, the uncinematic, the quotidian, the ordinary—things like dropping a line from a bridge while in transit—and iconoclastic attention to the details of travel, especially automotive details, are what these films are about.

Discussing this tendency to attend to the quotidian while in transit, Richard Chalfen writes:

> The majority of away-from-home movies are made during vacation times. When vacation consists of staying at a seaside cottage, a mountain retreat, a wooded camping spot, etc., topics are filmed that would not deserve attention when movies are made at home. For instance, in a vacation setting, home movies are likely to include common, everyday activities. . . . We find that topic choice for filming events may co-vary with the setting choice and that, ironically, topics and activities common to everyday life *at*-home are more often filmed *away*-from home.[29]

Travel, Chalfen suggests, affords an excuse to record and display basic domestic activities, demonstrating—one might even argue exhibiting—the relative ease with which the family can practice these activities elsewhere.

Maintaining this logic, the camera then pauses, in a moment of narrative clarity, on a roadside billboard. Signs in these films, in a manner that I suspect would have fascinated Roland Barthes, function as title cards, diegetically signifying critical information about location. The sign indicates that our transitory family will, here at the Lido Beach Planned Subdivision, built by Sibley and complete with private beaches, pause (the long take presages this desire): they will lay down nomadic roots, they will "play house." The next series of shots establishes their modern, low-lying, cinderblock vacation wonderland, their transitory neighborhood, and their own private home within it—complete, as all of the homes are, with a fairly conspicuous garage, which gets considerable screen time, and a price tag where an address should be: $13,990. The getting there, this series of pans tells us, is complete, and the remaining couple of minutes of this trip finds our family in various modes of touristic leisure: playing on the beach, enjoying the local gardens, and so on. They are, in other words, making themselves *at home*.

On the same reel, between the two Florida trips, is more footage of the family's Silver Spring home. Ray Jr. and his father take turns at batting and fielding. Then we

segue abruptly to more, later, Florida footage, but without attention to getting there. A slow pan establishes our aquatic proximity and is followed by images of another vacation home, yet another home away from home. The reel's final seven minutes—except for an approximately thirty second bit of "in-town" footage—is devoted entirely to the family playing in the water, devoted entirely to images of vacationing leisure on display, domestic pleasures uprooted and resituated ocean-side.

EXOTIC SUBJECTS: TRAVEL AND THE GEOGRAPHY OF SYNECDOCHE

A different sort of amateur film-family, the Weiss family, who traveled abroad extensively in the 1960s, did not edit their short reels together to create longer, travelogue films. Far more aggressive, both in their editing style and their compositional strategies, the Weiss family thought, it seems, in fifty-foot units. And, most of those fifty feet, as we shall see, would be filled not with the quotidian, as with our first family, but with the exotic.

In their original bright yellow Kodak processing boxes, the Weiss films begin to tell their story, begin to narrate, before they run. The collection consists of eight boxed, addressed, and labeled fifty-foot reels, all on their original blue-and-white Kodachrome spools. One film in the collection is boxless, though the spool is marked "Trip to Spain and English Countryside." All of the films are shot abroad in the 1960s except, critically I think, one. This film, postmarked May 1970, is labeled "Baby Robert March 1970, no good, very poor" (http://www.archive.org/stream/home_movies_misc/weiss_reel_8_256kb.MP4).

This is also the only box in the collection addressed, not to "Mr. Irving Weiss, USOM—APO 146, San Francisco, Calif.," but to "Mrs. I. Weiss, 1200 So. Courthouse Rd., Arlington VA 22304." As with our first family, the implication of "home" and its visibility are centrally important, marking here not the beginning or end of "the trip" but perhaps the end of the camera's usefulness to the Weiss family and the end of their own breathlessly documented mobility. The film's content, its address, and the value judgments its labeler passes on it are also intriguing for their assumptions with regard to gender and the cinematographic interest of the domestic in, as it were, its "natural habitat." The film, as its scribbled label suggests, is very poor indeed, yielding shot after shot of underexposed and barely visible footage. It is, however, no more or less cinematically "competent" than the other films in the collection, which are often similarly under- or overexposed, poorly composed, or wobbly. Exotic subject matter, it seems, affords a degree of aesthetic tolerance, at least for the Weiss family labeler.

The address on the boxes is, of course, an important detail. Irving Weiss was part of the United States Operations Mission (USOM), an arm of the Agency for International

Development active in Vietnam in the 1960s.[30] His travel footage, shot largely in Asia, bears the mark of leisure in the midst of "official duty." It is abrupt and desperately synecdochical, parts of a family and parts of journeys standing in for their larger and, perhaps even more chaotic totals. The fractional units of each fifty-foot reel, in the end, bear more significance than they can possibly carry.

The Weiss family was explicit, if slightly haphazard, in their labeling, traits that find their analogue in their cinematic and touristic decisions as well. Reel #4 in the collection is labeled "Thailand; Monkeys; Trip to Sukathai, Beginning of Joe's Trip" (http://www.archive.org/stream/home_movies_misc/weiss_reel_4_256kb.MP4).[31] The reel is implausibly full, and is also labeled, in a manner befitting the family's cinematic preoccupations, with the family name — a luxury not always encountered. Joe, who appears in the film briefly with an unidentified young woman, presumably borrows his parents' camera toward the end of his visit in Thailand, recording his own travels in Turkey, Sweden, and Norway. Again, my semifanciful proclamation above that these fifty-foot reels are being stretched thin is illustrated by what I take to be the Weiss family's attempts to find on the surface of these reels some connective tissue. Moving in disparate directions and at separate times, members of the Weiss family share, presumably, not only the camera but select fifty-foot reels. As a unit, they exist *on film* and with the promise (fulfilled or not) of future, collective exhibitions.

Amateur cinematography manuals emphasize the importance of capturing local flora and fauna, which the Weiss family does from the outset. Monkeys and other playful or resting animals establish a degree of otherness on this Thailand reel before any human beings enter the mise-en-scène. There is a cut to a group of onlookers and another pair of cuts indicate that these onlookers are witnessing a performance. A cut to a curiously composed goat is followed by a shot of a young man emerging from a building. A pan up on the building sets into motion an aesthetic decision that will mark the Weiss family collection from this point forward: pans up, especially on exotic architectural structures, will be dizzily repeated throughout — as will carefully composed shots of the family, with these structures in the background.

What's remarkable about the Weisses' collective aesthetic, however, is its breathless rapidity, as the number of cuts above might indicate.

Save for the pans and occasional shots of movement, their films resemble, more than anything, a slide show. A child saluting our cinematographer and our cinematographer's wife gazing into the camera's eye as she adjusts her earring in front of a seated Buddha remind us of our camera

operator's aggressive presence; but his aesthetic, his near Eisensteinian montage, was doing the same prior to these acknowledgments.

Shots of military activity, especially butted as they are against the shot of the saluting child, are a bit disconcerting, even if musical instruments are clearly visible in the distance. Then, from this scrutiny of the group, we cut to a lone child running across a field, and cut again to two grown men saluting each other. Mr. Weiss, it seems, is writing a cinematic essay on the politics of authority where his own authorship, and the implied authorship of his highly mobile familial unit plays a central role.

As the family wearily ascends an endless set of stairs in a physical realization of the vertical pan, the need for better lighting conditions becomes apparent. The cutting becomes more aggressive as the camera seems to float from location to location, panning across landscapes in a manner that surely would have agitated the manual writers to no end. Then, the camera lingers on a beautifully canted if poorly lit Buddha; here, and elsewhere, shots of statuary and/or architecture serve to indicate place. Whether traveling in Asia or Europe, the Weiss family films focus on differences in dress, architecture, custom, and landscape in a manner that seems to descend from *National Geographic,* a healthy run of which was also priced to move at the Weiss family estate sale.

Reel #2 (http://www.archive.org/stream/home_movies_misc/weiss_reel_2_256kb.MP4), an unusually marked reel (its yellow box, besides the usual address, bears no other identifying characteristics except for a lightly penciled "?"), is interesting for its fascination with alternative modes of transport. In fact, the reel joins nicely with reel #3, titled "Klong trip" (http://www.archive.org/stream/home_movies_misc/weiss_reel_3_256kb.MP4). A *Klong* (or, more correctly, a *Khlong*) is a narrow canal, like those found in Venice; they and the floating markets that travel them remain popular tourist attractions to this day. Our "?" reel ends as the family's Khlong journey begins.

The "?" reel begins in typical fashion with some footage taken from a moving vehicle—the compositions would suggest that the images were shot from the top of an open-air bus. The footage then cuts between images of ornate temple architecture and golden Buddhas in various postures. These, once again, are our images of difference. They are followed immediately by images of the family and what appear to be several other USOM familes, picnicking under an enclosure at the foot of a wooden bridge complete with bottled Coca-Cola, a dog, and a red-and-white metal cooler boldy named "The Pleasure Chest Pal." Although more remote and more rapid than our first family, the Weiss family is establishing a similar rhythmic structure that alternates between images that establish the "otherness" of location and images of "the comforts of home." The picnic

Figure 5: The familiar found. The Weiss family Khlong trip pauses for a commercial interruption.

footage is followed immediately by slightly less than five seconds of what appears to be a street celebration of some sort, followed by a shot of a sign, in English, announcing their arrival at the offices for Rock Cottages, and a pan across to, presumably, one of these cottages. Like our first family, the Weiss family (here and throughout the collection) positons images of familiarity and comfort next to images of difference. The remaining minute of film is shot from the deck of a boat making its way through the canals, capitalizing, like the "Klong Trip" reel, on an unfamiliar mode of transportaion. That "Klong Trip" ends, however, with images of Thai children seated around a flickering television indicates the draw of the familiar, even in the most unusual settings.

All told, both families' films begin to take on the aesthetic logic of the journeys they record. Our first family emphasizes the "getting there," stutters toward its goal, and pauses. Our second family is intriguing because of its businesslike abruptness. We are suddenly in Asia, and certain carefully selected icons of "otherness," artfully composed and furiously pieced together through in-camera edits, signify the "whole" of the journey itself—signify, in fact, the whole of the land and its people.

As much as these films assert some notion of the places they record, they also, perhaps puzzlingly, assert a notion of their cinematographers' temporal and geographical place.

The leisure of our first family and their ability to transplant their "home life" from Maryland to Florida is indicative of a postwar American culture in the midst of reclaiming itself and its nation. Their films depict a family *at home anywhere within our national borders,* though the trips to California and Florida do carry with them a certain air of awe with regard to what lies beyond the ocean's horizon.

Our second family, because they were shooting in Asian countries around the time of the Vietnam War, might invite claims of imperialism (the saluting child underlines this possible reading). The camera's lingering scrutiny over "Asian" signifiers — reduced, in most cases, to Buddhist statuary — and its insistence on documenting the family itself, posing next to these landmarks, is a holdover from still photography, certainly. But it is also, as Patricia Zimmermann has indicated, perfectly reflective of our postwar cultural values. Zimmermann quotes from a 1956 *Parents Magazine* article entitled "Better Vacation Movies": "Whether you spend your vacation at the beach or in the mountains, it isn't *the beauty of the place* that makes the picture good — *it's your family's response to it.*" Zimmermann sums up, positing that, "by the 1950s travel home movies, at least in the eyes of journalists, unmasked the penultimate expression of family togetherness."[32]

Although they define it differently and from dissimilar geographical and historical vantage points, both families are engaged in preserving their displays of familial unity. These acts are exhibited as the families travel, again as the films are screened at home — to those unsuspecting acquaintances Leo Salkin writes of — and, weirdly, are on display once again today in my scrutiny of them here and my depositing of them in the virtual space of the Internet Archive. They form a complex observational aesthetic that is at once artless and poetic, rebellious and conformist. In part because these camera operators defied the logic being fed them through brochures, instruction manuals, and magazines, our amateur cinematographers used the camera as they used their eyes, forming as they shot a record of their own curiously divergent priorities.

NOTES

An early version of this article was first presented at the *Orphan Film Symposium* in Columbia, South Carolina, in March 2004. That presentation and this article would not have been possible without the generous assistance of Skip Elsheimer, Raleigh, North Carolina's own A/V Geek, who digitized the images and made them available to Internet archivists. Snowden Becker at the Academy Film Archive answered technical questions and provided much encouragement. Thanks also to Marsha Orgeron for collecting with me and for her critical eye.

1. These films have all been digitized and are available online at the Internet Archive: http://www.archive.org/details/home_movies_misc. Within the article, I have included individual URLs for the streaming video files of the central films under discussion, though I do encourage readers to examine all of the films. The Internet has made studying home movies all the more feasible, since the films themselves may now be easily shared with a limitless audience. Melinda Stone and Dan Streible's introduction to *Film History*'s special issue on small-gauge and amateur film says it most succinctly: "Reading does not suffice. If you are curious about the unusual and almost forgotten films described here, we advocate seeing them for yourself" ("Introduction: Small-Gauge and Amateur Film," *Film History* 15, no. 2 [2003]: 125). While it is perhaps the subject of another essay entirely, one of the anonymous readers for *The Moving Image* has made me aware of an issue that must, however briefly, be acknowledged here. Availability, of course, changes the critical process in interesting ways, making visible the always-presumed but typically underplayed discrepancies between what the critic "argues," what the amateur cinematographer "intended," and what the contemporary viewer at large "sees." I think that this is a positive development and one that calls into question our desire to fix meaning at the point of critical intervention. That these images can *mean* differently, that they can continue to signify is what makes them especially worthy of our various engagements.

2. These films and all of the films discussed in this essay are regular 8mm reversal films as opposed to Super 8mm. That the Weiss family, whose footage extends into the 1970s, continued to produce in what was becoming an outmoded amateur motion picture format coincides interestingly with their commitment to the familiar more generally, a commitment that forms the center of the family's particular cinematic logic.

3. Patricia Zimmerman, *Reel Families: A Social History of Amateur Film* (Bloomington: Indiana University Press, 1995), xv.

4. Walter Benjamin, "Unpacking My Library," in *Illuminations*, trans. Harry Zohn, ed. Hannah Arendt (New York: Schocken, 1968), 61.

5. Susan Sontag, *On Photography* (New York: Farrar, Straus and Giroux, 1977), 3.

6. Ibid., 77. I should note, too, that, like so many of Sontag's statements in *On Photography*, this one's elegant economy masks what is, at best, its controversial logic. Especially when applied to amateur practice (still and moving), "systems" emerge. Of critical importance for our purposes, however, is the space between "the system" *in practice* (evidenced by the films themselves, which are unusually consistent—systematic, even) and "the system" in theory. Patricia Erens argues that, "as others have noted, there is a great deal of commonality in the poses and events photographed. Though we are supposedly free to photograph whatever we like, in reality, we don't." See Patricia Erens, "Galler Home Movies: A Case Study," *The Journal of Film and Video* 38, no. 3/4 (Summer–Fall 1986): 15.

7. The centrality of travel to the amateur filmmaker stems, no doubt, in part from the fact that travel itself has been with the cinema since its inception. See Tom Gunning's "New Thresholds of Vision: Instantaneous Photography

and the Early Cinema of Lumière," in *Impossible Presence: Surface and Screen in the Photogenic Era*, ed. Terry Smith, 72–99 (Chicago: University of Chicago Press, 2001), for an excellent discussion of the amateur roots of the Lumière films that addresses the idea of presenting the world to viewers that moves well beyond the travel implications of trains entering or exiting stations. See, too, Charles Musser, "The Travel Genre in 1903–1904: Moving Towards Fictional Narrative," in *Early Cinema: Space, Frame, Narrative*, ed. Thomas Elsaesser, 123–32 (London: BFI Publishing, 1990), for a detailed and specific historical account of early cinema's narrative alliance with the idea of travel.

8. See, for example, Heather Norris Nicholson, "Telling Travelers' Tales: The World through Home Movies" (in *Engaging Film: Geographies of Mobility and Identity*, ed. Tim Cresswell and Deborah Dixon, 49–68 [Oxford: Rowman and Littlefield Publishers, 2002]), for a recent, smartly researched, and engaging examination of British amateur Charles Chislet's skillful and widely screened travel films, produced from the 1930s to the 1960s; Heather Norris Nicholson, "British Holiday Films of the Mediterranean: At Home and Abroad with Home Movies, ca. 1925–1936" (*Film History* 15, no. 2 [2003]: 152–65), for an exploration of British films recording cruises within the Mediterranean; Richard Chalfen, *Snapshot Versions of Life* (Bowling Green: Bowling Green State University Press, 1987), for an anthropological examination of what the author calls "home-mode" communication that returns repeatedly to the role travel has consistently played in it; and Alan Kattelle, *Home Movies: A History of the American Industry, 1897–1979* (Nashua: Transition Publishing, 2000), for a detailed, popular account of all things "home movies" that, rather like Chalfen's analysis, gives considerable attention to the centrality of travel and provides statistics. Kattelle's research, based on a sampling of two hundred films, indicates that the Amateur Cinema League's second favorite type of film was the travel film, which accounts for 23 percent of their award-winning selections between 1930 and 1954—beat out, as it was, by the documentary category, which was, as Kattelle indicates, also frequently travel based. Patricia Zimmermann, in *Reel Families*, also zeroes in on the importance of travel, engaged as her study is with the industrial literature of the home-movie era, which was similarly concerned. Her chapter on the period from 1950 to 1962, toward the end, closely examines the travel footage of Ethel Cutler Freeman, shot in the winter of 1949–50.

9. Specifically addressing the camera's centrality to popular notions of travel, for example, Sontag writes, "Faced with the awesome spread and alienness of a newly settled continent, people wielded cameras as a way of taking possession of the places they visited. Kodak put signs at the entrances of many towns listing what to photograph. Signs marked the places in national parks where visitors should stand with their cameras" (*On Photography*, 65).

10. My use of the word *exhibition* here is admittedly complicated. What Richard Chalfen has referred to as "home mode" image making is by definition bound by its insularity. The audience, in other words, will more often than not be the participants themselves. Zimmermann has been critical of the home movie's *micro*-memorial capacity, writing that "home movies for

memory documentation veered into the family equivalent of bomb shelters for civil defense—insurance against the insecurities of the future" (*Reel Families*, 134).

11. Making a point of the editorial deficiencies of home movies has become something of an amateur film scholarship rite of passage. Chalfen considers the reasons behind this acknowledged lack: "Two reasons come to mind for [the lack of editing]. First, it may represent an unwelcome intrusion of work into what is classified by most people as 'play.' Or second, editing is unpopular because it does not share the social qualities that underlie the other events. One guide book stresses the solitary nature of editing as follows: 'Do try to get people to leave you alone while you're editing a film; that includes your family. It may take hours, or days, or weeks. However long, the process needs a lot of thought to be carried out successfully. *Uninterrupted* thought'" (Chalfen, *Snapshot Versions of Life*, 55).

12. This attention to the quotidian is inherited by a generation of international modernist filmmakers who, from the beginning of the 1960s through the 1970s, also found themselves roadbound. The critical, though typically neglected, domestic vein running through these films, their constant attempts to articulate a generation's shifting relationship to the notions of family, home, and community, descend in marked ways from an amateur tradition that only appears transparent. See, for example, Arthur Penn's *Bonnie and Clyde* (1967), Dennis Hopper's *Easy Rider* (1969), Monte Hellman's *Two-Lane Blacktop* (1971), and Wim Wenders's *Kings of the Road* (1976).

13. Benjamin, "Unpacking My Library," 67.

14. Zimmermann's bomb shelter metaphor (see note 10) is all the more relevant in this light. In their reinforced steel boxes, often in the basements of houses alongside other forgotten and/or obsolete objects, 8mm films seem to be hiding with their heads covered and typically emerge to a world greatly changed.

15. Like and usually related to statements regarding editing in these films, variations on this point are repeated across the body of amateur and small-gauge scholarly literature. See, for example, Patricia Erens who, in "The Galler Home Movies," refers very subtly and in a manner that underscores the complexities involved in such qualifiers, to "mistakes" in the films (Erens, "The Galler Home Movies," 16). Zimmerman, in *Reel Families*, offers a sustained analysis of the amateur's relationship to "official" modes of production.

16. Patrica Erens's "The Galler Home Movies" comes closest in this regard in its close attention to a wide historical sampling of films produced by one amateur family and their "evolving" aesthetic sensibilities.

17. Frederic Foster, "Make Your Movie Tell a Story" *Home Movies* 11, no. 1 (January 1944): 13.

18. Ibid., 40.

19. See David Cook, *A History of Narrative Film*, 4th ed. (New York: W. W. Norton, 2004), 371–74, for more on Hollywood's struggle to maintain its momentum in the years just following the war. As Cook indicates, 1946, with its record-breaking profits, brought with it a degree of confidence that, only months later, would be dashed as the studios scrambled to regroup.

20. The ad appears in *Home Movies* 11, no. 3 (March 1944), inside front cover.

21. Foster, "Make Your Movie Tell a Story," 13

22. Zimmermann, *Reel Families*, 74.

23. As Zimmerman indicates, "The advent of television and the postwar decline in movie attendance emboldened Hollywood to change its marketing emphasis from a belief that good pictures would attract audiences to a conviction that modern audiences desired technical novelties" (*Reel Families*, 119). It seems, however, that even more than technical novelties, American audiences wanted and would, by the 1960s, be greeted with *narrative* novelties and a steady move toward a decidedly non-Hollywood realist frame. That this frame has European roots, both in practice and in theory, is undeniable. That these roots shared space with and in fact themselves learned from "amateur" modes of production is arguable, but perhaps more interesting. Robert Sklar, in discussing the postwar decline in movie patronage, suggests that: "there has been more speculation than data on why movie patronage had begun to slip even before the impact of television, but it seems likely that the postwar spurt in the birth rate (the late 1940s 'baby boom,' during which young adults committed their time and money to home and family-building) led this prime consuming group to curtail its moviegoing habits." And, while it is precisely the type of speculation Sklar worries about, it seems likely—and Zimmermann's research seems to support this idea—that the American family was busy packaging and consuming itself during these years. Hollywood's miscalculation, it seems, was its assumption that the family as *subject* would win back its audience when, in fact, it was their mode of production that would, by the 1960s, appeal to a youth culture weaned on it. See Robert Sklar, *Movie Made America: A Cultural History of American Movies* (New York: Vintage Books, 1975), 274.

24. Leo Salkin, *Story-Telling: Home Movies: How to Make Them* (New York: McGraw Hill, 1958), 13.

25. Ibid.

26. Eastman Kodak Company, *How to Make Good Movies: A Non-technical Handbook for Those Considering the Ownership of an Amateur Movie Camera and for Those Already Actively Engaged in Movie Making Who Want to Improve the Interest and Quality of Their Personal Film Records* (Rochester: Eastman Kodak Company, n.d.): 27. Eastman Kodak produced variations on this manual from 1938 to 1958, changing bits and pieces of the title as they did so. These title changes are difficult to trace historically, however, because the books themselves are undated. At some point, however, the company moved from referring to "personal film records" to simply "films." Some of these changes may well indicate the company's perceived market. After 1958, the bestselling book was called *How to Make Good Home Movies* (emphasis mine), and in the 1970s, *How to Make Good Sound Movies*. For more on the extensive literature of the American home movie industry, see Kattelle, *Home Movies*, 248–64.

27. Chalfen, *Snapshot Versions of Life*, 129.

28. Gregg's Trail, named after trailblazer Josiah Gregg, was one of a number of similar Gold Rush arteries built before 1849.

29. Chalfen, *Snapshot Versions of Life*, 64.

30. The "APO" in his address stands for "Army Post Office."

31. Unlike the previously discussed collection, the Weiss family did not number their films. I have given them numbers here, in as chronological a fashion as possible, to aid in the clarity of my references for those who wish to view the films online.

32. Zimmermann, *Reel Families*, 135.

My Saga of the Newly Discovered Estate of Erich von Stroheim

RICK SCHMIDLIN

INTRODUCTION

According to Erich von Stroheim's first biographer, Peter Noble, the famed director was born in Vienna in 1885 as Erich Oswald Hans Carl Marie Stroheim von Nordenwald, the son of Colonel Frederick von Nordenwald of the Sixth Regiment of the Royal Dragoons of the Austro-Hungarian Empire, while his mother was a lady-in-waiting to Empress Elisabeth of Austria, the wife of Emperor Franz Josef I.[1] A few years later, Thomas Quinn Curtiss, von Sroheim's second biographer, repeated the story, only this time his mother was the sister of Franz Josef's Imperial Counsellor, Emil Bondy, while Erich attended elite Austrian officer academies.[2] Thus, one generation of film historian after another repeated many the legends Erich von Stroheim had himself created, in order to cover his modest beginnings as the son of a Jewish hat maker and shopkeeper, Benno Stroheim, and his Prague-born Jewish mother, Johanna Bondy. Just when Erich Stroheim came to the United States and transformed himself into Austrian royalty was a matter of speculation.[3] Getting at the truth proved to be elusive indeed because of a lack of surviving documents. All that changed in 1999.

This report explains how I discovered the personal documents of Erich von Stroheim and how they were placed on deposit at the Margaret Herrick Library. My goal is to describe the process from the original discovery of the estate in various parts of the world to how this project of recovery was fully realized, thus giving film historians and scholars access to material about the life and working practice of Eric von Stroheim that had, until now, been unknown. Finally I will discuss some of the ethical issues involved in my quest and my hopes for future academic research.

In 1999, I produced a reconstruction of Erich von Stroheim's 1924 classic *Greed*. It was during that time that I became friends with Erich von Stroheim's son, Josef von Stroheim. Josef shared with me many memories of his father and introduced me to Mary Alice von Stroheim, the widow of his half brother, Erich von Stroheim Jr. Mary Alice then told me about Jacqueline Keener, whose sister, Denise Vernac, was Erich von Stroheim's living companion in Paris the last years of his life. It was on their estate outside Paris where much of Erich von Stroheim's personal belongings remained, hidden for decades after his death in 1957. Not until my visit to Jacqueline Keener in 2000 did this material once again surface.

Going through the estate collection of Erich von Stroheim, I realized that I had the privilege of seeing what no other film historian had. I was amazed by the quantity and quality of this important historical material, and I couldn't believe that it existed in such a complete form. I also realized that, sooner or later, this material had to be placed in a public institution, which would make it accessible to those interested in the career of Erich von Stroheim. After returning to Los Angeles, I met with officials from the Academy of Motion Picture Arts and Sciences. Thus, it came about that fourteen boxes, containing more than three thousand photographs and hundreds of rare documents, eventually found their way to the Margaret Herrick Library. What can now be discovered at the Herrick is the most comprehensive collection of von Stroheim material in existence; a traveling exhibition detailing

the life and work of Erich von Stroheim has also been on tour. This report serves as an introduction to origins of this wonderfully rich material.

THE SAGA

This epic saga started when I was producing the reconstruction of *Greed* (1924) for Turner Classic Movies in the spring of 1999. During that time, I was informed by my consulting editor Carol Littleton that I should probably contact Joseph von Stroheim, who was a retired sound editor and resided in the San Fernando Valley. I was surprised, because I didn't know any of Erich von Stroheim's children were alive. I was of course looking for any missing links I could find about *Greed*. Carol gave me his phone number, telling me he was very well liked among his fellow sound editors and was known by colleagues as "'Joe Von." So, one evening in April 1999 I called Joe from my Hollywood apartment. I left a message on his answering machine, stating who I was and asking him to return my call. A little while later Joe called, just as I was draining the water from my pasta. Cradling the phone to my ear with excitement, I was totally in disbelief that I was talking to the son of Erich von Stroheim. I got so excited I burnt my wrist draining the water, while he told me he was wearing the famed bracelet his father wore in almost every film he directed or appeared in. I thought to myself, what other hidden treasures might there be? Joe told me he might have some things of interest "'in the attic'" and invited me for a visit. I have always loved field trips with attics to explore, and this seemed to be the ultimate adventure for an obsessed cinephile!

A few days later I was sitting in the comfortable living room of Joseph and Harriet von Stroheim. Joe resided in a nice tract house at the end of a cul-de-sac, a few blocks from Coldwater and Victory Boulevards in the San Fernando Valley. He was a jovial man with thick white hair and proudly sported a mustache; he loved a good joke and good laugh. Apart from being Erich von Stroheim's son, he'd had his own fascinating Hollywood career. According to Joseph, his father started courting Valerie Germonprez, a young actress, in 1918, and they

married on October 16, 1920, in St. Brendan's Church in Los Angeles. On September 18, 1922, their son Joseph was born. As a sound editor, he worked on everything from Republic westerns to television shows like "The Untouchables" (1959) to features like *The Getaway* (1972) and the Streisand/Peters remake of *A Star is Born* (1976). Obviously, Joe's career had been very different than his father's, and he really had little interest in his father's films. He would say that all he knew about Erich von Stroheim was that the director was his daddy, but that was not totally true, as I would find out! After paying many visits to the son, I was able to unlock the doors that provided me access into the world of Erich von Stroheim, a world no other film historian had ever entered.

As I was working on the reconstruction of *Greed,* I was getting a very personal understanding of von Stroheim through his son's reflections. While Joe could not provide insight into his father's working life, he could give von Stroheim flesh and blood through his memory of his father's words. Erich von Stroheim called his son "Poopsy" and in later letters reflects that the days with his "baby boy" were the best of his life. I learned that Erich loved to spend afternoons in the back yard at his former Brentwood residence shirtless in the sun. He also enjoyed Sunday afternoons with Maureen O'Sullivan and John Farrow, who lived across the street, sipping cocktails and enjoying the halcyon days of Hollywood. I discovered that during the 1920s, when the director was at his most productive, the most important thing in Erich's life was his son, whom he adored. If there was a party at the von Stroheims and it was time for "Poopsy" to go to bed, Erich would leave the festivities and creep upstairs to lie beside his son until he went to sleep. There was much insight that Joe could provide, even if it did not pertain to the ongoing reconstruction of *Greed*.

For weeks I would visit with Joe in the afternoon. Then, one day in mid-May 1999, he asked if I wanted to see what he had in the attic. As you can expect, I was delighted to have the opportunity to finally see the attic that housed his family heirlooms and personal items. No historian or scholar had ever been privileged to see these items, which included

drawings, letters, photographs, and other personal documents. They revealed many aspects of his father's life, spanning the years of Valerie and Erich's marriage, as well as much correspondence after they permanently separated in 1939. Joe also brought out family photo albums, but it was disturbing to find that many photographs had been taken from these albums, as if someone had pilfered the neatly bound books. Almost all the photographs that had Erich in them were missing. Unfortunately, I did not find any further material on *Greed*. What I did not realize was that there was the entire family history of Erich von Stroheim yet to be discovered, that is, all the family photos from Joe's youth in Brentwood in the 1920s and 1930s. Hanging in the living room was also a French Legion of Honor medal and certificate that Erich had been awarded on his deathbed in Maupaus, France, in May 1957.

Among the discoveries in Joe von Stroheim's collection were a postcard from the United States Department of War, Notice of Classification for Erich O. von Stroheim, 4418 Prospect Avenue, dated September 1918; a photo of Valerie Germonprez taken in 1918, when she first met Erich; the engagement portrait of Erich and Valerie, taken in Chicago on the way back from the New York premiere of *The Devil's Passkey* (1918); Erich von Stroheim and Valerie Germonprez's marriage license, dated September 16, 1920; a postcard of Sanjaninto from White Water, California, near Palm Springs, with von Stroheim's handwritten note, "Location of Alps from L. J."; a drawing of an Alpine house, possibly an early set design from *Blind Husbands* (1919); a letter from the War Department, asking for a statement from Erich Oswald von Stroheim in regards to his status as enemy alien, dated May 1925; a card filled out by Erich Oswald Hans Maria von Stroheim on June 2, 1925, for a hearing on September 25, 1925, regarding his citizenship; Erich's Certificate of Naturalization, dated February 19, 1926; a photo of Joseph and Erich on the set of *Fireman, Save My Child* (1927) with Wallace Beery; a photographic portrait of Erich, Joe, and Valerie, taken by Melbourne Spurr, as well as numerous proofs from the Spurr Studio on Wilshire Boulevard; a beautiful photograph of Erich and Joe on a boat at Catalina Island in the late 1920s; the Foreign Service list of passengers for the French Line, dated August 1, 1930; a small photo of Joe, Erich, and their driver with a touring car in the mountains; some wonderful color drawings by Erich of his family in their touring car; Erich's drawing of Santa Rita; a hand drawing of Pope Pius XI with two guards; a hand drawing of an Italian Carabinieri; a postcard of Joe and Erich at the Roman Zoo; two tickets for Monte Carlo beach for Erich's birthday on September 22, 1930; Valerie's postcard from Monte Carlo, addressed but not sent to Mr. and Mrs. J. Duffy, discussing their visit with Rex Ingram.

What a day it was! No, I didn't find the lost reels of *Greed,* but treasures nevertheless. As we looked at the drawings, Joe told me of his vacation to Europe in 1930 with his parents. He said that his father's best friend was Father John O'Donnel, a priest in Culver City. Erich presented himself as a devout Roman Catholic to his family and this explained a lot about the religious structure in his films. While Joe loved telling stories about his days as a sound editor and combat photographer during World War II, he would eventually start to candidly reminisce about his father. As my relationship with Joe deepened, and I examined more of the many fascinating personal items, I started to learn more about Erich von Stroheim. This helped me turn my reconstruction into an even a more meaningful project than I had expected.

In June 1999, I received another unexpected surprise. Joe told me he had been in contact with the son of his half brother, Erich von Stroheim Jr., and his wife Mary Alice von Stroheim. The latter was in fact still alive and resided in Bel Air. Joseph said he had her phone number and called to make a formal introduction over the phone.

The next weekend I was at the home of Mary Alice von Stroheim on Stradello Drive in Bel Air, where she had resided since the 1950s. Mary Alice was the second wife of Erich von Stroheim Jr., who was the only son of May Jones, Erich's first girlfriend in America. Erich and May met in New York City in 1909 and married in California in 1916. Mary Alice met Erich Jr. in the late 1940s, when her husband reunited with his father after many years of estrangement. Interestingly, Mary Alice von Stroheim knew a lot about Erich Sr., having had a long

Erich von Stroheim and Angie Adams in "Arsenic and Old Lace"

LYCEUM THEATRE PROGRAM

Lyceum Threatre program for *Arsenic and Old Lace*, courtesy of the Margaret Herrick Library, Academy of Motion Picture Arts and Sciences

correspondence with him and Denise Vernac in the 1950s. Mary Alice mentioned to me two boxes that Erich Sr. left to her and her husband's care after the filming of *Sunset Blvd.* (1950). She stated that the boxes had been in storage in the garage for decades, that she had never really been through them but thought they might be of interest. Mary Alice also told me she had many letters and other items, such as a few old scrapbooks. Friends of hers had suggested years ago that the silent film historian Anthony Slide should take a look, but at

the time she had no interest in allowing anybody to look through the contents. Again, as I went through these previously unknown parts of the von Stroheim estate, I found nothing of importance about *Greed,* but I did find information that would answer some of the questions scholars had posed about Erich's past, in particular about his first marriage to May Jones. During the summer of 1999, I spent numerous Sundays having a lunch prepared by Mary Alice, while examining all I desired to see.

One of the greatest discoveries was a group of original photographs of Erich and his family in Austria, including shots of von Stroheim as an infant; photographs of his father Benno Stroheim, taken in Frankfurt and in Trieste in the late 1800s; a lovely photograph of his mother, Johanna Bondy, taken in Prague before her marriage; an original photograph of Johanna Stroheim and Erich as a young boy; a rare photograph of May Jones (circa 1910); and a collection of eight postcards written by Erich to May Jones and her mother, dating from 1911, which revealed Erich's first reflections on being in America. Here is Erich's first known written account to May Jones:

> Dear May,
> This is the most terrible Saturday since I am here in America. All—all alone, of course I did not know what to do—I went to "Pabst" a place where I could dream about the past 6 months.[4] But it is no good at all for me to dream. I must wake up. Help me!!!
> Love Erich

I also found a travel itinerary of May Jones's trip from Chicago to Los Angeles, dated June 21, 1916; a postcard from Carl Laemmle to Erich from Karlsbad-Speudel; Erich's Certificate of Naturalization, dated February 19, 1926; telegrams from Albert Einstein, dated December 24, 1933, and February 5, 1934; the U.S. Foreign Service "Report of the Death of an American," dated June 6, 1957; a telegram from Denise Vernac to Erich Jr., informing him of his father's death; a French death certificate, dated May 12, 1957; many colorful costume sketches by Erich for unreleased film projects; two pages from a notebook, labeled "Property of Erich von Stroheim," with German insignias; plus May Jones's wonderful scrapbook that she kept on

Erich (1916–1921). When I told Richard Koszarski, who was my consultant on *Greed,* about these discoveries, he decided to rewrite a new edition of his book, *The Man You Love to Hate,*[5] using much of the new material.

My completed reconstruction of *Greed* was presented in October 1999 at Le Giornate del Cinema Muto in Sacile, Italy. While there, I talked to Lorenzo Cordelli and Livio Jacob, two of the Giornate's organizers, about the material I found at the von Stroheim homes in Los Angeles. We decided that I would curate an exhibition based on this material for the Giornate del Cinema Muto in 2000. When I came to Los Angeles, I informed both Mary Alice and Joseph about this project and asked for their permission to present their material. I also asked Joseph and his wife Harriet, on behalf of the Giornate, if they would like to attend the event, and they agreed. In April 2000, I traveled to Gemona, Italy, in order to personally deliver the precious exhibition materials to Italy and to start laying out the show. Informing Mary Alice about my trip, she mentioned Jacqueline Keener, who lived on an estate outside Paris that Erich von Stroheim had shared with her sister, Denise Vernac, the last years of his life. She suggested I should contact her while in Europe and said she would call to introduce me.

APRIL IN PARIS

I went to Gemona in April 2000, and all went well with the planning of the exhibition. I told them I might find more, but they said we already had more then enough and there might even have to be a second exhibit at later date. So, after a wonderful week in Gemona at the foot of the Dolomite Mountains, I was off to Paris. I arrived in Paris in the pouring rain. April in Paris *alone* is no picnic, rain or not! I was actually able to finance this side trip through Warner Bros., which agreed to cover the expense, since I was to meet with the French film director Bertrand Tavernier in order to discuss a special DVD edition of *'Round Midnight* (1986), which I might produce. Once in Paris, I contacted Jacqueline Keener and told her that Mary Alice suggested I call. She was a bit hesitant, so I said I was there to visit Bertrand Tavernier and suddenly she was very excited,

inviting me to her home. She said she would meet me at the train station in a bright yellow dress. So, on a rainy day in April, I was on a local train, looking out of the window at the passing suburbs, wondering what I might or might not find.

When I arrived at the station, I was greeted by a charming lady in her eighties. Jacqueline Keener spoke perfect English. She had lived in America with Erich and her sister during World War II and had worked in the perfume department at Desmond's Department Store on Wilshire Boulevard. She would later meet her husband, who was a production manager, and secure a job with Air France. With Erich moving back to France after *Sunset Blvd.,* Jacqueline and her husband also moved to Paris. As we drove to her cottage, which was on Erich von Stroheim's former estate, I couldn't believe I was really there. As we went through an old gated entrance and drove past the old house where Erich had lived, I could almost feel the spirit of many years ago. It was the kind of the feeling William Holden's character had in *Sunset Blvd.* when he first approached Norma Desmond's estate, but this was real! As we arrived at her small cottage there was already a fire burning in the fireplace. Rainy and cold as it was, it felt warm inside. It was a French dream as Jackie (as I came to call her) prepared a roast duck lunch with a great bottle of red wine. She asked how Mary Alice was and related to me her past, and how she missed her sister, Denise. She also talked about Erich and said she recently took her granddaughter to see *Shrek.* The story of the ogre reminded of her of Erich: coarse on the outside but very kind. Jackie then mentioned Thomas Quinn Curtis, one of Erich's biographers, who was very ill. She was upset, because nobody from the old days visited him but herself. The once-famed Paris drama critic for the *International Herald Tribune* was forgotten by all who once knew him. These were the topics of our first contact. She also stated that she initially wasn't going to meet me, but since I knew Bertrand Tavernier and Mary Alice, she thought it might be okay.

After lunch we sat by the fire and she poured some cognac from the region where her daughter-in-law grew up. Jackie said it was special, and indeed it was the best I ever sipped because, as I enjoyed the warm company, the fire, the cognac, she told me to go into the next room and there might be something I would be interested in seeing. There I found boxes of photographic binders and folders filled with papers and more photographs. Upon his passing in 1957, Erich von Stroheim's home office had been packed and placed in storage in the house where Erich had lived. Jacqueline said I was the first to ever see this material. She said that her sister had taken care of the estate but that it once was almost lost: Denise was married to a man in the 1960s, a World War I colonel, who had once had an affair with Gloria Swanson. One day in the mid-1960s, Denise came home from doing some errands and the colonel had a bonfire going in the yard. He was burning all his letters and photographs related to him and Swanson and was ready to burn all of Erich's belongings, too! Denise stopped him and forbid him from ever touching the materials again. As I looked through the binders, the papers, the scripts, and the scrapbooks, I was amazed. Jackie said that someday she wanted to donate this material to some institution but was vague about when or to whom. As the day finished (I had to catch the evening train), we made one more stop. About a quarter of a mile away were the graves of Erich von Stroheim and Denise Vernac. She said von Stroheim was buried on a rainy day just like today and that as the funeral procession approached the cemetery dozens of cows watched. The farmland was now gone and the area developed, but one could feel the past. We made it to the train on time and as I traveled back to Paris, I thought to myself, this collection must be protected.

I remembered the wonderful help that Special Collections Archivist Barbara Hall and Photographic Services Curator Robert Cushman, along with Margaret Herrick Library Director Linda Harris Mehr, had given me when I worked on *Greed.* I also thought about how helpful and accessible the Margaret Herrick Library had been. The Academy of Motion Picture Arts and Sciences could not only preserve film-related material but could also allow historians proper access. Arriving back in Los Angeles, I met with Linda Mehr and Curator Ellen Harrington. I told them that I would like to see if this material could possibly find a per-

manent home at the Margaret Herrick Library. Next, I had a meeting with Bruce Davis, Academy executive director and Ric Robertson, executive administrator. As Bruce entered, he smiled and talked about how he liked *The Great Gabbo* and how much he liked Erich von Stroheim. Ric Robertson loved Orson Welles and enjoyed my reedit of *Touch of Evil*. Together with Linda's and Ellen's track record in helping preserve the cinema's past, this was a dream team. I got the green light to pursue the collection in the name of the Academy. First, as I promised, I sent Jacqueline *Greed* on video, so that she could see my work. Not long after, I got a call from her, saying she loved the tape. I arranged for another visit to Paris, now funded by the Academy. *Greed* seemed to be the deciding factor in having Jacqueline consider a deposit at the Academy, but she also knew Erich had felt betrayed by Hollywood. She was unsure whether America, which had forgotten him when he was alive, deserved the estate. On the Academy's behalf, I was able to invite Jackie to visit the Margaret Herrick Library and meet with Linda and Ellen.

In October 2000, I presented the exhibition "From the Personal Files of Erich von Stroheim" at the *Giornate del Cinema Muto*. I brought Joseph von Stroheim with me, and it was an outstanding success. I was able to share the collections of Joseph von Stroheim and Mary Alice von Stroheim with the scholars who attended. Joseph shared many memories about his father with all who were interested. At the time he was in great health, but sadly within a year Joseph was lost to cancer. In retrospect, the warm reception given to Joseph gave him one of the happiest moments of his life, as he told me not long before he passed away.

On the way back from the Le Giornate, I stopped again in Paris to visit Jackie. I told her of the Academy's interest, and she agreed to come to Los Angeles. Soon Jackie was on a plane to LA, where I met her at LAX with Mary Alice and Mary Alice's son Erich von Stroheim III. A day later she visited the Margaret Herrick Library and was greeted by Linda Mehr, who had made a fantastic coffee cake. Not only could Linda give a knowledgeable tour of the library, she was also a gracious hostess. Jackie agreed to deposit the material with the proviso that after her passing it would pass into the

ownership of the Academy. The next day, Jackie went to the Academy's Wilshire Boulevard office to meet with Ellen and Linda to make arrangements for the transfer of the collection to Los Angeles.

I made one last trip to Paris in October 2002 to pack fourteen boxes, which contained more than 3,500 photographs and hundreds of rare documents. I will never forget the day as long as I live. I had just gotten back from *Le Giornate Del Cinema Muto,* where I had premiered my still reconstruction of *London after Midnight* and had been in damp weather. It was now October and dreary, just like that day in April in Paris when I first discovered the material. On October 22, 2002, my birthday, I was on another train to the former estate of Erich von Stroheim, accompanied this time by friend Sandra Reid, who lives in Paris and is the program director for the New Zealand Film Festival, and my partner Professor Francesca Marini, who helped me in many valuable ways throughout the entire project. I had a bad case of laryngitis (and to some who know me this was a blessing), but I had three days of packing to prepare this material to go to the Margaret Herrick Library. Jackie had again prepared a fantastic lunch and birthday feast. The problem was, we could not arrive before 12 PM and had to be on a train at 5 PM. Each day we had the same routine: a two-hour lunch with wine, which was mandatory, then packing. After three days and still no voice, DHL arrived and Erich von Stroheim's estate went off to Beverly Hills.

It arrived safe and sound, the papers went to Special Collections Archivists Barbara Hall and Val Almendarez who started to catalog the paper collection. The photographic collection went to Photographic Services Curator Robert Cushman, who noted in a letter of support,

> The extraordinary Erich von Stroheim Collection of Still Photographs, now housed at the Academy of Motion Picture Arts and Sciences' Margaret Herrick Library, contains nearly 3,000 items from the personal collection of the great director— surely one of the true giants of film history. These images are exceptionally rare, and many are certainly unique. There are over 800 prints from von Stroheim's masterpiece *Greed* (1924) alone. Other of the

TECHNICAL EXAMINATION
(For operating department applicants or employees)

DIVISION Western

RECORD OF

Name Erich Oswald Hans von Stroheim Age 27

Occupation Assistant Foreman

Hired or Promoted by D AP Date 10 30 12

Previous Experience

No. of inquiries as to record

Educational Test, Date_____ By___%

Technical Examination, } Date_____ By___%

Special Air Brake Exam., } Date_____ By___%

Time Card Examination, } Date_____ By___%

Trial Trip, Date

Seniority, Date 10 30 12 Train

Approved:

ENDORSEMENT OF CHIEF SURGEON

LOCATE ANY DEFECTS OR DEFORMITIES ON THE ABOVE DIAGRAMS.

5'7 15 7
Brown Brown
Dark
Scar over Right Eye

Application for employment with Southern Pacific, courtesy of the Margaret Herrick Library, Academy of Motion Picture Arts and Sciences

master director's films with strong representation include *Blind Husbands* (1919), *Foolish Wives* (1922), *The Merry Widow* (1925), *Queen Kelly* (1929, unreleased in the U.S.), and *The Wedding March* (1928). I have been the Photograph Curator at the Academy Library since 1972, and have never seen anything like this on most of these hugely important films. The rarity, compelling pictorial nature, and importance of these photographs cannot be overestimated.

It was not long after this material arrived that we lost Mary Alice von Stroheim to cancer. She was a wonderful lady, and were it not for her this collection would have never been discovered and preserved. She was a lady full of class and great warmth.

In January 2005, I guest-curated an exhibition, "Erich von Stroheim: A Life Discovered," at the Academy of Motion Picture Arts and Sciences' fourth-floor exhibition hall. In November 2005, I curated an exhibition at the Rheinisches Landesmuseum in Bonn, Germany.[6] My goal was to share the richness of the collection with the world and, with the support of all the aforementioned, this was becoming a reality. Some of the documents from the Erich von Stro-

heim Collection that were on view in the exhibition include a copy of his personnel record with the Southern Pacific Company (1912); a play von Stroheim wrote in 1912; a membership card from the Motion Picture War Services (1918); Erich's Scrapbook #1 (1918–1924), covering *The Hun Within* (1918), *The Heart of Humanity* (1918), and *Blind Husbands* (1919); von Stroheim's first script for *Blind Husbands;* preproduction documents for *Blind Husbands;* Scrapbook #2 (1919), including von Stroheim's sketches for all of the production designs for *Blind Husbands;* a letter from Carl Laemmle, dated February 20, 1920, giving Stroheim a bonus for *Blind Husbands;* a legal copy of a signed employment agreement with Universal Film Manufacturing Company (February 1920); an unsigned employment agreement, dated November 20, 1922, with Goldwyn Picture Corp.; von Stroheims's personal copy of the scenario for *The Merry-Go-Round* (1923); Scrapbook #3 (1922–1924) *Merry-Go-Round;* a letter about budget increases on *Greed,* signed by Abram Lehr (March 16, 1923); a signed agreement with M-G-M (April 14, 1925); a letter from Gladys

Lewis to Will Hayes, dated November 15, 1925, about von Stroheim's "orgies, with certain players"; a letter from Irving Thalberg, firing "Mr. von Stroheim"; a story synopsis for *Queen Kelly* (1928); von Stroheim's contract for *The Honeymoon, The Wedding March, Pt. II; The Wedding March* script (1928); correspondence pertaining to *The Wedding March;* Erich von Stroheim's personal horoscope (1928); a press book for *The Great Gabbo* (1929); a signed agreement for an unrealized remake of *Blind Husbands* (1931); an employment agreement for *The Lost Squadron* (1932); a breakdown of Erich's involvement in *Hello, Sister, Walking Down Broadway* (1933); an original screenplay for *Between Two Women* (1937); von Stroheim's *Arsenic and Old Lace* script (1941);[7] telegrams from Lillian Gish and Boris Karloff regarding *Arsenic;* "The Hun Rides Again," a story Erich wrote in 1941 for *The New York Times;* an invitation to the preview of *Five Graves to Cairo* (1943); Erich's casting suggestions for a story on the Greek gods (1944); correspondence between Peter Noble and Erich von Stroheim (1947 through 1953.); a 1954 letter from Richard Griffith at the Museum of Modern Art, stating the museum had acquired *The Devil's Passkey;* and a letter from Gloria Swanson stating she wanted to make *Sunset Blvd.* as a musical and asking whether von Stroheim would appear in it (March 14, 1955).

The importance for film history of the Erich von Stroheim estate collection cannot be overestimated. Yet, this collection may have ended up in the trash had it not been for some fortuitous encounters and good luck. For forty years after his death, various members of von Stroheim's family kept their materials a secret. One can only speculate, for example, why Jacqueline Keener did not give Thomas Quinn Curtiss access to the material when he wrote his book in the late 1960s, especially since he was apparently a friend. The fact is that survivors of important film industry people seldom consider the materials in their possession of great value, and many collections do end up in garbage bins. Even if they do value the work of their parents, grandparents, uncles, or aunts, survivors are often elderly themselves and are at a loss as how or to whom the boxes of stuff may be transferred. At other times, unscrupulous collectors have taken such materials and attempted to sell them, a practice becoming more frequent with eBay and other Internet sites auctioning film memorabilia. There can be no doubt, however, that such estate collections are best given to public institutions, whether archives such as the Academy's or university special collections. Only then can it be guaranteed that these materials will not only be preserved for posterity but also made accessible to any and all scholars, regardless of the thrust of their research.

My own hope is that now that the Erich von Stroheim estate is accessible in a public institution, it will lead to new research into the career and life of one of this country's greatest filmmakers.

NOTES
1. Peter Noble, *Hollywood Scapegoat: The Biography of Erich von Stroheim* (London: Fortune Press, 1950), 4.
2. Thomas Quinn Curtiss, *Von Stroheim* (New York: Farrar, Straus and Giroux, 1971), 4.
3. As late as 1994, the catalog for the Berlin Filmfestival Retrospective to Erich von Stroheim could not with certainty name a date for his emigration, although they did note that Erich had officially resigned from the Viennese Jewish Community on November 17, 1908, most probably just before leaving Vienna for the United States. See Wolfgang Jacobsen, Helga Belach, Norbert Grob, eds., *Erich von Stroheim* (Berlin: Argon Verlag GmbH, 1994), 275.
4. The Pabst was a drinking establishment, probably serving Pabst Beer, in New York.
5. Richard Koszarski, *The Man You Love to Hate: Erich von Stroheim and Hollywood* (Oxford: Oxford University Press, 1983); revised as *Von: The Life and Films of Erich von Stroheim* (New York: Limelight Editions, 2001).
6. The Bonn exhibition ran under the same title as the Academy exhibit. It was on view from November 20, 2005, to February 12, 2006.
7. The film was eventually made in 1944 by Frank Capra from a script by Julius and Philip Epstein, without von Stroheim receiving any credit.

Silent Film Exhibition and Performative Historiography
The Within Our Gates *Project*

ANNA SIOMOPOULOS AND PATRICIA ZIMMERMANN

Within Our Gates: Revisited and Remixed launched Black History Month in 2004 at Ithaca College in New York, with a newly commissioned score by jazz pianist Fe Nunn for Oscar

Micheaux's landmark silent film *Within Our Gates*. The performance featured live music from a jazz quartet, Baroque clarinet solo, African dancing, and djembe drumming. It also featured digital live mixes and spoken word performances by the Body and Soul Ensemble and the Ida B. Wells Spoken Word Ensemble. On a conceptual level, the project and the performance engaged four central ideas: critical historiography, the new film history, digital culture theory, and collaborative ethnography. The goal of this project was to rethink the exhibition of politically significant silent films and to encourage a contemporary audience to engage critically with one particularly important film, *Within Our Gates* (1920). In order to create a new reception context for a groundbreaking silent film, we used live music, digital technology, and spoken word performance; we hoped that this new presentation of the film would provoke audiences to see the cultural continuities and discontinuities between different technologies, and the political implications that these technologies have at different moments in social history.

Within Our Gates: Revisited and Remixed worked to establish a collaboration between the academic community and local musicians in Ithaca, a town recognized as a vibrant center for a wide range of music. The team comprised an interdisciplinary group of artists and scholars who brought different intellectual and aesthetic skills to the project. Patricia Zimmermann, a film, video, and new-media historian and theorist, conceived of the idea of rescoring a silent film for Black History Month at Ithaca College. One member of the collective, Anna Siomopoulos, had just completed a dissertation on Hollywood cinema and the politics of the 1930s for which she had done extensive research on Micheaux. Drawing on her research, she suggested *Within Our Gates* as a possible project because of its history of censorship, its importance in American film history, and its uncompromising view of black life in the 1920s. To rescore the film, Zimmermann commissioned the musical talents of Fe Nunn, a composer and songwriter who lives in Ithaca.

Other members of the collaborative included Grace An, who had just completed a dissertation using postcolonial theories of cross-cultural visual representation; John Hochheimer,

a scholar of journalism and radio at Ithaca College who possessed a vast knowledge of the history of African American musical forms; and Zachary Williams, a new faculty member in African American studies, a spoken word artist, and a preacher. Finally, four academically trained artists joined our project: Baruch Whitehead, from the School of Music, not only played classical oboe but also had experience in leading black choirs; filmmaking professors Chang Chun and Meg Jamieson helped create the staging and lighting effects for the performance; while Simon Tarr, a filmmaker and digital artist, volunteered to be the project video jockey.

Siomopoulos prepared for the entire team a packet of film history readings from recently published books and journal articles on Micheaux and the history of black film exhibition. During rehearsals, Nunn suggested that everyone involved in the project make his or her own particular contribution to the conception of the event and the final performance. Consequently, the spoken word segments of the production evolved from the collaboration between jazz musicians and academics: the musicians composed musical interpretations of the film, while the academics wrote a spoken word script with the idea of providing historical and theoretical analysis of Micheaux's film, African American cultural history, and the role of technology in the changing contexts of mass media reception. In this way, the music and words had a dialectical relationship to each other; the music released the images from silence and the past, while the spoken word operated as a distancing device to pull the spectator out of the film and into larger historical, theoretical, and critical debates.

Through a collaborative process that was not without conflict, argument, and debate, we attempted to rethink the way that music accompanies silent film screenings. Our performance evoked the improvisational, immersive experience of black theaters on the south side of Chicago in the 1920s. In these venues, live performance of jazz and blues drove the film and inspired audience participation, thus inverting the Hollywood film convention in which music predominantly supports the film narrative and promotes spectator identification. Based on our research into black exhibition practices during the silent period, we decided that the music

for our performance would not function sub-serviently to the filmic text or narrative but as an equal. In other words, we sought to destabi-lize the film text, reanimate film reception, and complicate film spectatorship through music, spoken word, and multiple voices.

The team formed two ensembles to put into practice our reconceptualization of silent film exhibition. Named for the 1925 Micheaux film starring singer and social activist Paul Robeson, the Body and Soul Ensemble was composed of Ithaca College faculty from the departments of journalism, television/radio, cinema, music, and the Center for the Study of Culture, Race, and Ethnicity. Together we worked to create a performance before the screening that would help the audience understand the complex relationship between Micheaux's film and contemporary cultural politics of race. Fol-lowing a digital mix of images from the civil rights movement and African American film, an African dancer performed a dance while accom-panied by a djembe drummer. Next came a short, spoken word segment in which different speakers read quotes from African American cultural history, rap, poetry, and critical theory. The Ida B. Wells Spoken Word Ensemble was a second research and performance group com-prosed of Ithaca College faculty. Named for the black feminist journalist who exposed the hor-rors of lynching, the group collaborated on a script that resembled the spoken word perfor-mance of the Body and Soul Ensemble prelude, in that it similarly combined historical and the-oretical source material. The difference was that the Ida B. Wells script would be read while the film was screened behind the performers; through this juxtaposition of flat-screen and live performance, we hoped to construct a lively dialogue between the technologies and racial politics of past and present.

In the essays that follow, the evolution of the different components of the project is doc-umented. Patricia Zimmermann, the executive producer and guiding spirit of the project as a whole, articulates the performance's theoreti-cal underpinnings, its attempt to rethink silent film exhibition in a digital age. John Hochheimer explains the project's historical relationship to the multiform radio programs of the 1950s and 1960s. Grace An describes the process that shaped the construction and performance of

the spoken word script recited before and during the screening of Micheaux's film. Anna Siomopoulos includes a version of her public lecture on *Within Our Gates, The Birth of a Nation,* and silent film exhibition in black the-aters of the 1920s, a lecture that preceded the performances of both ensembles. And Grace An and Anna Siomopoulos interview Fe Nunn on the musical collaboration that helped gen-erate the film's new score. Also accompanying the dossier are some of Simon Tarr's digital images from the performance of the Body and Soul Ensemble that immediately preceded the silent film screening.

The Birth of a Black Cinema
Race, Reception, and Oscar Micheaux's Within Our Gates

ANNA SIOMOPOULOS

In the last decade, film scholars have focused an increasing amount of critical attention on Oscar Micheaux's 1920 silent film *Within Our Gates* as an important African American re-sponse to D. W. Griffith's notoriously racist film, *The Birth of a Nation* (1915). Oscar Micheaux's landmark film provided a rebuttal to Griffith's depiction of black violence and corruption with a story of the injustices faced by African Amer-icans in a racist society. While Griffith's film represents black male assaults on white female purity, Micheaux's film sets the historical record straight with its depiction of the attempted rape of a black woman by a white man. But the racial reversals in the plot of the film are not the only challenges that *Within Our Gates* poses to Griffith's film. *Within Our Gates* also coun-ters *The Birth of a Nation* in the politics of its aesthetics, specifically in its very different use of parallel editing. Griffith's film uses cross-cutting to present a very simple opposition between white virtue and black villainy; in con-trast, Micheaux's film uses a complex editing pattern to present a larger social vision of many different, competing political positions within both white and African American society. The complicated style of Micheaux's editing works to constitute a spectator who is more politi-cally critical than the spectator constructed by

the classical Hollywood style of Griffith's film. Sequences in Micheaux's film crosscut among five or six different locations and twice as many characters; as a result, Micheaux's film demands an engaged and thoughtful spectator to discern conflicting and contradictory social and political claims about the power structure of race relations in the United States. Moreover, the critical spectatorship constructed by Micheaux's film would have been encouraged by the context of silent film reception in black theaters throughout the country, where live jazz and blues performances did not so much accompany film screenings as compete with them for audience attention and response. In this way, black films and black theaters truly created an alternative cinema, an important and often overlooked tradition of film spectatorship and exhibition in the United States. With a live rescoring of Oscar Micheaux's landmark film, scholars and musicians from Ithaca College and the local community hoped to continue and further that tradition. A multimedia collaboration designed with the intention of encouraging an interactive audience reception, *Within Our Gates: Revisited and Remixed* ac-

cepted Micheaux's challenge to reanimate and rethink the experience of cinema.

As both an aesthetic achievement and a cultural and political intervention, Griffith's infamous white supremacist film has a place in the history of Hollywood cinema. In histories of the aesthetics of Hollywood film, *The Birth of a Nation* is often cited as the first feature-length Hollywood film and as the culmination of Griffith's efforts to establish a set of rules of continuity editing to tell a coherent story of good and evil.[1] While Griffith did not invent the film techniques of the close-up, the insert, and parallel editing, he was one of the first to integrate these techniques into an approach to filmic narrative, one that creates a highly melodramatic fictional landscape in which virtue triumphs over villainy. In *The Birth of a Nation,* Griffith uses all of these cinematic strategies to tell the politically charged story of an honorable Northern white family that historical circumstances have pitted against an equally honorable Southern white family to the benefit of violent, black social groups and political figures. The most often-cited example of Griffith's filmic method of moral storytelling is his use of

Video projection, The *Within Our Gates* Project, courtesy of Simon Tarr

parallel editing at the end of *The Birth of a Nation,* when the Ku Klux Klan rides to rescue both the Stoneman and Cameron families from violently threatening black forces. In this instance of dramatic crosscutting, Griffith constructs a stark moral opposition between heroic whiteness and black corruption. Social critic Walter Lippmann wrote astutely about this scene as an example of the powerful and frequently distorting effect that the movies have on the public's understanding of society, politics, and history:

> In the whole experience of the race there has been no aid to visualisation comparable to the cinema. . . . The shadowy idea becomes vivid; your hazy notion, let us say, of the Ku Klux Klan, thanks to Mr. Griffiths [sic], takes vivid shape, when you see *The Birth of a Nation.* Historically, it may be the wrong shape, morally it may be a pernicious shape, but it is a shape, and I doubt whether anyone who has seen the film and does not know more about the Ku Klux Klan than Mr. Griffiths [sic], will ever hear the name again without seeing those white horsemen.[2]

In no small part due to the powerful simplicity and clarity of the moral opposition established through the crosscutting in the scene of the Klansmen's heroic ride, *The Birth of a Nation* has one of the most nationally significant and politically virulent reception histories in American film. Released on the fiftieth anniversary of the end of the Civil War, the film represents the war between the states as unnecessary and tragic in its outcome. Film critic and cultural historian Linda Williams has persuasively argued that *The Birth of a Nation* effectively used a melodramatic aesthetic to provide a white supremacist response to Harriet Beecher Stowe's *Uncle Tom's Cabin;* by reversing the racial roles of victim and victimizer, Griffith's film helped turn the popular tide against racial equality in the United States.[3] As many historians have argued, the film contributed to the resurgence of the KKK in the late 1910s and to a dramatic rise in the number of white lynchings of African Americans in 1915. The NAACP considered the film so incendiary that it initiated a national campaign to have the film cut or banned altogether by local and state censors. Although the association's activities did manage to get the film banned in eighteen states, the controversy ultimately increased ticket sales, and the film was a huge box office success. Nevertheless, the campaign against the film helped to give the NAACP a focus for their political efforts, and it motivated the black press to publicize the importance of investing in black film production companies and black theaters.[4]

In this way, *The Birth of a Nation* contributed to the development of the institutional conditions required to establish a black cinema, most significantly, the proliferation of venues for the exhibition of black film. In the years immediately following the release of Griffith's film, there was a sharp increase in the number of black theaters in urban centers, especially in Northern cities, where the population of blacks more than doubled during the Great Migration between 1890 and 1920. A small but relatively affluent merchant and professional class of African Americans emerged and began to invest in black theaters that would refuse to exhibit horrifically racist films like *The Birth of a Nation.* Black theaters, like the Pekin, established in Chicago in 1905 and advertised as "Home of the Colored Race," did not discriminate against African Americans, who were typically seated in balconies at white theaters. Theaters in African American neighborhoods usually did not exhibit first-run features, and they were not as opulent as white theaters; moreover, theaters in African American neighborhoods were generally white-owned. Nevertheless, African Americans preferred black theaters because they had cheaper ticket prices and because they employed blacks as ushers and ticket sellers.[5]

Movie theaters were important sites of black urban culture, where African Americans could both engage in mass culture and adapt it to the needs of the black community, especially through the live musical performances that would accompany the films. At black theaters, managers often discarded the classical music cue sheets that were distributed with Hollywood films and hired jazz, blues, and vaudeville acts to help give a local, African American context to films that mostly featured whites. At black movie theaters in Chicago, top billing was often given to musicians like Bessie

Frame enlargement, *Within Our Gates* (1920), courtesy of Jane Gaines

Smith, Ma Rainey, Ethel Waters, Louis Armstrong, and Fats Waller, who played at the screenings of Hollywood films. As film historian Mary Carbine has shown, the music of these performers did not punctuate action, heighten emotion, or support character development; in fact, the music accompanying white films often ignored the story altogether, to the horror of some black film critics who wanted black spectatorship to resemble white spectatorship in white theaters. One such critic bemoaned a performance of the song "Clap Hands, Here Comes Charlie" that brought down the house in the middle of a death scene.[6] The mixture of differing and competing media in the exhibition context of black theaters created a space for audience members to recognize each other and register their conflicting and contradictory experiences of race, class, and social position.

This clash between popular audiences and the promoters of middle-class mores in black theaters was heightened when the films exhibited were those of Oscar Micheaux, a filmmaker who succeeded in promoting controversial subject matter. While most black film production companies were able to make only a few films before disbanding, Micheaux made a film every year for two decades. Inspired by Booker T. Washington's theories of racial up-

lift through self-help and rugged individualism, he traveled around the country with his films to acquire bookings and financing for future projects. In addition, he promoted the stars of his films, arranging press conferences for them and advertising their arrival in local papers before the screening of each of his films. When his films failed to pass state and local review boards, he found ways around the censors; sometimes he would affix phony seals of approval to his circulating films. On one occasion, when Micheaux's film *The House behind the Cedars* had trouble with censors in Virginia, who thought that the film would cause blacks to riot, Micheaux wrote a letter of protestation. He tried to shame censors by writing, "There has been but one picture that has incited the colored people to riot, and that still does, that picture is *The Birth of a Nation*."[7]

Micheaux's films not only had problems with white censors; sometimes his films were criticized by prominent African Americans, who accused Micheaux of airing the black community's dirty laundry. When *Within Our Gates* was released, black ministers criticized the film for its depiction of the clergy, and, as a result, some black theater owners refused to book the

Portrait of Oscar Micheaux. Frame grab from *Body and Soul* (1925), courtesy of Simon Tarr

film. In some cities, black audience members walked out of the film before it had finished. This response was often attributed to the film's close resemblance in storyline to the incident that provoked the Chicago race riot of 1919, the refusal of white police officers to arrest a gang of white boys who had drowned a black boy. Nevertheless, Micheaux also had supporters among the black press, especially upon the release of *Within Our Gates,* a film that the black newspaper the Chicago *Defender* called "the biggest protest against Race prejudice, lynching, and 'concubinage' that was ever written or filmed."[8]

In its praise of the film's representation of African Americans, this review made a veiled comparison between Micheaux's film and *The Birth of a Nation,* a comparison that Micheaux clearly intended audiences to make. Just as Griffith's film had a longer running time and cost more to make than any other Hollywood film up to that point in time, *Within Our Gates* set new records as the longest and most expen-

sive African American film ever made. Most significantly, both films incorporated controversial subject matter; lynching, rape, and miscegenation are represented in the films of both Griffith and Micheaux, albeit from opposite ends of the political spectrum. Like Griffith, Micheaux found ways to profit from the controversy his film generated; for example, after censors removed scenes from *Within Our Gates* in Chicago, he advertised the screening of an uncut director's version in Omaha, Nebraska.[9]

Micheaux, however, does not only borrow from Griffith, he also criticizes Griffith's racism and his hypocrisy. For example, the title of Micheaux's film ironically references an epigraph from Griffith's 1919 film *The Romance of Happy Valley* that calls for social harmony and tolerance: "Harm not the stranger Within your gates, Lest you yourself be hurt." In direct opposition to *The Birth of a Nation, Within Our Gates* exposes the horrible injustices and brutalities suffered by innocent African American men who were lynched, and by African American women who were sexually attacked by white men. Micheaux's film tells the story of Sylvia Landry, an African American woman who travels north to raise funds for the small Southern school where she teaches. Sylvia manages to secure a substantial donation from a Northern white philanthropist, but only after Mrs. Warwick becomes convinced of the racism of her Southern friend, Mrs. Stratton. The racist Southern woman is played by an actress who strongly resembles an elderly Lillian Gish, the embodiment of white, female innocence in *The Birth of a Nation*.[10] Another ironic allusion to Griffith's film is the inclusion of intertitles composed of historical facts, intertitles that recall the historical footnotes inserted throughout Griffith's film. In the second half of *Within Our Gates,* Sylvia narrates the story of the lynching of her family after her adopted father was wrongly accused of murdering the plantation farmer for whom he worked as a sharecropper. Sylvia also explains that she was the victim of attempted rape by a white man who stopped his attack only after he saw a scar on Sylvia's chest that made him realize that she was his own daughter.

But Micheaux's representation of race relations does not simply reverse that of Griffith, insofar as *Within Our Gates* does not just

Frame enlargement, *Within Our Gates*
(1920), courtesy of Jane Gaines

exchange black morality for black corruption. Important Micheaux scholar Jane Gaines has focused on the way that crosscutting in the climactic scene of *Within Our Gates* connects the rape of black women and the lynching of black men, "the double reaction of the period of reconstruction to whites' nightmare vision of blacks voting and owning property."[11] I would add that Micheaux's use of crosscutting not only works to criticize white racism but also to replace the moral polarities of Griffith's film world with a complex representation of many different social groups, both black and white, who have many competing visions for achieving social harmony in the United States. In one notable ten-minute sequence, Micheaux cuts among ten different scenes involving Dr. Vivian; Sylvia; Mrs. Warwick; Mrs. Stratton; old Ned, the black preacher; Ned's white racist benefactors; and Reverend Jacobs, the director of the Piney Woods School. Through this dizzying display of parallel editing, Micheaux conveys a multitude of simultaneous but nonconverging efforts at social transformation, including the educational mission of Reverend Jacobs, the political- and public-sphere efforts of Dr. Vivian, and the charitable efforts of Sylvia and Mrs. Warwick. Unlike the crosscutting in Griffith, which works to construct a mythic battle of good versus evil, Micheaux's complex pattern of crosscutting undermines any building sense of suspense that could carry the spectator to a melodramatically fated ending. Although the different scenes are occurring at the same time, they do not move toward a narrative resolution that would collapse all of the separate spaces and make all of the different aims and actions represented come together in a simple conclusion. As a result, *Within Our Gates* conveys a much more complicated, less melodramatic vision of the social world than *The Birth of a Nation*.

Moreover, with its unusually large number of characters and frequent shifts from scene to scene, Micheaux's film demands much greater spectator engagement than Griffith's. Spectators must concentrate in order to understand the relations of time, space, and causality among the many different characters and settings. To the extent that Micheaux's film disregards classical Hollywood narrative strategies of representation such as linearity and closure, it does not work to suture the spectator into the time and space of the narrative. Rather, the film has a heterogeneous style that acknowledges and addresses many kinds of spectators who occupy many different social positions, and it encourages those spectators to acknowl-

Frame enlargement, *Within Our Gates*
(1920), courtesy of Jane Gaines

edge and address each other. When the film was first screened in the 1920s, audience participation and interaction would also have been encouraged by the institutional conditions of black theaters, where audiences interacted with musicians, singing and dancing to the music of the band. Unlike the typical exhibition context of classical Hollywood cinema, in which a film has the status of a uniform commodity and is screened in a standardized context of reception, the open style and mixed program of African-American cinema promoted an engaged reception that Miriam Hansen has described as an "alternative public sphere." Both the film and the exhibition context created a space for nondominant ideological positions to become visible; in this way, African American cinema in general and *Within Our Gates* in particular prompted black audiences to recognize themselves as a collective body working to

negotiate and confront the specificities of their social experiences of region, race, and class, social positions rarely if ever acknowledged by the cinema of Hollywood.[12]

The February 2, 2004, screening of *Within Our Gates* was the inaugural event for Ithaca College's celebration of Black History Month, funded by the Ithaca College Office of Multicultural Affairs and the Cinema on the Edge Media Series of the Roy H. Park School of Communications. *Within Our Gates: Revisited and Remixed* rescored Micheaux's film with live music, digital imaging, and a spoken word performance, a multimedia program inspired by the exhibition context of black theaters of the 1920s and the inherent heterogeneity of the style of Micheaux's film. The event began with an invocation performed by the Body and Soul Ensemble, a group named after another Micheaux film starring the legendary singer and political activist Paul Robeson. During this prelude, Robeson's image was mixed live with other images from black political and cultural history and accompanied by djembe drumming and an African dance performance. After the invocation, the film was screened with a new score performed live by Fe Nunn's Musical Productions. Nunn's new score was in dialogue with the film, but, like the jazz and blues musicians of the 1920s, who did not subordinate their performance to the film image, Nunn's playing had an autonomous logic and structure. The spoken word performance by the Ida B. Wells Ensemble ran throughout the invocation and screening, and it included quotes from seminal African American thinkers, cultural theorists, and film historians. Afterward, there was a discussion with Fe Nunn and the historians, theorists, and players who created the event. Throughout the performance, we encouraged the active participation of the audience, made up of the Ithaca community and Ithaca College faculty, students, and administrators. These spectators became equal creators in the performance; they frequently responded to the events on stage and screen with singing, dancing, applause, and shouts of approval and disapproval. Although this project began as part of a course on the history of Hollywood and American film, its reinvention attempted not only to highlight the heterogeneity of styles and social histories represented in and by the

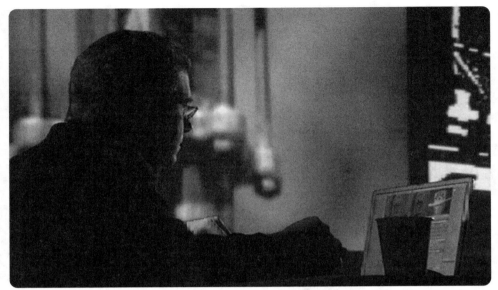

Video Project Jockey, Simon Tarr, courtesy of Simon Tarr

film but also to inspire an experience of the film as multimedia in its composition and political in its performance, as were the film's original screenings in African American theaters throughout the United States. We wanted both to show the continued political and social relevance of this important silent film and to expand the boundaries of intellectual inquiry, social analysis, and political engagement, as Oscar Micheaux would say, "within our gates."

NOTES

1. On the historical role played by D. W. Griffith and *The Birth of a Nation* in the establishment of the style of Hollywood narrative film, see, for example, David Bordwell, Janet Staiger, and Kristin Thompson, *The Classical Hollywood Cinema: Film Style and Mode of Production to 1960* (New York: Columbia University Press, 1985); and Tom Gunning, *D. W. Griffith and the Origins of American Narrative Film* (Urbana: University of Illinois Press, 1991).

2. Walter Lippmann, *Public Opinion* (New York: Macmillan, 1960), 91–92.

3. Linda Williams, *Playing the Race Card: Melodramas of Black and White from Uncle Tom to O. J. Simpson* (Princeton, N.J.: Princeton University Press, 2001), 96–135.

4. On the reception of *The Birth of a Nation* and the response to the film by the NAACP, see Thomas Cripps, *Slow Fade to Black: The Negro in American Film, 1900–1942* (New York: Oxford University Press,

1977). On the role that *The Birth of a Nation* played in spurring the growth of black cinema, see Jesse Algeron Rhines, *Black Film / White Money* (New Brunswick, N.J.: Rutgers University Press, 2000).

5. For an excellent account of black theaters during the silent period, see Mary Carbine, "'The Finest outside the Loop': Motion Picture Exhibition in Chicago's Black Metropolis, 1905–1928," in *Silent Film,* ed. Richard Abel, 234–62 (New Brunswick, N.J.: Rutgers University Press, 1996).

6. Ibid., 251–55.

7. J. Ronald Green, *Straight Lick: The Cinema of Oscar Micheaux* (Bloomington: Indiana University Press, 2000), 1.

8. Chicago *Defender,* January 10, 1920, quoted in Pearl Bowser and Louise Spence, *Writing Himself into History: Oscar Micheaux, His Silent Films, and His Audiences* (New Brunswick, N.J.: Rutgers University Press), 123.

9. For direct comparisons between Micheaux and Griffith, see Green, *Straight Lick,* 1–30.

10. For the most convincing argument that Mrs. Stratton is a thinly veiled representation of Griffith's favorite actress, see Green, *Straight Lick,* 9–12.

11. Jane M. Gaines, *Fire and Desire: Mixed-Race Movies in the Silent Era* (Chicago: University of Chicago Press, 2001), 177.

12. Miriam Hansen, *Babel and Babylon: Spectatorship in American Silent Film* (Cambridge, Mass.: Harvard University Press, 1991).

Revisiting and Remixing Black Cinema

PATRICIA ZIMMERMANN

The goal of *Within Our Gates: Revisited and Remixed* was to create a new way to critically read Oscar Micheaux's film, a way that refused the arbitrary divide between the past and the present, between the analog and the digital. Our creative collaborative was a combination of academics and community-based musicians, artists and scholars who sought to use musical improvisation and spoken word performance to rethink the exhibition of silent film. Within an institutional context of interdisciplinary cooperation, we brought to life theories of artistic collaboration, critical historiography, and multimedia exhibition in order to rescore this historically important film in a new reception context. Sociologists, film theorists, media historians, filmmakers, and local musicians worked together to mobilize public space and new media forms in order to reanimate a politically important film for a contemporary, heterogeneous audience.[1]

Within Our Gates Revisited and Remixed was a historical first for Ithaca College: a commission to a local composer to score and accompany a silent film for live performance. Founded in 1892 as a music conservatory, Ithaca College houses a preeminent school of music. It also has the well-known Roy H. Park School of Communications, which includes a film school that has existed for over thirty years. As a comprehensive college that mixes the liberal arts with professional schools such as music, communications, health sciences and human performance, and business, Ithaca College is not the typical small, liberal arts college. Rather, for most of its existence, Ithaca College has had high barriers among the six different schools and divisions, each of which is distinctive in its own educational mission and national reputation.

Five years ago, a new Institutional Plan was instituted under President Peggy Williams that determined that the insularity of the schools was not stimulating intellectual and creative growth, creating a campus with high walls and divisions. To remedy this situation, the Institutional Plan advanced interdisciplinary and joint projects across schools, providing new incentives and financial resources to stimulate projects that involved more than one school or division. *Within Our Gates Revisited and Remixed,* then, was produced within the context of a larger institutional plan that supported work between and across schools that would have been inhibited by lack of administrative support and resources only five years before.

During my sabbatical, I had an appointment as a visiting professor at Nanyang Technological University in Singapore, an internationally recognized engineering school. In the School of Communication and Information where I was appointed to teach, course projects and final-year projects were done in groups, not individually, as is the case in most American film schools. I observed the emphasis on collaboration, team building, generation of ideas, and quality of product that this structure enabled. I also observed that faculty was involved in a variety of joint research projects and research groups, not only doing their own writing but also working with others. This model of horizontal structure, of course, is congruent with the way that the new economy and new media organizations are structured to promote innovation and invention. I observed firsthand how a deemphasis on the individual pushed ideas further, much faster, often with more rigor and vivacity, and how it also increased focus on ideas and concepts. I was also struck by how this model was entirely different from my own academic experience in the United States. Needless to say, this model of working on a collaborative project with others who have different academic ranks and experience inspired me to think about how to enact a similar think-tank model at my home institution.

Despite two internationally recognized arts programs in music and cinema, Ithaca College had, oddly, never undertaken the project of scoring a silent film. *Revisited and Remixed* evolved from a joint partnership between the Office of Multicultural Affairs on campus and a curatorial collective called Cinema on the Edge, which is composed of a group of senior and junior faculty in cinema and television/radio. For over five years, this partnership had successfully programmed film and video screenings

for Black History Month. In fall 2003, the assistant director of the Office of Multicultural Affairs, Stephanie Adams, suggested that the February 2004 program focus on African American music. She wondered if there were perhaps a way to engage in film programming less predictable than a social realist documentary on some aspect of Black History screened with a panel of faculty.

Adams wondered if our curatorial group could think of some kind of film event that would include music but also invoke history in a way that would mobilize (rather than ossify) it for an audience of college students. The student groups present at the meeting decided to focus on hip-hop culture. Our group tossed up the idea of scoring an Oscar Micheaux film with live music to create a media event that was immersive, surprising, and historical. The Office of Multicultural Affairs, the School of Music, the Roy H. Park School of Communications, the Office of the Provost, and the Division of Interdisciplinary and International Studies provided funding for the project and for the commission to Fe Nunn, an Ithaca College alumnus and accomplished local musician. Without collaboration across schools and disciplines, the project not only would never have been funded but also would not have evolved the way it did into a multimedia performance that reconceptualized how to think about the relationships among music, the spoken word, and the image.

Why undertake a collaborative project combining academic research, critical theory and history, visual and musical creation, feature-length film scoring, lighting, and performance for a film that is more than eight decades old? Why open Black History Month with a dialectic between the past and the present, between analog and digital, between celluloid and live performance?

To answer these questions, one needs to consider the normative forms of cinema education at the university level and how a project like *Within Our Gates* could provide a somewhat different model of the creative enterprise. The major tendency in most film programs, at least on the undergraduate level, is to focus on production courses and then some film studies. Distribution and exhibition, the most powerful economic sectors of the global entertainment industry, are rarely if ever addressed, whether in studio or critical studies courses.

Indeed, a cursory overview of most film studies programs would reveal an epistemological overemphasis on the text, whether in producing a new text or analyzing old ones, whether in production or film studies. On one end, many film schools adopt an industrial model of production, with an emphasis on a division of labor, hierarchies, classical narrative structures, and narrative transparency and unity. Often dubbed "professional training," this model mimics the classical Hollywood studio system of the golden era from about 1920 to 1948. On the other end, a more individualistic, nineteenth-century Romantic notion of the artisanal filmmaker who expresses his or her own inner feelings in a unique way often enters both experimental and documentary practices. However, other models of production exist, such as ensemble models, collaborative models, group projects, collectives — models derived from cinematic and visual culture practices outside the commercial or art-world models.

Our team was interested in exploring the question of how to rethink the politics of exhibition in the digital era outside and beyond these two modes of hierarchical production or artisanal work. Several contingencies and ideas contributed to exploring the idea of a collaborative ensemble that would provide a different kind of model for making creative work and that would alter the relationships among production, distribution, and exhibition.

The writings and films of critical ethnographer David MacDougall, especially his influential book *Transcultural Cinema,* provided ways to think about the collaborative process.[2] MacDougall, a filmmaker with many decades of experience working in Australia, Asia, and Africa, advances the idea that filmmaking is not speaking *about,* but speaking *alongside* and *with.* He elaborates models for collaboration that employ a more horizontal, flat structure and that could construct an ethical representation of difference. He argues that the creative process of filmmaking is not about making a representation or an image but about two parties entering into a relationship that takes them into a liminal zone and, as a result, changes them. Thus, the ethics of representa-

tion is not so much about the image or the representation but about the exploratory process of performative acts of engagement with others that produces a common knowledge. For MacDougall, culture, and, by extension, the act of creation, is a continual process of interpretation, reinvention, and multivocality. It is always about crossing into liminal zones of difference that require participation, collaboration, and acknowledgment of an encounter. It is always a convergence and conversation across difference and across cultures.

MacDougall's ideas were important in thinking through the racialized and gendered issues of *Within Our Gates*. Our team was mixed race, including African Americans, Asian Americans, Mexican Americans, and European Americans. We were dealing with a newly dubbed classic film of African American independent cinema that approached difficult race issues of black education, segregation, the black middle class, lynching, and rape. This collaborative model—which of course has many cultural iterations beyond the academy, in jazz, in folk music, in ideas about cultural hybridity and cultural flows—provided a way to think through how to remake and reimagine beyond the politics of representation toward a politics of cultural collaboration.

Yet several questions lurk behind this description of how the project emerged within the institutional context of a push for interdisciplinarity and a larger intellectual and artistic context of rethinking the politics of archival film exhibition in the digital age. In the current media ecology, the traditional format of screening films on a wall in two dimensions has been somewhat drained of social and aesthetic impact with the proliferation of media that move across multiple platforms, and between private and public arenas. The entire practice of film exhibition needs to be reconceptualized because images themselves are now more accessible than ever. Many artists and archivists are investigating ways to reinvent film exhibition through multimedia forms.

The idea is that the two-dimensional image lacks saliency now that it is almost infinitely accessible and privatized within home viewing. The central dilemma for curators and programmers, today, is how to create a public space for exhibition that is unique from other forms of spectatorship. Commercial cinematic practices in the twenty-first century have moved toward and embraced visual and auditory spectacle; theaters have been transformed into entertainment experiences beyond the image itself by IMAX projections, large screens, raked stadium seating, and digital immersive surround sound. In the art and public media worlds, similar reimaginations of theatrical space have emerged, with the development of microcinemas, installation digital and video art, and live musical performances that accompany various forms of projection, including experimental works, orphaned cinemas, found footage, and classic silent films. *Within Our Gates: Revisited and Remixed* aimed to enter into this question of the place and function of historical cinema in a changing exhibition context by creating a form of counterspectacle mobilized by intellectual and musical ideas rather than simply by theories of cinematic spectacle. Our project asked the question of how to create a spectacle that did not rely solely on visuality and overwhelming the senses but on activated critical engagement.

For this reason, our collective of scholars and musicians kept returning to the same central question: how could music and spoken word mobilize a silent film in a way that countered the classical Hollywood model of music driving the narrative and supplying emotion?[3] Drawing on conceptual models from critical historiography, the project sought to reroute the linear drive of the narrative of the film (problematized by Micheaux's rather fragmented and polemical intercutting in the first instance) with a more spatialized configuration that connected the historical context of the film, the contemporary historical context, and musical references from a range of African American musical traditions. The critical historiographic theories of writers like Hayden White, Tzvetan Todorov, Jacques Derrida, and Ranajit Guha have posed as a central epistemological issue the question of how to narrate histories as multiple and multilinear, in contradistinction to the metanarratives of history that are singular, unified, and immutable.[4]

These writers are interested in questioning the distribution and structure of primary

source material, interrogating the formation of the archive. Critical historiography counters this linear unity and immobility of traditional historiographic models of explanation with new explanatory models that emphasize different archival sources, polyvocality, and an interplay of multiple, contested meanings.

Within the context of the new film history that seeks to move the historical project away from the dominance of classical Hollywood texts and corporate archives toward a recovery of marginalized historical practices and spaces, *Within Our Gates: Revisited and Remixed* was interested in creating a way to embody theoretical concepts of an archive that opened, as Derrida has stated it, toward the future. Because the film was recovered only in the 1990s and then entered the U.S. National Film Registry, it had not been considered a canonical text. The developments of the last ten years in film historiography not only have expanded the range of visual cultures of cinema to be analyzed beyond studio and national cinemas but also have advocated new critical models of history that foreground contiguities over continuities and contexts over texts. Examples of new areas that have been mined include amateur film, exhibition practices, exploitation films, African American cinemas and other minoritized practices, and industrial and educational films. In fact, U.S. government archival policy now identifies films that do not have a corporate home as "orphaned films," and provides special initiatives for acquisition, preservation, and access to these materials.[5]

Our conceptual models, then, for producing *Within Our Gates: Revisited and Remixed* derived from an intellectual and creative interest in addressing these two emerging, intersecting debates of critical historiography and the new film history about how to reevaluate and reanimate the archive. For this reason, the project was not subservient to the textual operations of the film, and our score did not use music to amplify emotional readings positioned by the film's narrative or formal structure. Instead, the film was considered an open archive; in our construction of the score, we complicated the film by inserting spoken word and music that recalled multiple histories and theories of African American film, music, and culture, such as the historical context of the race riots of the late teens and 1920s in the United States, the production and exhibition history of African American independent film, postcolonial theory advocating agency and a decentering of racialized white models, and vernacular folk tales and music that voice the quotidian.[6]

D. W. Griffith changed film language and film form in *The Birth of a Nation* (1915). He also produced a film that celebrated the Ku Klux Klan and racism, playing off white fears about African Americans, black male sexuality, and imagined threats to white women. The NAACP organized protests about the depictions of African Americans in this film at theaters around the country. Five years later, as a retort to *The Birth of a Nation,* African American independent filmmaker Oscar Micheaux produced *Within Our Gates*. The film combines an unflinching portrayal of the gross violations perpetrated by whites against blacks with a determined call for black idealism. Repeatedly recut by censors who deemed the harrowing sequences of lynching and attempted rape too incendiary in the wake of the Chicago race riots of 1919, few saw Micheaux's film as he intended it. Lost for seventy years, *Within Our Gates* was rediscovered at the Filmoteca Española in Madrid and was restored by The Library of Congress in 1993. The music and spoken word in the *Within Our Gates: Revisited and Remixed* project reinvented how to think through the relationship between film and history by taking the historical back story and foregrounding it, transforming the context into a polyvocal text. A powerful and enlightening cultural document and a landmark film, *Within Our Gates* is no less relevant today than it was in 1920. It resonates and reverberates with racial profiling, defunding of education, diaspora, the War on Terror.

The project sought to reconfigure silent film as a performative act that was not historically fixed but constantly changing and reacting to different exhibition contexts. In our conceptualization of the performance, we used recent film-historiographic theories and practices, and engaged digital culture theories of recombinant media. As many digital theorists have advanced, digitality suggests that visual culture is always mobile and changeable, no longer fixed and stable. It is endlessly repro-

ducible. It is also endlessly open to reconfiguration. These ideas of mobility and changeability challenge film theory's traditional orientation toward close textual analysis of a fixed text and also challenge cultural studies' assumptions about resistance located in subversive readings of mass-mediated cultural practices and discourses.[7]

Although the project relied heavily on film theory to analyze the structure and aesthetics of the film and drew on cultural studies models to research the history of spectatorship and the use of music in black silent cinema, these models did not drive the project as much as they contributed to deciphering the problem of how to narrate the film differently and how to create a different kind of social exhibition space that was racialized and gendered differently. Many digital theorists have pointed to the idea that the divide between the digital and the analog is an imaginary state, projecting binary oppositions based on technologies that practices and discourses refute. For these theorists, previous analog digital forms have been poured into the computer where divisions between media forms and platforms are no longer distinctive. Our project operated in several ways as a dialogue with these emerging ideas about digitality as both new and old. First, the project assumed ideas about mutability, changeability, and lack of fixity as a model for developing the various musical and spoken word elements. Second, we formulated a conception that the film itself was a series of hyperlinks to other ideas, both historical and musical, thereby allowing the film to open up into African American history and contemporary discourses on the War on Terror and the USA PATRIOT Act. Thus, rather than moving in toward exposition and enhancement of the film's text, we used the film to move out toward historical and political contexts. Third, we created an opening of a digital remix of images of African Americans in cinema that was accompanied by live drumming and dancing in order to visually suggest a critique of the false separation between the live and the mediated, the analog and the digital, and history and the present.

In this way, *Within Our Gates: Revisited and Remixed* provided a different model of the creative enterprise in efforts to put into effect dialectics between past and present, analog and digital, music and spoken word, critical theory and performative practice. Our collective, an interdisciplinary group of artists and scholars who brought to the project different intellectual and aesthetic skills, constructed a different paradigm for making a multimedia work, one that altered the traditional relationships among production, distribution, and exhibition. By rescoring a silent film for a diverse audience, we revisited a canonical example of African American cinema history and remixed it for a new, digital landscape.

NOTES

1. The following are the credits for *Within Our Gates: Revisited and Remixed* as they appeared in the program that was distributed to audience members:

The Office of Multicultural Affairs and
Cinema on the Edge Present
A Special Kick-Off Event for Black History Month
WITHIN OUR GATES: REVISITED AND REMIXED
February 2, 2004
Park Auditorium, Ithaca College

A Day Long Interdisciplinary Exploration and
Multimedia Celebration of

WITHIN OUR GATES
Oscar Micheaux, dir. USA, 1920, black and white,
silent 78 minutes. The first African American
feature to be included on the United States
National Film Registry, with the World Premiere
of a newly commissioned score performed live by
Fe Nunn's Musical Productions,
the Body and Soul Ensemble, and
the Ida B. Wells Spoken Word Ensemble

*Within Our Gates Revisited and
Remixed Production Credits*

A co-production between the Office of
Multicultural Affairs and Cinema on the Edge

Fe Nunn's Musical Productions

Fe Nunn, piano, drum, and percussion
Charles Leo, tenor saxophone
"Olivia," African dance
Mike Vitucci, guitar and percussion
David Chitamber, drum
Baruch Whitehead, oboe (courtesy School of Music)

The Body and Soul Ensemble

Grace An, spoken word
(courtesy Cinema and Photography)
Changhee Chun, lighting
(courtesy Cinema and Photography)
John L. Hochheimer, spoken word
(courtesy Journalism and TVR)
Meg Jamieson, lighting
(courtesy Cinema and Photography)

Charles Leo, saxophone
Fe Nunn, djembe drum
Olivia, African dance
Anna Siomopoulos, spoken word
(courtesy Cinema and Photography)
Simon Tarr, live VJing
(courtesy Cinema and Photography)
Elisa White, spoken word (courtesy CSCRE)
Baruch Whitehead, (courtesy Music)

The Ida B. Wells Spoken Word Ensemble

Grace An (courtesy Cinema and Photography)
John L. Hochheimer (courtesy TVR)
Margaret Jamieson
(courtesy Cinema and Photography)
Anna Siomopoulos
(courtesy Cinema and Photography)
Simon Tarr (courtesy Cinema and Photography)
Elisa White (courtesy CSCRE)
Zachary Williams (courtesy CSCRE)
Patricia R. Zimmermann
(courtesy Cinema and Photography and DIIS)

Production Team

Stephanie Adams, executive producer
(courtesy OMA)
Patricia R. Zimmermann, producer
Fe Nunn and Patricia R. Zimmermann,
co-artistic directors
Fe Nunn, musical director, composer,
arranger, conjurer
Anna Siomopoulos and Grace An,
associate producers
Elisa White, director of spoken word
Grace An, Anna Siomopoulos, Elisa White, and
Patricia R. Zimmermann, historical research
John Hochheimer, music historian
Simon Tarr, archival film research and
computer alchemy
Grace An, script collage
Margaret Jamieson and Changhee Chun,
co-directors of lighting
Sean Zimmermann Auyash, CD sales

2. David MacDougall, *Transcultural Cinema* (Princeton, N.J.: Princeton University Press, 1998).

3. For discussions of how music in classical Hollywood narrative films supports the narrative rather than interferes with or intervenes into it, see Kathryn Kalinak, *Settling the Score: Music and the Classical Hollywood Film* (Madison: University of Wisconsin Press, 1992).

4. For examples of critical historiography, see Jacques Derrida, *Archive Fever* (Chicago: University of Chicago Press, 1995); Keith Jenkins, ed., *The Postmodern History Reader* (London: Routledge, 1997); Howard Marchitello, *What Happens to History: The Renewal of Ethics in Contemporary Thought* (New York: Routledge, 2001); Ranajit Guha, *History at the Limit of World-History* (New York: Columbia University Press, 2002).

5. For discussion of the impact of orphan-film policy in the United States on archival acquisition, see

Patricia R. Zimmermann and Karen I. Ishizuka, *Mining the Home Movie: Excavations in Histories and Memories* (Berkeley and Los Angeles: University of California Press, forthcoming).

6. For an extended scholarly analysis of Oscar Micheaux, see Pearl Bowser and Louise Spence, *Writing Himself into History: Oscar Michaeux, His Silent Films, and His Audiences* (New Brunswick, N.J.: Rutgers University Press, 2002).

7. For discussions of these ideas of networks and the mutability of the digital, see Sean Cubitt, *Digital Aesthetics* (London: Sage Publications, 1998); Critical Art Ensemble, *Electronic Civil Disobedience and Other Unpopular Ideas* (Brooklyn, N.Y.: Autonomedia, 1996); Peter Lunenfeld, *The Digital Dialectic: New Essays on New Media* (Cambridge, Mass.: MIT Press, 1999); and Lev Manovich, *The Language of New Media* (Cambridge, Mass.: MIT Press, 2001).

Media Antecedents to Within Our Gates:

Weaving Disparate Threads

JOHN L. HOCHHEIMER

No medium of communication exists by and of itself. Each operates in relation to other media forms, each with its own historical, cultural, economic, and societal development. This history of contrasts and intersections becomes all the more evident when differing media are consciously and simultaneously used to both enhance and interrogate each other in a single presentation. Multimedia performances provide a multiplicity of entry points both for creators and for their audiences. Mining ever-wider arrays of cultural and political referents, contemporary artists often use several media simultaneously in order to engage the audience/viewer/listener in the active creation of meaning. The more media that are incorporated by the producer, the greater the possibilities of experience for the listener/viewer. For the listener/viewer, the more parts of the multimedia piece one can recognize, and the greater the connections between them one can create, the deeper and broader the meaning one can derive from the experience. In this very real sense, the viewer/listener becomes an active cocreator of the meaning of the work.

When I was recruited to help construct and perform the *Within Our Gates: Revisited and Remixed* project, I drew on my own back-

ground as a radio producer, historian, and theorist. I suggested that an important multimedia model for our endeavor was provided by the multiform performance, record, and radio projects of the 1950s and 1960s. In these projects, producers borrowed parts of different forms of media, counterpoising time and space in order to create something new. These audio collages—both live and preproduced—would form the foundation for the sampling techniques of the rap/hip-hop deejays of the 1980s and beyond. What unites these productions of different eras is the attempt to combine varied means of expression—genres of music, sound, and spoken word—to create something larger than the sum of the individual contents of the production. Like the audio collage producers of the 1950s, the scholars and musicians who worked on rescoring Oscar Micheaux's classic silent film made many different kinds of contributions, and, as a result, provided multiple points of entry for different listeners. Using spoken word, film images, digital mixes, and live music and dance, we offered to audience members many different sets of meaning, twined strands that provided the warp for the woof of *Within Our Gates: Revisited and Remixed.*

The most renowned of the multiform performance artists was Richard "Lord" Buckley (1906–1960). Buckley combined scat singing, ghetto slang, church preaching, and Shakespearean dialogue to create what he called the "Hipsemantic." A white man from the Gold Rush country of central California, Buckley told the story of Jesus in African American urban slang to describe the life of "The Nazz," whom Buckley described as "the sweetest, gonedest, wailin'est Cat that ever stomped on this sweet, swingin' sphere," while being backed by a solo gospel singer. Marc Antony's Funeral Oration from Shakespeare's *Julius Caesar* was recited as "Hipsters, Flipsters, and Finger-Poppin' Daddys! Knock me your lobes. I came to lay Caesar out, NOT to hip you to him," complete with Dixieland jazz band accompaniment, bringing the Bard to the masses in a vivacious, new way. He did the same with Abraham Lincoln's Gettysburg Address, providing multiple novel layers of meaning and possibility by purposefully combining contrasting cultural traditions and by tying past and present together.[1]

The most commercially successful of the multiform recordings was *Flying Saucer (Parts One and Two)* by Bill Buchanan and Dickie Goodman, which was released in 1956 (see http://www.cod.edu/People/Faculty/pruter/Horror/flyingsaucer.htm). In this humorous retelling of the classic 1938 radio broadcast *War of the Worlds,* Buchanan and Goodman presented a simulated radio broadcast that was interrupted by a bulletin that a flying saucer was approaching Earth, much as Orson Welles and the Mercury Theatre presented their radio drama as a news bulletin reporting an alien attack on a town in New Jersey.[2] In place of a reporter presenting sound bites of people on the street as parts of his "news bulletin," Buchanan and Goodman used bits of prerecorded hit records of 1955–56 by such artists as Joe Turner, Little Richard, Carl Perkins, The Platters, Fats Domino, Elvis Presley, Chuck Berry, Etta James, and Smiley Lewis (among others). In this recording, they sampled the music genres of blues, ballads, rockabilly, rhythm and blues, and early rock and roll from such scenes as Kansas City, New Orleans, and Memphis, and were one of the first to bring them together on one record for a national audience. *Flying Saucer* was quite popular, reaching number 3 on the Billboard charts in 1956, and it is noteworthy enough to be included on the CD *Billboard Top Rock & Roll Hits: 1956.*

This sampling of different genres and juxtaposition of spoken word and music provided the inspiration for two noteworthy radio projects.[3] Beginning in Chicago in the mid-1950s, the work of Ken Nordine has been described as a combination of the prose of Franz Kafka and poetry of Edgar Allan Poe with the music of Chico Hamilton jazz band, the Grateful Dead, and others. Nordine called this free-form combination *word jazz,* and with it he sought to combine fantasy and multiform takes on reality to create "a theater behind the eyes."

The other radio project of the late 1950s and early 1960s was Murray ("The K") Kaufman's *Swingin' Soiree* on WINS-AM, New York, a nightly program that used minidramas as a means to introduce rock and roll songs on live radio. Kaufman presented preproduced simulations of old-time radio dramas, complete with music, sound effects, and spoken word in order to create a mood and a context with which the

audience could understand the song about to be presented. One example of these "radio stories" was the horror story introduction to the song "Mother-in-Law" called "Murray the K-Doe."[4] The "story" provided an aural build-up to the song, which seemed to come from nowhere. There was a moment of silence between the story and the song, allowing the listener a moment to ponder where it was all headed. In this performance, then, the listener became an active participant in the creation of the meaning of the story/song nexus. This work would be emulated by radio producers on free-form FM stations as either live or prebroadcast productions in the mid-1960s and 1970s. Among these multimedia producers were Wes "Scoop" Nisker on KSAN in San Francisco, Tom "Uncle T" Gamache on WBUR, Boston, Joe "Mississippi Harold Wilson" Rogers on WBCN, Boston, and myself on WBUR and WBCN.

In these performances, the deliberate juxtaposition of various seemingly conflicting sources was intended to prevent audience members from imposing any "one" meaning on a program. The intention, instead, was to provide multiple possibilities for interpretation, to be drawn from often explicitly conflicting messages or from musical and performance elements that did not overtly fit together at all. As such, the performers and programs created aural spaces in which listeners could become actively engaged in the creation of meaning, using bits and pieces of information as well as the contexts within which they had been placed, just as the producers had done.

Or, indeed, as each of us does as we actively engage the world. The essential moment of the creation of meaning emerges when the theater in front of the eyes mixes with the theater behind the eyes. In other words, the listener participates in the construction of aural meaning when he or she personally responds to pictures, words, and sounds in a way that reflects his or her own cultural and social history. In this interaction, the producers' range of meanings actively engages with those of the audience.

To produce such an experience, the creative team that worked on the *Within Our Gates* project similarly mixed different media forms and traditions. We started with the film itself, which provided a number of important themes that we could develop: responses to *Birth of a Nation*, media depictions of African Americans, issues of race and class, African antecedents to black peoples' experience in the United States, racially motivated crimes of lynching and rape. A new musical accompaniment to the screening was then commissioned. The music, composed by local musician Fe Nunn and performed by his band, brought together both contemporary and traditional themes in the new film score. This was the first step in juxtaposing aural meanings with visual images. By adding a more contemporary sound, built upon jazz, blues, and African rhythms, and performed by a live band, the producers sought to free the silent film from its more traditional presentation with solo piano or organ. Because the producers assumed that the only live music accompaniment their audiences had ever heard with a silent film was solo piano, we thought that this performance would be an immediately decontextualizing experience.

Working with the music, the producers sought to build a complex layering of contexts with which to experience the film. We framed the prefatory music with a live VJ-ed visual and sound collage, thus juxtaposing the earliest film production and presentation technology against the most up-to-date use of CD-ROM, Internet, and computer technology. Another collaborator prepared a prefatory lecture on the historical significance of the film and its producer/director Oscar Micheaux to provide a context of the film in time. This lecture was followed by introductory music that served as the bridge between the past and the present, in terms of both media technology and cultural experience. Thus the live music bridged the lecture and the mixed media/sound collage both technologically and culturally. The on-screen images then blended with the music to connect to the next part of the production: a dancer in West African dress who provided an homage to the roots of African American culture and a blessing for its future, thus making the scene a sacred creative space. To tie together the visual media display and the dance, the performers used the greatest of African contributions to world music: the drum. The drum not only provided accompaniment but also signified one of

the world's first instruments of mass communications and information dissemination.

As the performers rehearsed, we kept coming back to the problem of how to tie all the issues together for the viewers. Given that this event was produced in a time of great national concern about terror and the significance of terrorism, we decided to focus on one of the more widely used forms of U.S. domestic terror as depicted in the film: lynching. The performers wanted to show many of the ways this particular form of terror was used as a means of controlling black people throughout the Jim Crow era, which the film was especially intended to depict. We preceded the film with an explanation of the definitions, practices, and social functions of lynching in the United States of America, where, from the 1880s through World War I, one black person was lynched every three and a half days. We interlaced the definitions of lynching with the "offenses" for which this punishment was deemed appropriate.

The performers read parts of speeches, bits of poetry, and pieces of African American folk wisdom throughout the film screening to enhance or to interrogate the image on screen, and, in the process, expose some of the inherent contradictions in the film and in U.S. society. In one scene from the film, for example, an actor portraying a fool sells out the heroine as a means to curry favor with the whites in the community. The accompaniment juxtaposed his actions with a reading/singing of the poem "Signifyin' Monkey," a tale of double-talking and duplicity. As in *Flying Saucer,* the story on the screen was enhanced by the music that was presented with it. In other readings throughout the screening, the performer referenced Lord Buckley's sense of rhythm and timing, metaphorically juxtaposing the drawl of ghetto slang with the King's English of the Shakespearean theater, hip-hop, and high theory. A scene of the gathering of the lynch mob and the capture and torture of their victims was accompanied by a quotation from current U.S. President George W. Bush, "You are either with us, or you are with the terrorists." Who, in fact, is "us" here? Who is the terrorist? A scene of the spreading of news of the lynching was presented with a group singing of the spiritual "Go Tell It on the Mountain," along with audi-ence participation. Tell what? To whom? How does the constellation of past and present affect both intended and derived meaning? As in Buckley's retelling of the story of "The Nazz" with jazz accompaniment, whose truth is being told here? Whose vision of the sacred? What is profaned? By whom?

After the credits, the music ended, the screen went black, and there was silence. The theater was dark.

And then, from within the darkened, silent space, came the voice of Billie Holiday, singing a tragic song of the South written by a Jew from New York:[5] "Southern trees bear a strange fruit. / Blood on the leaves and blood at the root." The audience heard the lyrics of "Strange Fruit" in a darkened auditorium. After so many pieces had been threaded together, after so many varied sensory inputs, there was nothing but Billie Holiday's voice, backed by a muted instrumental accompaniment. No other sound was made, no performer moved. As in Murray Kaufman's radio work, all of the aural stimuli were directed to this final, stark moment. As in Lord Buckley's performances, differing cultural traditions were combined to lead the audience members in the active creation of a new understanding of the relationship between the past and the present moment in politics and race relations.

"Strange Fruit" ended with a loud climactic sound, an audio *chop.* As this faded into silence, the house lights were slowly brought up. There was silence for a few seconds, and then loud applause, as if everyone—audience as well as cast—let out a great sigh together. The applause went on for quite a long time.

Although the producers' intention was to use all of the various components to focus on the issues of racism, violence, and terror, the multiform layering was designed to allow all in attendance to be active creators of meaning, to go in whatever directions made the most sense to each person. So much of the experience depended on the background and level of participation of each member of the audience. To someone familiar with both ghetto slang *and* Shakespeare, Marc Antony's funeral oration in the "Hip semantic" would take on wholly different levels of significance than it would to someone who knows neither. And, to someone

familiar with "Go Tell It on the Mountain" as a song of the civil rights struggle, or of "Signifyin' Monkey" as an African American practice of the dozens, the inclusion of these works in our production would, of course, have different levels of meaning than they would to someone who was hearing them for the first time.

The creators of this multimedia experience—scholars and practitioners, people whose background was in cinema studies, journalism, cinema and video production, audio production, dance, music, history, television and radio—blended live music, dance, poetry, CD-ROM, lecture, live VJ creation, live song, audience participation, jazz, blues, spiritual, and Billie Holiday and, of course, Oscar Micheaux's *Within Our Gates* to create something entirely new, and yet quite old. Its roots and its performance can be found in both the cultural experiences of African Americans and in the media collages of multiform performance, recording, and radio artists of the 1950s and 1960s.

The performance ended with some resolution, but the underlying questions of truth and justice remained. Although the producers sought to focus on the issues of racial inequality, lynching, rape, and terror, the conclusions needed to be drawn by each viewer. For this reason, *Within Our Gates: Revisited and Remixed* exemplified one of the truest forms of mediated communication, a living creation of performers and audience members alike.

NOTES

1. See Oliver Trager, *Dig Infinity! The Life and Art of Lord Buckley* (New York: Welcome Rain, 2001). Buckley's admirers included Ed Sullivan, Bob Dylan, Robin Williams, Eric Bogosian, and George Harrison, among many others.
2. Hadley Cantril, Hazel Gaudet, and Herta Herzog, *The Invasion from Mars: A Study in the Psychology of Panic* (Princeton, N.J.: Princeton University Press, 1940).
3. Another such radio project was *The Goon Show* series that ran on the BBC from 1951–1960. This program featured Peter Sellers, Harry Seacombe, and Spike Milligan creating programming noteworthy for the multilayered use of sound effects, counterpoised story lines, and plot twists. These programs were heard sporadically in the United States.
4. The story and song can be heard at the Web site http://www.reelradio.com/mk/.
5. "Strange Fruit" was written in 1938 by New York schoolteacher Abel Meeropol under the pseudonym Lewis Allen.

The Spoken Word in *Within Our Gates: Revisited and Remixed*

GRACE AN

Spoken word, a participatory form of poetry that jazz artists have combined with percussion and rhythm, constituted an integral part of the multimedia celebration of Oscar Micheaux's *Within Our Gates* at Ithaca College in February 2004. Interestingly enough, spoken word did not figure in the original conception of the event by the executive producer, Patricia Zimmermann, and the composer of the new score, Fe Nunn, who both initially imagined the event in musical terms. In early considerations, Fe Nunn's band was going to be the highlight of the event. Yet, during the first rehearsals of the program, discussions of the relationship between film and history, as well as the relationship between scholars and artists, led to an inspired decision in Fe Nunn's direction of the spectacle-to-be. Spoken word, he suggested, could provide a crucial link between the artistic and the academic, between image and text, past and present, and the film and the audience.

Spoken word is usually understood as a form of literary art or performance in which poetry, stories, and text are spoken rather than sung. Often associated with background music in a performance setting, spoken word can be improvisational or planned, and, although it is not sung, the prose of spoken word is usually more artistic than normal speech. It became a topic of fascination during the 1960s, when Beat poets such as Allen Ginsburg, Jack Kerouac, and William Burroughs incorporated it in their poetry readings and performances, drawing inspiration from African American and Native American oral artists, as well as the history of oral poetry dating to Homer. These Beat legends also inspired artists of the 1990s, who helped prolong the practice by paying homage to their predecessors. And, as mentioned above, jazz artists soon made space for it in their artistry, too. Questions about the classification of spoken word still arise, since certain

academic circles are not always ready to accept it as "poetry," but it is nevertheless accepted by many as a form of literary performance art and an important vehicle for political, social, and cultural commentary.

Both the Body and Soul Ensemble and the Ida B. Wells Spoken Word Ensemble consisted of Ithaca College faculty members from the departments of cinema and photography, television and radio, music, and the Center for the Study of Culture, Race, and Ethnicity. Each member of the two ensembles contributed material that she or he found informative and provocative. During the Body and Soul invocation (our preface to the screening of the film), Professors Elisa White and John Hochheimer alternated in a spoken word duet, citing "Reasons for Lynching," which was material documenting justifications for lynching during Micheaux's time. One by one, other faculty members joined in, with quotes from various black and white American individuals who marched, legislated, protested, and spoke against lynching, segregation, discrimination, racism, and targeted surveillance. Ida B. Wells and W. E. B. DuBois, the two figures we quoted most, were heard through the voices of the Body and Soul Ensemble. Also quoted were Paul Gilroy, Gayatri Spivak, Tzvetan Todorov, Stuart Hall, and Wahneema Lubiano. This text weaving continued during the screening of *Within Our Gates,* when the Ida B. Wells Ensemble added a layer of film historical information specific to the production and exhibition of Micheaux's film, including a recital of "Signifyin' Monkey" by faculty member and musician Baruch Whitehead, a rap by faculty member Zachary Williams telling everybody to "wake up," the singing of "Go Tell It on the Mountain," and, perhaps most chillingly, the listing of names of lynched African Americans. This composite "sound track," as it were, was organized in loose synchronization with the narrative arc of *Within Our Gates* but maintained its autonomy as a separate space of dialogue, traversed by the diversity of interventions that were enabled and carried by spoken word.

Many of us academics who conducted film historical research in preparation for this multimedia event were reluctant to emerge from our preferred position behind the scenes and present ourselves as a collective performance team in front of spectators. But Fe Nunn was determined to make performers out of us! More important, however, were the voices of film historians, historiographers, and African American scholars, such as W. E. B. DuBois, who were evoked by the pieces of spoken word written into the performance. By quoting the very thinkers and writers who had influenced and forged our engagement with Micheaux and his film, we foregrounded our intellectual and cultural debts to these figures, while exhibiting as explicitly as possible the collaborative nature of our intervention.

When they entered the auditorium, members of the audience each received a piece of paper with a name on it, and they found out only at the end of the screening that each name belonged to a person killed by lynching. The notion of holding a written name in one's hand was crucial to our conceptualization of the role of the spoken word and how it invited, if not demanded, audience participation. "We started to *talk* about something that was going on," Fe Nunn explained. "Everyone had a word or some words to hold onto." When Nunn first suggested bringing spoken word into the performance, he envisioned it as one of many layers that would make people think and make meaningful sense of the film. The spoken and written word together would "wake everybody up" from passive spectatorship and raise consciousness about the historical implications of *Within Our Gates.*

Informative, evocative, and musical in its own right, spoken word seemed to enhance what we wanted to accomplish in the celebratory context of this Black History Month event. Spoken word also enabled us to blend the pedagogical with the artistic and intellectual. Eventually, our increasing attentiveness to the specific audience in question (namely the students of Ithaca College as well as Ithaca city residents) further defined the role of spoken word as providing the audience with varying points of entry into the performance. In short, we incorporated the spoken word into the soundscape of the spectacle in order to represent many different voices — belonging to others as much as to ourselves — in the remixing of *Within Our Gates.*

Once we began to develop the spoken word "script," the film historians and critics in

the Spoken Word Ensemble imagined a Brechtian effect of sorts, insofar as the different bits and moments of spoken word would bring the audience into the film and its historical critique, yet also provoke a more critical sensibility. Ultimately, the spoken word, more than the music and the other layers in the multimedia performance, offered the most explicit expression to the investments and ideas that drove and informed the orchestration of this entire experience. With references to other forms of twentieth-century genocide, the USA PATRIOT Act, Matthew Shepard (the gay man killed in Wyoming in October 1998) and James Byrd Jr. (the African American man who was brutally murdered in Jasper, Texas, in June 1998), spoken word also enabled the two ensembles to call attention to connections that the history of lynching has with other significant moments in American history. Through spoken word, we scholars and academics could display our intellectual contributions to the artistic and musical experience, suggesting the role of intellectual work in artistry, on the one hand, and the artistry of intellectual work, on the other. The spoken word invocation that preceded the film screening follows.

INVOCATION

ELISA:
The Reasons Given for Black Lynchings:

Acting suspiciously
Gambling
Quarreling
Adultery
Grave robbing
Aiding a murderer
Arguing with a white man
Inciting trouble
Robbery
Attempted murder
Indolence
Banditry
Inflammatory language
Sedition
Being disreputable
Slander
Being obnoxious
Injuring livestock
Spreading disease
Insulting a white man

Stealing
Insurrection
Swindling
Conjuring
Killing livestock
Testifying against a white man
Living with a white woman
Miscegenation
Trying to vote
Disorderly conduct
Vagrancy
Voodooism[1]

HOCH:
A lynching consisted of:

(1) a notice to other whites in neighboring towns, so they could witness the lynching;
(2) a huge spectacle with thousands watching;
(3) the burning of the victim, usually a male, at the stake, after first being exposed to hours of wrathful pain, known as "surgery below the belt," and, as if that wasn't bad enough,
(4) the observers took parts of the mutilated body as souvenirs and took pictures for postcards.[2]

GRACE:
On July 28, 1917, in East St. Louis, Missouri, the Negro Silent Protest Parade marched against the horrors of lynching. One protest sign read:

India is Abolishing caste,
America is adopting it
Memphis/Waco, centers of
American culture
We are maligned as lazy and murdered
when we work
Mother, do lynchers go to heaven?
Mr. President, why not make America
safe for democracy.[3]

Cue: shortly thereafter

ANNA:
A leaflet passed out during the Negro Silent Protest Parade proclaimed the following: We march because we deem it a crime to be silent in the face of such barbaric acts. We march because we are thoroughly opposed to Jim Crow segregation, discrimination, disenfranchise-

ment, LYNCHING, and the host of evils that are forced upon us.[4]

Cue: shortly thereafter

GRACE:
The blood and anguish of genocide saturates the history of the twentieth century. Modernity writes itself on the bodies of the dead.

HOCH AND ELISA:
5,000 African Americans lynched
1,500,000 Armenians;
3,000,000 Ukrainians;
6,000,000 Jews;
6,000,000 Gypsies and Slavs;
25,000,000 Soviets;
500,000 Indonesians;
1,200,000 Tibetans;
1,000,000 Ibos;
1,500,000 Bengalis;
1,700,000 Cambodians;
200,000 East Timorese;
500,000 Ugandans;
800,000 Rwandans;
250,000 Burundians;
200,000 Guatemalans;
2,000,000 Sudanese and counting . . . ;
1,600,000 North Koreans and counting . . . ;
10,000 Kosovars and counting . . .[5]

PATTY:
Ida B. Wells, an African American journalist and feminist and anti-lynching crusader, wrote:

> The men who make these charges belong to the race which holds Negro life cheap, which owns the telegraph wires, newspapers, and all other communication with the outside world. They write the reports which justify lynching by painting the negro as black as possible. Those reports are accepted by the press associations and the world without question or investigation.[6]

MEG:
Tzvetan Todorov, a theorist and historiographer, explains: "Totalitarian regimes of the twentieth century have revealed the existence of a danger never before imagined: the blotting out of memory. These twentieth century tyrannies have understood that the conquest of men and territories could be accomplished through information and communication and have created a systematic and complete takeover of memory, hoping to control it even in its most hidden recesses."[7]

ELISA:
Stuart Hall, a cultural theorist of Caribbean heritage, has argued: "there is a past to be learned about, but the past is now seen, and has to be grasped, as a history, as something that has to be told. It is narrated. It is grasped through memory. It is grasped through desire. It is grasped through reconstruction."[8]

GRACE:
The Electronic Frontier Foundation has recently pointed out that the USA PATRIOT Act has expanded surveillance without checks and balances, propelled nationwide roving wiretaps, and spurred government spying on suspected computer trespassers with no need for a court order.[9]

HOCH:
After the Chicago Race Riot of 1919, the young black poet Claude McKay wrote a poem to the new militancy. He wrote:

> If we must die, let it not be like hogs
> Hunted and penned in an inglorious
> spot
> While round us bark the mad and
> hungry dogs
> Making their mock at our accursed lot
>
> If we must die, O let us nobly die
> So that our precious blood may not be
> shed
> In Vain, then even the monsters we defy
> Shall be constrained to honor us
> though dead.
>
> Like men we'll face the murderous,
> cowardly pack
> Pressed to the wall, dying, but fighting
> back.[10]

PATTY:
Paul Gilroy, a black cultural theorist, observed:

> There is a democratic, communitarian moment enshrined in the practice of antiphony which symbolizes and anticipates (but does not guarantee) new, nondominating social relationships. Lines

between self and other are blurred and special forms of pleasure are created.[11]

ZACH:

Wahneema Lubiano, a black feminist literary critic, observed:

> The story's deliberate subversion of itself remains constant. Within its frame, stories have potential to save lives and allow for connection. . . . Neither this narrative nor this narrator is part of a pattern for unproblematic and centered control, for a unified subject. The story is, however, a sure ground for exploration, for problematizing, and for decentering.[12]

ELISA:

Gayatri Spivak, a theorist, says: "Culture alive is always on the run."[13]

NOTES

1. See Ida B. Wells-Barnett, *On Lynching: Southern Horrors, A Red Record, Mob Rule in New Orleans* (New York: Arno Press, 1969); also see www.umass.edu/complit/aclanet/USLynch.html.
2. From *African American Holocaust*, www.maafa.org.
3. Philip Dray, *At the Hands of Persons Unknown: The Lynching of Black America* (New York: Modern Library, 2002), 236.
4. Ibid., 236–37.
5. Statistics are from the Campaign to End Genocide, www.endgenocide.org.
6. Ida B. Wells, "Lynch Law in America," www.afroamhistory.about.com/library/blidabwells_lunchlawinamerica.com.
7. Tzvetan Todorov, "The Uses and Abuses of Memory," in Howard Marchitello, ed., *What Happens to History: The Renewal of Ethics in Contemporary Thought* (New York: Routledge, 2001), 11.
8. Stuart Hall, "The Local and the Global: Globalization and Ethnicity," in Anne McClintock, Aamir Mufti, and Ella Shohat, eds., *Dangerous Liaisons: Gender, Nation, and Postcolonial Perspectives* (Minneapolis: University of Minnesota Press, 1997), 186.
9. For updates on the consequences and impact of the USA PATRIOT Act, see www.eff.org.
10. Quoted in Dray, *At the Hands of Persons Unknown,* 256.
11. Paul Gilroy, *The Black Atlantic: Modernity and Double Consciousness* (Cambridge, Mass.: Harvard University Press, 1993), 79.
12. Wahneema Lubiano, "Shuckin' off the African-American 'Native Other': What's Po-Mo Got to Do with It?" in Anne McClintock, Aamir Mufti, and Ella Shohat, eds., *Dangerous Liaisons: Gender, Nation, and Postcolonial Perspectives* (Minneapolis: University of Minnesota Press, 1997), 222.
13. Gayatri Spivak, "A Moral Dilemma," in Howard Marchitello, ed., *What Happens to History: The Renewal of Ethics in Contemporary Thought* (New York: Routledge, 2000), 222.

Interview with Fe Nunn

ANNA SIOMOPOULOS AND GRACE AN

Fe Nunn is a songwriter and composer who lives in Ithaca, New York. He has written music for television and radio commercials as well as for film. He composed and performed the original score for the award-winning documentary *Passin' It On* (directed by cinema professor Simon Tarr and a collaborative team of Ithaca College students in 2002). As a pianist, he specializes in jazz and avant-garde musical forms. Nunn grew up in Buffalo, New York, during the powerhouse jazz era of the 1960s, where he regularly heard John Coltrane, Sonny Stitt, and Roland Kirk perform live at the Blue Moon. He wrote the score for the All of Us Project, an initiative to involve the entire Ithaca community in children's education. With Ithaca College professors Jeff Claus and Baruch Whitehead, he helped to launch the Community Unity Music Education Program, a new form of music school. His CDs include *We Can Make It* (1999) and *Precious Moments* (2004). A fourth-grade teacher at Beverly J. Martin Elementary School in Ithaca, he is interested in how involvement in the performing arts can spur academic success. He and guitarist Mike Vitucci, who also performed live during the *Within Our Gates* screening, have played together for more than twenty-five years. Nunn brought to the project his own impressive experience in avant-garde jazz, as well as the combined talents of an ensemble of musicians who could rehearse a score beforehand and still respond spontaneously to each other's playing on the night of the actual performance.

ANNA SIOMOPOULOS: How did you first get involved with the *Within Our Gates* project?

FE NUNN: Well, I've known Patty [Zimmermann] for a long time. She was involved with *Passin' It On,* a documentary produced for a filmmaking class at Ithaca College about the South Side Community Center in Ithaca. I was involved with that project in many ways—I did the musical score for the film, and I was interviewed in the film as the director of the center. Patty was a consultant on that project. She

also was responsible for getting me jobs playing live at Ithaca College events. At one of those events last November, the inaugural event for a new college program, Patty asked me if I would be interested in doing a score for a silent film.

AS: What were your first thoughts about scoring a silent film?

FN: I had scored commercials for years, and I had just done the score for *Passin' It On,* but I had never scored a silent film. But Patty makes everything colorful and exciting. She has that kind of powerful energy. She makes you feel good about yourself because she feels good about herself. She really pumped me up, and told me, "Fe, you're not just a piano player, you're a writer and a composer." I said, "Patty, just show me the water, and I'll drink." Once we started to collaborate, she opened up the path for my creativity, and my ideas about how to put it together with the dancer, the drummer, the spoken word.

AS: Let's go through each of those ideas, why you thought of them, and how you thought they would work.

FN: Well, Patty thought that the project should be more than just a silent film with music, or the kind of black-history event where they show *Eyes on the Prize* and sing "We Shall Overcome" at the end. She kept asking, "What else can we do?" That's when I suggested the drummer and the African dancer. At one point, we even considered having two little girls play patty-cake at the front of the auditorium during the invocation. And Patty said "We've got two new PhDs working with us. We can ask them for ideas, and there's a new film production professor named Chang [Chun] who would be great at coming up with the lighting design." And we knew that Zach [Williams] had these great oratory skills, and an ability to project. It was really beautiful how it came together, to see everyone get into it.

AS: I really thought that Zach's rap was one of the highlights of the performance. How did that come about?

FN: I had just written a new song called "Wake Up," but I hadn't finished the lyrics. And we knew that Zach was teaching a course on hip-hop, so we thought that he could write a rap. We just asked him to say whatever he thought that people should wake up and realize about any of the issues addressed in the film or in a contemporary context about race relations today. I wrote the chorus and the first few lines — "We're gathered here for a history lesson, so buckle your seats, education is in session" — but what we wanted was for Zach to come in and add his Martin Luther King / Malcolm X insert on top of it, after the second verse.

GRACE AN: Fe, can you tell us about the spoken word? I have to admit that I had never heard of that concept before you suggested it for the performance.

FN: I really thought that it would give some color to what was happening. And Patty kept saying, "Let's make it more contemporary," so I thought of spoken word, which is an ancient form, but now it combines poetry and music. In the late sixties, the Last Poets combined poetry and percussion, poetry and rhythm; now they're combining poetry and jazz, poetry and choral voices. Every party is really free; they're connected, but they're not connected. That's not to say that there's no structure. It's not as locked in as classical forms, but each element has a pattern and a purpose. You can say what you want to say, and I can play what I want to play, and we can't make a mistake. And that's what we always felt about the spoken word. Remember? We kept repeating that idea at rehearsals: "you can't make a mistake."

GA: Fe, were you surprised when Anna and I said that we needed a script, something tangible to hold onto so that we would feel comfortable coming in at certain moments? In the end, everyone said, "Thank God we had it," but at first I was somewhat embarrassed. I felt bad, like I was cutting into that ease that you were trying to cultivate by telling us there was

no wrong way to participate. Patty teased us—"the PhDs need everything written down."

FN: I thought that reading from a script was a classical approach, but that it didn't mean that you weren't feeling it, that we couldn't groove. It felt appropriate because of the serious subject matter, like reading from the scrolls.

AS: That's true. We were serious about what we were reading about the history of civil rights, quotes from Du Bois and Ida B. Wells. We took it seriously.

GA: What was the focus and aim of mixing so many different kinds of performance together in one event?

FN: We wanted to provide something for everyone, enough for each person to latch onto at least one thing. That was the real focus of the mix, and why we really let go and got so many different types of performers involved. We thought, we'll let Simon do his digital mix; and then we'll have an African dancer come down; and then right after she finishes, we'll have a sax player come down. And then the whole band will kick in, and then we'll have some spoken word; and then the film credits will start to roll, and the whole band will come in. And in the end there was something for everyone, even for the straightlaced administrator white guy who didn't move a bit and just sat there while we got funky, when we were jamming with "Wake Up, Everybody." He was probably just tied up in the visual of the film.

AS: It really was an eclectic mix of visual and musical styles and formats.

GA: And I think the approach worked for the audience. Because I had some students who said, "I got the most out of the spoken word," and I had other students who said "there was a lot going on, but I held onto Fe's music."

FN: No one could ever imagine that that could happen for a silent film. I mean, let's face it. No one has ever had spoken word over a silent film. We're the pioneers of this format. Some silent film expert try-ing to check out the scene would have wondered what the hell was going on: there was a dancer; there was a guy in a jazz fedora jammin' on the keyboard; there were some film professors singing "Go Tell It on the Mountain." It was a really beautiful experience. It really lives with me—I think with all of us—the way it happened.

AS: Fe, what did you think the first time you saw the videotape of Micheaux's film Within Our Gates?

FN: I didn't know. At that point, we were still talking about my just playing piano, although I wasn't going to play the kind of ragtime that gets played traditionally over black silent film. Even then I was going to play my own kind of jazz that mixes in funk, soul, bebop, and hip-hop.

AS: How did you compose the score? Did you think of different songs to fit different scenes, or did the score have its own separate logic?

FN: You gave me a video copy of the film early on, and I studied the film. I thought this tune would be great for this scene, and this tune would fit here. Patty helped a lot, too, making good suggestions, because she knew my songs.

AS: Did you want to play a different song for each scene and for each major section of the film?

FN: At first I did. But then I had to let go of that when everything else started coming in. Patty helped me with that when she said, "Just play."

AS: Plus, the film itself is crazy. Sometimes in five minutes there are five different scene changes.

FN: It's all over the place. Although I must say that at first I tried to create a more traditional score. At first, I thought I'd have it all planned out which songs I would play and when I would play them. That was my original head set. But then I said, "This is crazy. I just have to play."

AS: The film's structure almost demanded a more open musical score. It required that you do your own thing.

GA: The one part of the film for which the score had to be carefully orchestrated was the section near the end of the film that included the attempted rape and lynching. You were drumming during that section to increase the dramatic tension of the scene.

FN: Exactly. You couldn't play a song then. The rape/chase scene that led up to the lynching was appropriate for solo drumming.

AS: Fe, that part of the performance was particularly powerful and moving. It makes me wonder how you view your audience. What's your relationship to your audience while you're playing? What are you trying to communicate with your music? What do you want the audience to do with your music?

FN: You want them to be connected, but you also want them to feel comfortable enough where they don't have to follow a specific pattern. People in the audience are feeling different things, and you want to reach all of them. Certain parts of the music will connect with some and disconnect with others. I think that as a musician, you have the ability to reach everyone in the room, no matter what their form of thinking is. In that way, I think I'm more influenced by John Coltrane than by anyone else. As a little, nappy-headed kid, I saw him play at the Blue Moon in Buffalo. No one else played like Coltrane. He was so committed to the sound; he was spiritual. That was the way he affected everyone in the room. When he played, people were still; they were like stuck in their seats. His music was a cacophony, but yet it wasn't. There were patterns to his playing and what he did. Especially the way he did "My Favorite Things." It was totally original music, but it was still the song everyone knew. I think that's what blew everyone away. You could hear it one way, or you could hear it another way, and no way was wrong. It was magical. It was cool.

AS: But, while I can imagine different people having different emotional or intellectual responses to Coltrane's music, I think that there had to have been a certain consistency in how audience members interpreted the politics of his music and his playing in a black neighborhood in the sixties. Did you feel that there was a political aim to your music during the *Within Our Gates* performance, and to the conception of the project as a whole?

FN: Oh, yeah, definitely. That was one of the wonderful things about the spoken word, which was very specific about what was going on. And I thought the idea really came to fruition when we added the spoken word because everyone could understand how we were using it, what we were doing, and what we were saying, whether or not they agreed. Everyone can understand the spoken word, in a way that they may not be able to understand the music. They may have floated off during the musical performance, but the word always brought them back to the history of lynching, and to the continuing effects of racism. It put them in a place where they had to connect to the performance.

AS: And it forced them to think. It made the event more than just an entertainment.

FN: Exactly. Especially Zach's rap.

GA: And "Wake Up."

FN: I don't think we ever separated ourselves from being educators. Because that's what we are. We were teaching something through music, and film, and poetry, and dance, colors, and lights. We were trying to teach in a way that everyone could be touched by the show, everyone could learn from the show and enjoy it at the same time. It was like a party. That's what Patty kept saying: "We're going to have a party. It's going to be like a happening." We were even dressed for a party in our black and white outfits, bright-colored Chinese New Year's lanterns swinging over our heads. It was something really wonderful. It was cool.

REVIEWS

Books

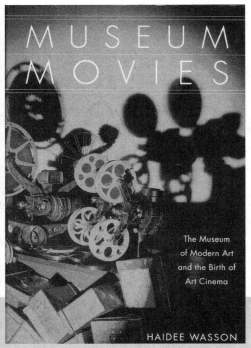

Museum Movies: The Museum of Modern Art and the Birth of Art Cinema
by Haidee Wasson
UNIVERSITY OF CALIFORNIA PRESS, 2005

Barbara Selznick

The Museum of Modern Art's Film and Media Library historically has served as a rich and important resource. Scholars, critics, publishers, and fans—whether they know it or not—have probably come into contact with films, research, and/or photographs from MoMA's collection. What many of us may not have real-ized, however, is how much more we owe to MoMA's early Film Library for its efforts to legitimize film as an art form and its early work to archive films and relevant reference materi-als. Haidee Wasson's fascinating and thor-oughly researched *Museum Movies: The Mu-seum of Modern Art and the Birth of Art Cinema* focuses our attention on the significance of MoMA's Film Library by examining the library from its creation and early development in 1935 through the end of the decade. Wasson explores the cultural moment that brought to-gether changes in museology, the film indus-try, and institutions of social uplift to make the unlikely combination of film and art possible in a studious museum setting. Wasson's work is original and fresh for its exploration of both nontheatrical exhibition and her focus on the interwar period.

Wasson highlights some of the major contributions made by the Film Library to the field of cinema studies. For example, the Film Library began the process of classifying and archiving films by their year of production (other, nonchronological classifications were equally possible); the library helped to develop a network of film societies and clubs through-out the United States; and the Society of Cine-matologists, which would eventually become the Society for Cinema and Media Studies, began from meetings held at MoMA. Beyond these, Wasson stresses that the exhibition environment created by MoMA was one of the Film Library's most important contributions to cinema culture. At MoMA, viewers were asked to take films seriously. Although audiences did not always oblige, by placing films in a con-templative museum setting, the Film Library required that fans and cultural elites question the assumption that film was a "business pure and simple," designed to entertain the masses.

The creation of museums as a nontheatri-cal distribution window for films required that

the MoMA staff (most significantly the legendary Film Library curator Iris Barry and her husband John Abbott, the Film Library's director) convince several groups that a Film Library belonged in a museum of art. The museum's trustees, for example, had more traditional notions about what belonged in a museum of art, even if it was a museum of *modern* art. By stressing the importance of particular "great directors" and including many European films in the collection, the Film Library staff connected film to other forms of "high art," thereby appeasing the trustees.

Another group that helped shape the theatrical experiences created by MoMA was the Rockefeller Foundation, which provided the key funding for the Film Library for its first few years. The Rockefeller Foundation had a strong interest in the educational potential of film. In order to meet the educational and outreach requirements of the Rockefeller Foundation, the Film Library needed to actively engage in film exhibition; however, to satisfy the museum's trustees, these screenings had to avoid resembling a night at the picture palace. The Film Library, therefore, created a space in which films could be watched in a serious and intelligent context.

Wasson clearly and astutely lays out the conflicting interests that the Film Library faced. Working with new methods of museology, MoMA was designed, through the construction of traveling exhibitions, to benefit people throughout the United States, not just those who visited the New York museum. To fit in with the goals of the museum, then, the Film Library did not just archive films and information about them but also distributed and exhibited films. Wasson offers a particularly interesting examination of the considerations that went into constructing and distributing these early film programs, especially during a politically heated time of nationalism and insecurity (films from the Soviet Union and Germany were particularly difficult to exhibit). Especially significant is MoMA's work to encourage the use of films in classrooms and to develop a network of film societies and clubs that would rent MoMA programs. Although Wasson does not delve deeply into the economic workings of the Film Library, she does provide information about the costs of renting these traveling programs, highlight-

ing the fact that film availability was one of the basic difficulties of running a film society in the interwar years.

The development of the nontheatrical market—museums, film societies, and educational institutions—was complicated by the particular arrangements worked out between the Hollywood industry and MoMA's Film Library. Reluctant partners in the plan to archive films, the Hollywood majors eventually donated some (older) films with the requirement that these films only be shown privately either through a club or an educational institution—admission could not be charged. Wasson's discussion of Hollywood's involvement with MoMA is one of the most interesting sections of the book. A memorable photograph included in *Museum Movies* shows Iris Barry looking on as Joan Crawford peers into a kinetoscope. Despite several publicity stunts, Wasson explains that the major studios, focused on profit not culture, did not recognize the significance or understand the desire to save old films; they were reluctant to help create a nontheatrical market when its potential effect on box office was not yet clear. The means used by the Film Library to appeal to Hollywood, mainly an approach centered on nostalgia and cultural history, are perhaps worthy of another manuscript.

Wasson does not suggest, though, that the Film Library was the lone agent promoting a shift in the cultural position of film. While a fair amount of attention has been paid to the creation of the art film movement after World War II, the groundwork laid for this movement before the war is rarely explored in great detail. Wasson brings together the social, cultural, and even technological (e.g., 16mm film) elements that worked together to encourage and allow the cultural "uplift" of film at this time. Based on Wasson's research, however, it appears that, despite the potential that existed in distribution and exhibition, there was not yet a significant audience that wanted to contemplate films in the ways that social reformers and museum trustees desired. While the sociocultural impetus for these films may have existed before World War II, it may be that a sizable audience for this serious film viewing did not exist until after World War II.

Additional information about the Film Library's actual audiences would have been

helpful in better understanding who was being served by this department in the late 1930s. Throughout her study Wasson primarily relies on internal documents from MoMA, along with articles in the popular and trade presses. This research provides a solid basis for understanding how the Film Library developed and its discursive positioning of film for internal and external audiences. What it does not provide is an overall look at who was watching MoMA's films. Although MoMA may not have done or kept audience surveys, interviews with people who attended screenings at MoMA at this time would have offered a livelier angle on the film-going experience.

Perhaps, however, that is another project waiting to be written, because, as it is, *Museum Movies* is an insightful and important book that draws on a range of theoretical frameworks to understand the value of MoMA's Film Library. Wasson, particularly in her conclusion, foregrounds the contemporary significance of this research. In today's world of instant media gratification, *Museum Movies* offers important insight into all the work that went into making films that had ended their theatrical runs available to scholars and fans. The importance of understanding this history goes beyond nostalgia to raise intriguing questions about the cultural acceptance of emerging media technologies, posttheatrical distribution and exhibition, and the future role of archives in media scholarship.

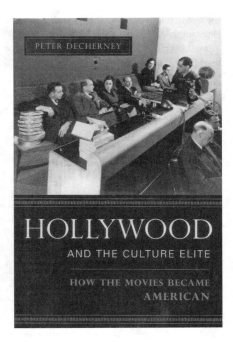

Hollywood and the Culture Elite: How the Movies Became American
by Peter Decherney
COLUMBIA UNIVERSITY PRESS, 2005

Heidi Kenaga

As a historian of early cinema accustomed to an ephemeral object of study, I am often struck by the sheer accessibility of films (and moving images) for contemporary spectators. Comparing the consumption contexts of "new media" with the exhibition and reception practices during the first three decades of the twentieth century can be a little unsettling. The quite social and public features of filmgoing in previous generations, when cinema attendance approximated that of theatrical performance in terms of restriction to time and location, may seem downright confining to younger viewers. Of course, during the studio era, U.S. film producers relied on this very temporality to predict demand and thus better control the market for their product. New films constantly replaced the old; since the studios invested most of their capital into theaters, they had little incentive to encourage exhibition spaces outside of their commercial venues. And there were other factors: the *Mutual v. Ohio* decision in 1915 had placed cinema in direct opposition to art, providing the industry with not just a legal justification for censorship but an economic imperative to ensure the production and distribution of formulaic narratives to which the fewest number of audience members might object. How is it, then, that such a corporatized product, apparently devoid of those qualities of permanence and innovation so prized in traditional discourses about aesthetic expression, could come to be considered "art" worthy of collection and study in the museum, archive, or institutions of higher learning?

This is one of the questions explored by Peter Decherney in his wide-ranging study

Hollywood and the Culture Elite. Rather than recapitulating the commonplace view that the relationship between Hollywood and American arts institutions was at best ambivalent, Decherney explores examples of active collaboration and mutual benefit between the major U.S. film producers and museums, universities, and government agencies. In historiographical terms, he offers a valuable "hidden history," presenting not a set of isolated case studies but a longitudinal analysis of an "integral but virtually unexamined aspect" (3) of the classical studio era. He argues that the film industry had myriad financial motivations for the repositioning of cinema as art: encouraging economic stabilization by defining above-the-line workers as "artists" rather than contract labor and thus not subject to unionization initiatives, and extending a film's ordinarily rather short shelf life, since the "producers realized that the value of art, when packaged properly, increases with time" (8). In addition, the transformation of Hollywood into a "civic industry" via associations with cultural and state elites helped legitimize its dominance in popular culture. In turn, such elites gained access to the broad moviegoing audience (particularly the burgeoning middle class) and thus helped maintain their status as cultural custodians with a stake in the expression and preservation of American identity, particularly those serving their nationalist aspirations. Rather than parallel histories, these developments were inextricably intertwined. At issue is the wielding of cultural power (who would lay claim to both the huge audiences commanded by Hollywood cinema since the teens as well as film's singular association with American culture?) and the articulation of cultural nationalism (how could this equivalence be used to further state agendas in the domestic and international spheres?).

Decherney's first chapter details how during cinema's first decades a variety of theorists and filmmakers in the United States and Europe (e.g., D. W. Griffith, Boleslas Matuszewski) conceived of the archive in nationalist terms, "born out of a desire to control rather than facilitate" citizens' knowledge of the world (15). In contrast, Vachel Lindsay proposed a "Universal Film Museum" in *The Art of the Moving Picture* (1915/1922), a noncommercial model for exhibiting American films in a public forum to encourage democratic debate and participation "in the negotiation of national identity" (36). Lindsay imagined a kind of filmic chautauqua whereby the twentieth-century movie theater supplanted the educative and socializing functions of the nineteenth-century museum and library, as well as Hollywood's commercial venues, in providing spectators with "civic training grounds." Despite its florid prose and highly utopian vision, *The Art of the Moving Picture* was a "seminal text in the invention of film collection" (21), notes Decherney, and influential for the avatars of film collecting in Britain and the United States, most notably Iris Barry at the Museum of Modern Art (MoMA).

In chapter 2, Decherney discusses the collaboration between Columbia University and two major producers to establish a film education program and script archive in 1915 as a means to deflect middle-class anxieties about the dangers of filmgoing in a commercial, public setting, both literally (the flammability of nitrate stock) and figuratively (the undisciplined movie theater audience). Almost since the inception of Famous Players, Adolph Zukor and Jesse Lasky had actively promoted the idea of film preservation and storage, but less out of a commitment to the cinematic artifact than to achieving cultural legitimacy, seeking to "reclassify the film industry—through the tangible example of the film print—as safe, enduring, and respectable" (47). Columbia's courses in photoplay construction were attempts to both professionalize screenwriting and tutor the movie patron in the moral and political values of American civic culture. At its core, then, this collaboration was much inflected by Progressive ideologies about "Americanization," which sought to transform "crowds" into "publics" (61).

Chapter 3 explores a subsequent partnership initiated by the studio heads in the late 1920s with another Ivy League institution as a means to reclassify their product as "art" for economic ends. Harvard's Fogg Museum was home to a rising class of experts who could evaluate films "as enduring works of art and celebrate the skilled artistry that went into making them, two goals that simultaneously helped sell old films and postponed unionization" (73). Decherney points to the significance of the "Harvard Film Library Agreement," a

blueprint for film collection that suggests the financial motivations for the foundation of the Academy of Motion Picture Arts and Sciences (AMPAS). By defining actors, writers, and directors as "artists" subject to public recognition for their innovation and aesthetic expression as distinct from below-the-line craftspeople whose labor was a relatively interchangeable commodity, AMPAS served the industry's management agenda to stave off collective action by those workers whose labor clearly had market value (the director's name, the star's aura). In turn, the Fogg Museum used the Film Library Agreement (which relied on purely aesthetic criteria) as a model for extending the practices of skilled evaluation to film, replacing the nativist and class-based "paternalism of cultural stewardship" (9) of eastern elites that excluded immigrants and Jews who had professional credentials. Although the Fogg did not apparently acquire any films, Harvard's Department of Fine Arts produced a generation of influential historians and curators who helped define cinema's place in the New York art and museum world. Some of these gravitated to the Marxist approach of film critic Harry Alan Potamkin, who promoted a library and archive of experts who would expose the "hidden class and national foundations" of the film industry rather than mythologize the commercial film as either "high art" or "just entertainment." Potamkin's untimely demise in 1933 resulted in a shift in the elites' allegiance from Harvard's Fogg Museum to the Museum of Modern Art's Film Library, whose archival initiatives ultimately moved in a quite different direction.

In chapters 4 and 5 (really the core of *Hollywood and the Culture Elite*), Decherney explores the forces behind the nationalistic turn of film preservation during the 1930s and 1940s under Iris Barry's aegis as MoMA's first curator. As a London film critic in the 1920s, Barry feared the onslaught of American imports was encroaching upon "Britain's ability to represent itself" (104). She helped found the London Film Society in 1925 out of a conviction that noncommercial venues were ideal for exhibiting domestically produced films with a specifically national character, counteracting the "emasculating" effects of the Hollywood product on the male British patron. At the same time, cinema's provision of "vicarious plea-sures" constituted a potentially empowering outlet for the female moviegoer, as "English women . . . had been denied the protected social mobility of men" (119). Soon after arriving in America, however, Barry "replaced a fear of American homogenization with an admiration for American diversity," a surprising shift not fully explained by either her taking up residence in the United States nor by the exigencies of her new position at the museum. Still, Barry's transformation was closely aligned with the emergent ethos of film collecting at MoMA. In chapter 5, Decherney situates the activities of the Film Library during World War II and the Cold War within a nexus of power brokering among Hollywood, the government, and philanthropic organizations (chiefly the Rockefeller Foundation) to promote American political ideals through the medium of popular film. Rather than redefining public taste, spectatorship practices, or responses to mainstream cinema, during this period MoMA promoted Hollywood as a "quintessentially democratic, American modernist art form" by adopting a new "patriotic, corporate museum" model that state and institutional representatives found quite amenable. Decherney rightly points out that the MoMA's politicization was part of the increasingly asymptotic relationship between media and government after the 1930s, as it became evident that popular cinema's power over mass audiences not only could be but also had to be harnessed in service of public relations campaigns. While MoMA claimed to collect Hollywood films as representative "sociological documents," the Film Library's role as "the nucleus of the U.S. film propaganda machine" during the rise of communist and fascist states in Europe became apparent as the Rockefeller Foundation established itself as its primary source of funding. With connections to state intelligence agencies and a network of communication researchers conducting empirical studies of media effects (with antecedents in the Payne Fund Studies), the foundation collaborated with the Film Library "to put theories of visual propaganda into action" and act as a primary vehicle for Americanism via "blockbuster shows and traveling exhibits" in the Cold War era.

Chapter 6 is a coda to Decherney's study of how "Hollywood film became museum art,"

investigating the persistence of avant-garde cinema in the face of the inhospitable turn in museum patronage in postwar America. Arts administrators (like Barry) and state officials regarded such filmmaking as at best not politically useful and at worst "anti-American." Of course, such views might well have contributed to the avant-garde's distinctive, oppositional status, but at the same time, this mode of cinematic production did require some sort of institutional structure or framework. The question was, "how [could it] be professional without being commercial?" (169). Jonas Mekas's controversial attempt to establish an alternative, "New American Cinema [as a] national art form with government, foundation, and museum backing" (195) in the early 1960s never materialized. For Decherney, it was paradoxically this very lack of support that created the image of the avant-garde artist as a "full-time amateur," set in opposition to the commercial film worker promoted by Hollywood (e.g., those receiving Oscars from AMPAS). He examines the complicated relationship between this Romantic figure (epitomized by Stan Brakhage) and an underlying "system of institutions— journals, foundations, distribution centers, a museum" supported by the "private patronage" (163) of Jerome Hill. Himself a filmmaker, Hill nearly single-handedly funded the production and exhibition of experimental cinema during the 1960s, including the innovation of Anthology Film Archives in 1970 as kind of "avant-garde film museum." Its theater space, subdivided into multiple individualized cubicles meant to isolate the spectator from anyone else in the audience and compel complete absorption in the film, "rejected both the commercial practice of one-time theatrical exhibition and the series format of museum film exhibition" (201). Hill's intervention was short-lived, however, as increasingly in the 1970s and 1980s avant-garde cinema was able to secure financial support from foundations.

As might be surmised, Decherney covers a lot of ground in *Hollywood and the Culture Elite,* which ironically constitutes the book's chief weakness. Individual chapters (especially the first three) present fascinating and unexamined aspects of Hollywood's collaboration with cultural elites, particularly in regard to situating the ideologies of film collection and preservation in relation to differing conceptions of the national subject and the public sphere during the early decades of the twentieth century. Yet the overarching goal to explain "how the movies became American" via the nationalist aspiration of arts institutions gets a little obscured, especially in the last chapter on avant-garde cinema. Further, while the discussion most overtly devoted to this theme— the chapters exploring the politicization of MoMA's preservation and exhibition activities during the 1930s–1950s—provide an insightful analysis of the Film Library's internal operations, there is little sense of *how* these activities disseminating "visual propaganda" were actually received by spectators, tutored and "lay," domestic and international. In his introduction, Decherney notes that he focuses on the relationship between Hollywood and taste-makers as an institutional rather than formative phenomenon, since he believes this association had no "significant impact on the political or artistic content of films . . . [whereas] an understanding the institutional filters that guide the reception of film . . . is essential to any understanding of the politics of film texts or the many ways that viewers understand them" (3), hence the book's steadfast address of consumption contexts. Still, historically the studios were often willing to alter films' "political or artistic content" in order to accommodate the demands of a variety of cultural stewards and state institutions who wanted to protect or maintain leverage over the huge moviegoing audience under the guise of making Hollywood a "civic industry." As such, the book might have addressed the similarities and divergences between the film industry's collaborations with museums and universities and those with other cultural gatekeepers. Nonetheless, *Hollywood and the Culture Elite* is a clearly written and well-researched historical work that makes a strong contribution to film scholarship and affiliated fields such as museology by providing a "hidden history" of relationships during the classical era between "institutions that guard elite and national culture" (4) and Hollywood in service of industry stabilization and product legitimacy.

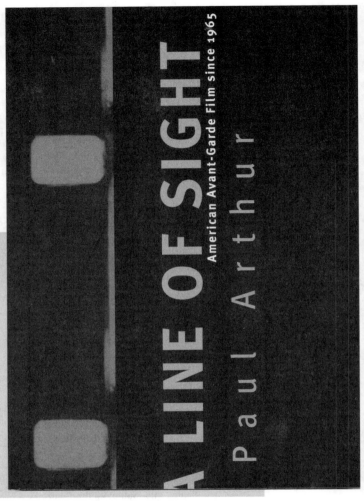

A Line of Sight: American Avant-Garde Film since 1965
by Paul Arthur
UNIVERSITY OF MINNESOTA PRESS, 2005

The Most Typical Avant-Garde: History and Geography of Minor Cinemas in Los Angeles
by David E. James
UNIVERSITY OF CALIFORNIA PRESS, 2005

Jan-Christopher Horak

Until recently, the history of American avant-garde cinema was written by critics who were often filmmakers themselves or polemicists for the avant-garde, so that their historical narratives were imbricated with other agendas. Descriptions and analyses of avant-garde films went hand in hand with valorizing specific filmmakers. Given the focus on individual works, most histories eschewed discussions of cultural contexts or theoretical frameworks in favor of enlightened connoisseurship. Unanswered were questions of how various avant-garde movements were constituted through institutional networks, historical ruptures, and continuities. As I noted in *Lovers of Cinema,* "Avant-garde film movements can only be historically circum-scribed if they are constituted in terms of production, distribution, exhibition, and reception. Their role in the history of cinema should not only be gauged according to their individual aesthetic achievements, but also in terms of the myriad contexts of their institutional frameworks and reception."[1] The two new books reviewed here are very different, but both are informed by similar concerns for establishing historical contexts. While Arthur's monograph is a collection of essays focusing on a more narrowly defined modernist film avant-garde in America, organized according to a rough chronology from the 1960s to the present, James's history of alternative film production

in Los Angeles over the past ninety years is a monumental work of historical synthesis that seeks to place Los Angeles beside San Francisco and New York as a center of avant-garde practice.

Originally published between 1982 and 2003 and reworked for the present volume, Paul Arthur's essays chronicle the American avant-garde's checkered trajectory through the past forty years. As both an acute observer and critic and a participant in the avant-garde—he has been closely associated with *Millennium Film Journal*—Arthur writes both from within the movement and from outside it, being also an academic film historian. His book's title, then, refers both to the internal vision of the filmmakers as constituted in aesthetic artifacts and to the external vision of the audience and its construction. While each chapter can stand alone, Arthur notes continuities in his introduction: "the legacy of sixties counterculture; uses and theoretical implications of found footage; the allegorizing of technology; intersections of personal and social histories; the philosophical schism between poetic, expressive tropes and structural film's anti-subjective, rationalist basis" (xiii).

Arthur's first chapter focuses on Jonas Mekas while discussing the rise of what was then called new American cinema in the context of the burgeoning 1960s counterculture, seeing in the culture at large the very same elements of incompleteness, fragmentation, and presentness in Mekas's diary films and exhibition/distribution projects. Quoting Mekas's dictum, "The policy of NO POLICY is also a policy," Arthur sees the sense of improvisation, of going with the flow, of staying independent by never tying yourself down as key to both the success and weakness of the times. An intense distrust of language went hand in glove with the lack of definitions, because language could be used by the ruling class to control. In chapters 2 and 3, then, the urge to capture the moment is explicated in terms of film portraiture and cityscapes, respectively. While the work of Andy Warhol (*Eat, Henry Geldzahler*) serves as an example of portraiture, Arthur next discusses numerous city symphonies from Shirley Clarke's *Bridges-Go-Round* to Hollis Frampton's *Zorns Lemma* to Ernie Gehr's *Signal—Germany on the Air*. Common to all these projects is a radical subjectivity that insisted on the primacy of aesthetics and formal experimentation over politics.

In the 1970s, then, the American avant-garde turned away from its "desire to exist outside history" by embracing what Foucault has called "the archive." Influenced as much by the New Historicism as by gender and sexuality politics, avant-gardists turned to the essay form to create improvisational meditations that offered multiple and often contradictory points of view by juxtaposing various kinds of found footage, whether mainstream Hollywood clips, home movies, or industrials, with autobiographical voice-overs and other images (61). Referencing works by Marjorie Keller, Alan Berliner, Yvonne Rainer, Morgan Fisher, Craig Baldwin, and, in particular, James Benning's *American Dreams,* Arthur states that "old footage is capable of exposing through its visual qualities something of the social matrix in which it was produced . . . [and these images] participate in historical and aesthetic trajectories that culminate in the achievements if the American avant-garde" (67). Found-footage projects have indeed continued to preoccupy the avant-garde right up to the present.

Moving into the 1980s and 1990s in his later chapters, Arthur comments on the predilection toward feature-length avant-garde narrative forms, as opposed to previous structural idioms, African-American experimental film and video, and feminist and postmodernist interventions into the avant-garde, while chapter 6 hones in on the Los Angeles avant-garde. Himself briefly a participant in the Los Angeles scene, Arthur sees a particular tension between the (Hollywood) industry, technology, and the environment that has been fruitfully mined by filmmakers like Betzy Bromberg and Pat O'Neill, most spectacularly in the latter's *Water and Power.*

Not surprisingly, this is also one of the theses of David E. James's monumental history of the Los Angeles avant-garde, *The Most Typical Avant-Garde: History and Geography of Minor Cinemas in Los Angeles:* "The structural tensions that shape the city geographically have recurred in the potentials that shape its arts, and Hollywood exists not only as a spatial

center around which other cultural practices construct themselves but also as a formal or thematic point of reference for them" (10). More importantly, James seeks nothing less than to rewrite the history of alternative American film practices in the twentieth century by reconfiguring the geography of those practices to encompass not only the epicenters of New York and San Francisco by adding Los Angeles as an equal partner. In keeping with recent historiography, James expands the definition of the film avant-garde to include experimental, poetic, underground, ethnic, amateur, and orphan cinemas. In moving beyond the narrowly defined formalist avant-garde of "the essential cinema," James subsumes in over five hundred pages of richly descriptive text "these diverse and often mutually incompatible avant-garde traditions" under the term "minor cinemas" (13).

James begins in the 1920s at the very moment when the major Hollywood studios had codified classical narrative as the official practice of the industry, thus pushing any formal experimentation to the periphery, even while such experimentation was firmly embedded in the modernist aesthetic of a global avant-garde that included Dadaism, German Expressionism, and Soviet Constructivism. While discussing in some detail Alla Nazimova's *Salomé* (1923), Charles F. Klein's *The Tell-Tale Heart* (1928), and Boris Deutsch's *Lullaby* (1924), James's major discovery is Dudley Murphy's *Soul of the Cypress* (1921), which the author identifies—thanks to an archival fluke—as the first postmodernist film. Originally an erotically charged, if sexually repressed, "scenic" featuring a female figure frolicking along a California coast dotted with phallic cypress trees, the only surviving print was apparently re-edited to include a stag film scene of sexual intercourse, possibly the work of Murphy or some unknown film collector. The complex semantic relationship between the original and the additional found footage allows James to conclude, "The only *Soul of the Cypress* we have, then, traces a cinema that is doubly minor, and creates one minor cinema out of another."

In the following chapter, "Hollywood Extras," James covers an incredible amount of territory from Robert Florey's *The Life and Death of a Hollywood Extra* (1927) to the amateur *Even as You and I* (1937) to Morgan Fisher's *Standard Gauge* (1984) to Julie Dash's *Illusions* (1982) to the No-Movie Collective's work. Each of these films offers a discourse on Hollywood from the perspective of outsiders who have remained invisible in the matrix of industrial relations, whether disenfranchised extras, the working class, African-Americans, or Chicanos. Chapter 4, then, shifts gears by looking at avant-garde film practice within the 1930s Hollywood film industry, namely the montages of Slavko Vorkapich, the musical extravaganzas of Busby Berkley, and Orson Welles's *Citizen Kane*.

James's method is therefore to move both chonologically and thematically, discovering convergences but also emphasizing the isolation of these alternative practices within the city of Los Angeles, their only commonality being geography and their metaphoric relationship to Hollywood. Thus, in the following chapter, James analyzes working-class initiatives in early cinema (*From Dawn to Dusk*, 1913), during the Film and Photo League era in the 1930s (*The Salt of the Earth*, 1954), and the New Left's *Los Angeles Newsreel* in the 1960s, followed by a chapter on amateurs, including Andy Warhol, Stan Brakhage, and Japanese-American filmmakers interned during World War II. Chapter 7, "The Forties," returns to the terrain of the classical American avant-garde, recontextualizing Maya Deren, Curtis Harrington, Kenneth Anger, and Gregory Markopoulos as originally quintessential Los Angeles filmmakers. Whereas Deren in *Meshes of the Afternoon* (1943) created the ur-narrative of sexual desire exploding from the confines of Hollywood objectivity to form a new radical subjectivity, her acolytes "realigned the sexual tensions by shifting from a female heterosexual to a male homosexual protagonist" (185). Subsequent chapters deal with visual artists who also worked in film (e.g. Oskar Fischinger, Jules Engel, and John Baldessari); and ethnic cinemas, including the so-called LA Rebellion (Charles Burnett et al.); Chicano Cinema (Jesus Salvador Trevino); and Asian American cinema (Karen Ishizuka); gay and lesbian films (e.g., Fred Halstead's homosexual porn classic *L.A. Plays Itself*); and independent art films about

Los Angeles. Throughout, James refers not only to canonical avant-garde works but also discovers important films that have been forgotten by history, e.g., Kent MacKenzie's feature on Native American urban dwellers, *Exiles* (1961).

But James is not just interested in films and filmmakers. Discussing working-class cinema, James incorporates a history of the labor union movement in Los Angeles, and, in a long chapter on "Minor Cinemas," James further analyzes the influence of alternative screening spaces—film societies, independent film distributors, film journalism, and film schools—on the construction of a Los Angeles avant-garde.

This is such a rich text that no review can do it justice in terms of its narrative strategies, its many surprising findings, and its ability to interweave the many disparate threads of alternative film practices and film cultures in Los Angeles. James constructs a complex montage of Los Angeles's sprawling geography and diverse topography mirrored in minor cinemas that were equally fragmented and often extremely ephemeral, just as Thom Anderson's brilliant new film *L.A. Plays Itself* (2005) constructs multifarious images of the city through the films it has produced. Like Paul Arthur's *A Line of Sight,* David James's *The Most Typical Avant-Garde* is a must-read for anyone interested in alternative film practices.

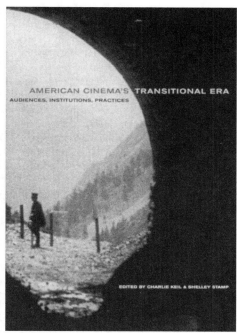

NOTE
1. Jan-Christopher Horak, *Lovers of Cinema: The First American Avant-garde, 1919–1945* (Madison: University of Wisconsin Press, 1995).

American Cinema's Transitional Era: Audiences, Institutions, Practices
EDITED BY CHARLIE KEIL AND SHELLY STAMP
UNIVERSITY OF CALIFORNIA PRESS, 2004

Kristen Anderson Wagner

The period between 1908 and 1917 was a time of tremendous change for American cinema. The increasing complexity in representational practices and formal techniques, including the transition from single-reel to multiple-reel films; the rise of the studio system and the growing cult of celebrity; the shift in exhibition from a variety format in nickelodeon theaters to feature programs in movie palaces; and the expansion and diversification of film audiences, are some of the considerations that prompt Charlie Keil and Shelley Stamp, in their anthology *American Cinema's Transitional Era: Audiences, Institutions, Practices,* to boldly state that these years "arguably witness the most profound transformation in American film history to date" (1).

The essays in this anthology never lose sight of the impact and effects of this transformational period, even while debating its terms. The book's use of the term "transitional era" to describe these years reflects Keil's earlier writing on the subject[1] but proves to be a source of contention within the volume, as several authors find the term limiting or inadequate to fully describe the period. The editors welcome these debates, and their inclusion in this volume serve to highlight and mirror the complexity of the era.

The first section of the anthology, "Defining Transition: Revision and Debate," features

provocative debates over the suitability of the term "transitional" to describe the era, as well as discussions of the applicability of the modernity thesis to transitional era films. In the opening essay, Tom Gunning examines the 1911 D. W. Griffith film *The Lonedale Operator* and claims that the impact of modernity continued to be felt in motion pictures after 1907, at which time the shocks of the cinema of attractions began to be absorbed, not always seamlessly, into longer and more complex narratives. Gunning questions the use of the term "transitional" to describe the era, arguing that this term shifts focus away from the period itself and onto the years that precede and follow it. He instead refers to the period from 1907 to 1913 as the "single-reel era." This terminology has its own set of problems, however, as it implies that single-reel films existed within a discrete timeframe, when in fact they coexisted with multiple-reel films throughout the 1910s. Furthermore, the term "single-reel era" foregrounds technological and narrative aspects while minimizing the many social, cultural, and industrial factors that helped define American cinema during these years.

Charlie Keil, in his essay, examines the theory that links the development of early cinema to a culture of urban modernity. Keil questions how modernity, which is closely linked to the cinema of attractions, continues to shape films during the transitional era, with their decreasing reliance on an aesthetic of attraction. Keil finds fault with the limited ability of the modernity thesis to account for stylistic changes that occur during the transitional era, and, while he concedes the broad point that modernity had an influence on cinema, along with other components of turn-of-the-century culture, he cautions against privileging the impact of modernity above all other determinants that shaped early cinema. Ultimately, Keil "calls for a more moderate stance in advancing arguments about how film relates to cultural trends of the period" (4).

In the next essay, Ben Brewster eschews the neat periodization that typifies so many accounts of early cinema, and demonstrates that short films and features existed as parallel institutions throughout the transitional era. Furthermore, he shows that stylistic and institutional contexts informed and influenced one another throughout this period. Like Gunning, Ben Singer argues against the use of the term "transitional" to describe the era, suggesting instead that "transformational" better captures the magnitude of the changes that took place during these years. In his essay, Singer tracks the shift from shorts to features, pointing out, like Brewster, that the two formats coexisted for a time before features eventually took over as the dominant mode of production. Singer offers the unexpected revelation that, contrary to many historical accounts, short films did not suffer a sudden, cataclysmic demise upon the introduction of features, but rather they continued to be produced in increasing numbers until 1915, well into the feature-film era. The two were able to initially coexist, he points out, because each format was seen as filling distinct needs in the market in much the way that legitimate theater and vaudeville did.

The book's second section, "The Transitional Screen: New Genres, Cultural Shifts," addresses issues of representation and spectatorship in the transitional era. The four essays in this section demonstrate that the transition from an attractions-based cinema to classical Hollywood cinema was not acted out exclusively onscreen. Just as formal and industrial elements changed, so did the role of the audience, as spectators adjusted to the changing cinematic landscape. Jacqueline Stewart, in her essay on black female domestic characters, reveals the way that these and other African American figures served to "unify the gaze of an increasingly diverse 'white' audience" (109). At the same time, the visibility and mobility of the black female domestic in motion pictures, her ability to disrupt both the film's narrative through unruly performances as well as the orderly and specifically white world presented within the film provided spectators with an alternate, subversive way to read these characters and these films. In the next essay, Richard Abel addresses the formation of a mass audience by showing how the "imagined community" of the Western helped to create a specifically "American" identity in the United States and overseas.

Lauren Rabinovitz and Jennifer Lynn Peterson, in their essays, suggest that certain

transitional-era genres elicited a mode of spectatorship far different from the passive and fully engaged viewing of the classical era. Rabinovitz compares the corporeal delight audiences experienced when viewing slapstick comedies to the physical sensations encountered at turn-of-the-century amusement parks and argues that "this kind of physiologically engaged spectator negates the notion of a distracted, disembodied spectator that reigns as the ideal in spectator theory" (175). Peterson, writing about travelogues, suggests a spectator very different from the laughing, embodied viewers posited by Rabinovitz but one who is similarly removed from the classical model. Although travelogues were touted for their educational and uplifting qualities, Peterson sees more subversive possibilities in them, suggesting that viewers may have experienced a dreamlike state while watching these films. Travelogues succeeded in circumventing classical modes of spectatorship as well as reformers' calls for uplift by "[encouraging] exotic fantasies just as much as they served any educational purpose" (195).

The essays in the final section of the anthology, "The Industry in Transition: Changing Institutions and Audiences," focus on industrial issues, from cinema's role in shaping urban geographies to the film industry's uneasy relationship to women's impact on motion pictures. J. A. Lindstrom's essay highlights the ways nickelodeon theaters in Chicago were an important part of industrial and tenement neighborhoods, and how they helped change new working-class neighborhoods as the city grew. Lindstrom's research shows that early film audiences were not as static as many film histories have claimed and that movie theaters played an important role in forming new communities away from immigrant ghettos. Scott Curtis looks at the rise and fall of the Motion Picture Patents Company (MPPC) in his essay, arguing that the group's demise was due in large part to the tensions that came about as short films gave way to features. Disputing the familiar account that the MPPC was brought down by court decisions that left their patents unenforceable, along with the group's unwillingness to abandon the single-reel format in favor of features, Curtis claims that internal friction was the primary reason for the group's decline. This internal friction, caused by the members' "inherent mistrust of one another, coupled with self-interest at the expense of the organization" (241), ultimately led to paralysis within the group and an inability to react to changes within the industry that they helped create.

Efforts by reformers to render "harmful" cinema "harmless" are discussed by Lee Grieveson in the next essay. Censor boards envisaged the public role of cinema as apolitical and culturally affirmative, a perception that would shape cinema's function throughout the classical era. Constance Balides addresses in her essay another hot topic for reformers, the commercialization of leisure and the "social disease of specatoritis" (289).

Roberta Pearson's essay details the complicated relationship between cinema and live theater during the transitional period. Pointing out that cinema had been dependent on the theater for performers, exhibition venues, and representational practices during its early years, Pearson claims that this dependency continued into the 1910s. Although the differences between the two forms of entertainment were such that the cinema never fully absorbed the theater, many writers at the time blamed motion pictures for the theater's declining popularity. Pearson offers the intriguing assertion that, as the theater responded to the threat of the movies, it was redefined as a medium for the minority, a highbrow alternative to cinema's mass appeal. In this way cinema's effect on theater can be seen in a positive light: by "freeing it from the demands of the mass audience" (326) motion pictures provided legitimate theater with the opportunity to define itself according to its newfound cultural prestige.

In the book's final essay, Shelley Stamp examines the discourses surrounding starstruck young women who flocked to Hollywood hoping for a chance at fame and fortune in the motion pictures. The press had a contradictory relationship to these women, on the one hand breathlessly describing the Cinderella-type success stories of beauty contest winners and extra girls plucked from obscurity and signed to lucrative contracts, while at the same time

warning of the dangers that awaited young women on their own in Los Angeles and encouraging movie hopefuls to stay home. Stamp argues that the focus on "movie-struck girls" longing for a chance to see themselves on screen and the myth of young women "discovered" by male directors and producers minimized the actual contributions made by women in the film industry. These stories perpetuated the idea of women passively waiting to be seen rather than actively working at their craft. Stamp points out that the mid-1910s was a period of tremendous opportunity for women screenwriters, directors, and producers, a fact that was overshadowed by the widely circulated images of long lines of would-be starlets standing outside studio gates. Furthermore, by depicting aspiring actresses as victims of their own delusion or, even worse, of unscrupulous male producers and directors, these accounts "disarmed the considerable threat that hundreds of unmarried, casually employed, recently transplanted young women posed to the filmmaking industry, to the Los Angeles community, and to ladylike codes of behavior" (343).

American Cinema's Transitional Era provides a lively and accessible survey of a long-overlooked period of film history. The essays contained in this anthology only scratch the surface of this complex era but offer the reader an intriguing view of the industrial, social, and historical forces that played a role in shaping cinema between 1908 and 1917. The debates and differences of opinion expressed by the authors seem somehow appropriate to a period in film history so uniquely characterized by difference, transformation, and possibility.

NOTE

1. Charlie Keil, *Early American Cinema in Transition: Story, Style, and Filmmaking, 1907–1913* (Madison: University of Wisconsin Press, 2002).

Films

Walden (1969)

FILMED AND EDITED BY JONAS MEKAS
VHS DISTRIBUTED BY RE:VOIR VIDEO EDITIONS

Joshua Mabe

A wealth of immediate and intense beauty on display in Jonas Mekas's *Walden* can be found in the pleasures of watching a frantic kaleidoscope of circus performers, deep green grasses, and the amusement of children and friends at play. *Walden* is unique in that it has many such moments that can be viewed separately from the film as a whole, like reading a favorite poem from a collection. And just as more familiarity with a poet's world increases appreciation for

each individual poem, so too can the experience of watching *Walden* be deepened by viewing the film as a whole and knowing something of the world in which it was filmed.

Walden is a collection of diary films created by poet and filmmaker Jonas Mekas from the spring of 1965 through the summer of 1968. According to the filmmaker, these filmed diaries were never intended to be shown publicly but were meant to be exercises in form that would help him master the intricacies of the handheld 16mm Bolex. Mekas wanted to capture images around him instantly so that no moment would slip away unfilmed due to hesitation over technical issues. The spontaneity of the filming often makes *Walden* feel like a home movie, which it essentially is. However, the connection to the home-movie style is more of a spiritual kinship wherein Mekas embraces the amateur, allows for "mistakes," and generally accepts the consequences of immediate expression, ultimately integrating those consequences into an aesthetic.

There is a feeling of continual invention and discovery throughout *Walden*. The only consistency in the shooting and editing styles is in the joy of abandoning forethought for a passionate connection with the film and the people and events depicted. On display is an encyclopedic litany of avant-garde techniques: rapid montage, superimpositions, portraiture, various film speeds, and abstraction, just to name a few. The film's many intertitles, jumps in chronology, and both aural and written commentaries lightly hold together these imaginative cinematic diaries.

Viewing *Notes on the Circus*, for instance, provides a fascinating example of the shifts in meaning in each element of the film. This twelve-minute section of *Walden* consists of five uncut hundred-foot rolls of film that document several performances by the Ringling Bros. and Barnum & Bailey Circus and were shot in a combination of fast-motion and single-frame styles. The dreamlike intensity of *Notes on the Circus* seems to mimic saccadic eye movement. Mekas's Film-Maker's Cooperative catalog entry for this film states that it can be viewed without sound for the "film purists." When viewed silently, the film appears frantic and blindingly chaotic. The musical accompaniment by Jim Kweskin's Jug Band provides a levity and buoyancy that is not necessarily found in the images, and the music acts to conceal the danger and intensity of the visuals.

Mekas's achievements as filmmaker, poet, and founder of the Anthology Film Archives, the Film-Makers' Cooperative, and *Film Culture* journal are probably familiar to most readers. Less well known are the dozens of friends and associates who appear in *Walden*. Enjoyment of the film does not depend on an intimate knowledge of everyone who appears onscreen (many are left unidentified), but certainly the more one knows about the events depicted, the more accessible the film becomes. Re:Voir's new box set of *Walden* goes to great lengths to provide a context for the work and to deepen the experience of viewing it. Packaged with the two videocassettes is *The Walden Book*, which includes an essay on diary films by David E. James and an appreciation of Mekas by Jean-Jacques Lebel. The book also includes a scene-by-scene breakdown of the entire film, transcriptions of the title cards, and descriptions of the scenes and sounds. For some scenes, there are explanations of what is actually shown, usually including direct quotes from Mekas. Other scenes are explained through reminiscences from friends that relate to the events that are shown. Each person of note that appears onscreen (such as Barbara Rubin, Peter Kubelka, or Allen Ginsberg) is introduced in the text and his or her relationship to Mekas is explained. Like most avant-garde films, *Walden* defies easy summary. There is no simple narrative and to attempt to describe the events of the film would simply restate the text of *The Walden Book*.

However, no matter how faithfully the accompanying book tries to document the facts of the film, *Walden* remains a deeply personal work in which many moments remain enigmatic. The energy and lightheartedness one feels as Mekas films children jumping on a trampoline with the sun shining bright behind them needs no explanation. Similarly, why Mekas chooses a grand piece of music for a simple driving shot or why one detail at a dinner party catches his camera's eye will remain inscrutable. This is a film where the discovery of rabbit shit in the snow is treated as a revelation.

Mekas's entire diary film output is novel and somewhat confusing with its nesting-doll

structure. This film contains four separately released shorter works: *Report from Millbrook* (1965/1966), *Hare Krishna* (1966), *Notes on the Circus* (1966), and *Cassis* (1966), each a complete work with different styles and subjects. *Walden* itself is only part of a larger work called *Diaries, Notes, and Sketches,* a name that refers to Mekas's complete oeuvre. Mekas allows and encourages viewers not to view the film in its entirety but rather to move through the film nonlinearly; flipping back to certain moments, for example, for greater understanding or enjoyment. He is quoted in the book as saying that one does not read a novel in one night, and similarly one should not have to view a film in one sitting. However, for those unfamiliar with Mekas's style, there is much to be gained by watching *Walden* straight through, even though it may require some initial effort to connect to its cinematic rhythm and language.

Entering into Mekas's world through *Walden* is genuinely refreshing for its near complete lack of judgment and heartfelt fondness for its subjects. In this world, narrative filmmaking's concern for good and bad or conflict and resolution are irrelevant. People simply exist and are celebrated. Mekas revels and luxuriates in the ecstasies of the world around him and it's a pleasure to be taken on the journey with him.

Why We Fight
Directed by Eugene Jarecki
Sony Pictures Classics, 2005

Jill Kozeluh

In its exploration of the forces that have determined U.S. foreign policy since World War II, Eugene Jarecki's latest documentary, *Why We Fight,* takes a closer look at the increasingly influential role of the military-industrial complex. In light of recent reports indicating that the United States government will spend close to two trillion dollars on the Iraq War, this film is a necessary meditation on the profitable nature of war as well as the public's conception of freedom and democracy.[1] Guided by two important pieces of archival footage — President Dwight D. Eisenhower's 1961 farewell address, in which he discusses how the military-

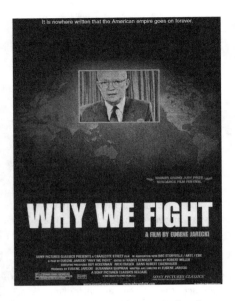

industrial complex could compromise democratic liberties, and Frank Capra's *Why We Fight* film series, which explores America's reasons for entering World War II — Jarecki's film asks, why do we, Americans, fight?

When considering contemporary social commentary pertaining to U.S. foreign policy, the film's argument is quite familiar. Michael Moore's *Fahrenheit 9/11* provides a scorching criticism of President George Bush's policies following the September 11 attacks. And in *The Fog of War,* former U.S. Secretary of Defense Robert McNamara discusses the important lessons he learned about foreign policy and modern war, lessons that are certainly relevant today. Although *Why We Fight* is firmly situated in the most recent cycle of political documentaries intended to stimulate serious debate, the film differentiates itself in the way it appropriates archival footage to denounce the many forces that have pushed the United States in the direction of war since World War II. Jarecki invokes Capra's footage to serve partly as a historical document as well as to contrast the attitudes U.S. citizens expressed in World War II with those today expressed about the Iraq War. The archival footage is not mere supplementary material but rather plays a vital role in linking the past to the present.

Furthermore, the film does not, as Roger Ebert writes, tell "us nothing we haven't heard before."[2] Yes, we have heard similar arguments

about U.S. politics before, but unlike many political documentaries that vilify one individual or institution, *Why We Fight* reveals a complicated, multitextured machine of great magnitude that includes people at all levels of society. Changes in government and foreign policy, the film argues, demand more than plucking one individual from this system; removing the current U.S. president will not, unfortunately, eliminate the problem. U.S. militarism has been and is a system in progress; it is a mosaic composed of many parts and pieces. And contrary to Ebert's view, this *is* something most American citizens do not know. Many people who do not have time to connect the dots and thoroughly explore relations between government, military, and business may perhaps rely on someone else to do such probing. This is not to say that everything in Jarecki's film—or any documentary for that matter—is completely accurate; however, documentaries of this nature are effective in asking the right questions and invoking further discussion on such issues.

Why We Fight opens with archival footage of President Eisenhower's farewell address, in which he cautions U.S. citizens of the perils of the military-industrial complex, a term that was first used publicly by Eisenhower in this speech.[3] Although he believed in sustaining a solid military base, Eisenhower warned of the increasingly influential role of the military-industrial establishment:

> This conjunction of an immense military establishment and a large arms industry is new in the American experience. The total influence—economic, political, even spiritual—is felt in every city, every State house, every office of the Federal government. We recognize the imperative need for this development. Yet we must not fail to comprehend its grave implications. Our toil, resources, and livelihood are all involved; so is the very structure of our society. In the councils of government, we must guard against the acquisition of unwarranted influence, whether sought or unsought, by the military-industrial complex. The potential for the disastrous rise of misplaced power exists and will persist. We must never let the weight of

this combination endanger our liberties or democratic processes.[4]

As Eisenhower warned, military contracts should not dictate U.S. foreign policy; government works for the citizen and not for military contractors. Today Eisenhower's words echo with clear resonance when considering the current government's associations with those (former President George Bush, Vice President Dick Cheney, and Colin Powell) affiliated with military contracting companies and who stand to profit from a war. In helping to secure military contracts for their close acquaintances and business colleagues, politicians are serving corporate interests before those of the citizens. Consequently, the United States is motivated to enter into war for reasons that go beyond the standard one supplied to its citizens—the dire need to promote democracy and freedom in other countries. And using democracy and freedom as a guise for self-serving motives, the film argues, is a serious problem.

In examining America's predilection for war, Jarecki defends his appropriation of Frank Capra's film series *Why We Fight* to further critique the corporatism that he finds compromises democracy today. Jarecki expressed his admiration for Frank Capra and his work during our interview in January 2006 in Chicago. Jarecki explained, "He [Capra] asked Americans to be willing to stand up and fight to defend democracy, which was imperiled overseas. And in my film *Why We Fight*, I am also urging Americans to stand up and fight to defend democracy. It's just that I see democracy imperiled here at home."

In revealing portions of Capra's film series in his own work, Jarecki invites comparison of America's attitudes toward World War II with perspectives on the Iraq War. Both Capra and Jarecki ask and attempt to explain why America fights. But in sharp contrast to Capra's footage of American citizens unified in their support for the war effort, Jarecki's film features citizens doubtful about the current war. To take one example, a woman today who works in a factory that creates bombs for war admits that she would prefer to make toys for children.

Another noteworthy comparison between Jarecki's documentary and Capra's film series

includes its representation of U.S. citizens. The Capra footage as viewed in Jarecki's *Why We Fight* consists of citizens working together—a group of men prepare a plane for warfare and people in the factory busily construct war products.[5] Jarecki's decision to single out shots of collective unity among citizens during World War II paints a vastly different wartime picture when compared to today. Jarecki's presentation of war today features individuals more divided than those in Capra's footage.[6]

Jarecki's and Capra's representation of the enemy also greatly differs. Whereas Capra depicts the Axis powers as villainous and inhumane, Jarecki provides a sympathetic portrayal of Iraqi civilians coping with war devastations. As Bill Nichols notes, Capra's representation of America—a country that refuses to address its own social problems—is in strong contrast to the demonic, dictatorial regimes it condemns. Nichols observes, "How America can be a cherished, free democracy in the face of these problems would require a far more elaborate argument, one that would detract from the primary goal of painting a clear-cut picture of good and evil."[7]

Jarecki noted during our interview that he also uses these archival materials to clearly illustrate the significance of the past: "It is the role of the archivists and preservationists to cause the past to haunt the present, to require that the past be allowed to haunt the present, and force us to remember and absorb, and hopefully learn, the lessons of history." His use of archival footage serves many purposes, but, above all, it functions as a force of political change. Jarecki explained that he tries in his own way to tell an interesting story that will attract the spectators' attention and inspire greater public dialogue. And in his individual style, which includes using archival footage to question contemporary social problems, Jarecki hopes to promote a form of dialogue centering on today's social issues.

In surveying the complicated landscape of U.S. foreign policy since World War II, Jarecki also interviews individuals whose beliefs range across the political spectrum. His bipartisan approach includes commentary from key political figures (such as Senator John McCain), neoconservatives supportive of America's foreign policy (such as William Kristol and Richard

Perle), and critics openly opposed to U.S. foreign policy (such as Gore Vidal, Charles Lewis, and Karen Kwiatkowski).

One of the film's most memorable characters includes Wilton Sekzer, a retired New York City police officer and a Vietnam War veteran whose son was killed while working in Tower One of the World Trade Center on September 11, 2001. After hearing President Bush explain that Saddam Hussein was accountable for the attacks on September 11, Sekzer decides to honor the memory of his son by having his name painted on a bomb that would be dropped on Iraq. Time passes and the President declares that he never made the connection between Saddam Hussein and September 11. Sekzer's anger and dismay over the president's words leave him feeling guilty about his son's name being written on a bomb used in a war motivated by corruption and lies. He mulls over this decision, "Was I wrong to write my son's name on the bomb?"

Sekzer, who was once extremely supportive of U.S foreign policy, realizes that his patriotism and love for the country were exploited in order to carry out a war motivated by reasons concealed from citizens. Sekzer, as Eisenhower did in his 1961 farewell speech, shows that it is possible to change your views after being presented with new information. Eisenhower, a former militarist himself, comes to understand the threat that the military establishment could pose in the future. Similarly, Wilton Sekzer, Jarecki explained, "inspires people to recognize the possibility for change at a time when we need change. And since you need change, it's important to see examples that it's possible, otherwise you become deeply disillusioned."

Finally, does the film answer the question posed: Why do we fight? We fight for many reasons. As the film suggests, we fight for power and control; we fight for capitalism; we fight for the right to free markets. Responses among average U.S. citizens interviewed in the film are certainly varied in complexity and depth. Some stated that they believe we fight for oil; others answered that they honestly do not know why the U.S. went to war with Iraq. Many cited freedom and democracy as justifications for going to war. Jarecki discovered that when people were then asked to elabo-

rate on freedom and democracy, they had their doubts about these concepts. He remarked,

> It's very difficult to answer [why we fight] and people struggle with that, and I think the first thing people say when we ask them all around the country was freedom. And if I ask one more question and dig a little deeper, you discover very quickly beneath the surface of that word freedom people have doubts. And they're having trouble reconciling the hopes for democracy that they have with the reality in this country that they see.

Jarecki effectively leads the audience through an immense collection of historical events and interviews that presents a general overview of U.S. militarism and the ways it jeopardizes democracy and freedom today. The presentation of information, figures, dates, and testimony is organized in a way that balances the demands of seeking truths with those of entertainment. Above all else, Jarecki's *Why We Fight* espouses former President Eisenhower's call for "alert and knowledgeable citizenry" and urges citizens to engage in dialogue about contemporary social issues.

NOTES

1. Jamie Wilson, "Iraq War Could Cost U.S. Over $2 Trillion, Says Nobel Prize-Winning Economist," *The Guardian Unlimited,* January 7, 2006, http://www .guardian.co.uk/Iraq/Story/0,2763,1681119,00.html.
2. Roger Ebert, review of *"Why We Fight," Chicago Sun-Times,* February 17, 2006, http://rogerebert .suntimes.com/apps/pbcs.dll/frontpage.
3. See "Military-industrial complex" in *Wikipedia: The Free Encyclopedia,* http://en.wikipedia.org/wiki/ Military-industrial_complex.
4. Dwight D. Eisenhower, "Military-Industrial Complex Speech," *Public Papers of the Presidents,* http:// www.yale.edu/lawweb/avalon/presiden/speeches/ eisenhower001.htm.
5. Bill Nichols notes that the representation of U.S. citizens in Capra's *Why We Fight* is that of a collective unit. Film techniques such as editing function to deny the viewer from identifying with one individual and, instead, the viewer identifies "with the sense of collective participation itself." See Nichols's *Representing Reality* (Bloomington: Indiana University Press, 1991), 174.
6. It is worthwhile to note that Frank Capra's film series *Why We Fight* was produced by the U.S. War Department and the U.S. Army Special Service Division. This certainly influences the nature of Capra's representation.
7. Nichols, *Representing Reality,* 136.

IN THE REALMS OF THE UNREAL
A Documentary by Academy Award® Winner Jessica Yu THE MYSTERY OF HENRY DARGER

Notre Musique (2004)
WRITTEN AND DIRECTED BY JEAN-LUC GODARD
PRODUCED BY AVVENTURA FILMS
DVD DISTRIBUTED BY WELLSPRING MEDIA

In the Realms of the Unreal (2004)
DIRECTED BY JESSICA YU
PRODUCED BY DIORAMA FILMS
DVD DISTRIBUTED BY WELLSPRING MEDIA.

Lindy Leong

Speaking from "purgatory," Jean-Luc Godard, in his familiar sardonic tone, declares that "humane people don't start revolutions, they start libraries." To this observation, an addendum, "and cemeteries," follows and imposes on us an ambiguous truism. In this meditation on war, genocide, violence, and ethnic hatred, the former *nouvelle vague* enfant terrible continues his exploration into who and how we might interpret and interrogate history and the possibilities of gleaning new regimes of knowledge. Simultaneously privileging and condemning the site/sight of the cinema, he insists on the feasibility of the two faces of truth: "death; life,"

"dark; light," "good; bad," "real; imaginary," "activist; storyteller," . . . "shot; reverse shot."[1]

Likewise, these "eternal opposing movements" haunt Jessica Yu's *In the Realms of the Unreal,* an animated, documentary fiction on reclusive Chicago janitor Henry Darger and his secret life as artist/storyteller of a 15,000-page illustrated epic, *The Story of the Vivian Girls, in What Is Known as The Realms of the Unreal, of the Glandeco-Angellianian War Storm, Caused by the Child Slave Rebellion.* The title itself merely gazes upon the surface of this man's complex, interior life, only made public in 1973 after his death at age 81. Just as Godard contemplates the history of cinema and the cinema of history as "deeply personal, but which is also the story of us all," Yu weaves a universal tale of a social outsider who, by retreating into a world of his own creation, showed us the capacity of the human imagination to thrive and survive in captivity.[2] The films resonate with each other for they explore the parameters of intelligibility constructed by the artist and his oeuvre, the work of memory and its often-clandestine relationship to personal and historical trauma, and the archive as theoretical and cultural concept.

These journeys toward historical and universal truths foreground the artistry both of their subjects and their creators. Considerations of Godard and the French New Wave's contributions to and influence on the cinema being numerous, here we mention Godard's autumnal achievements, beginning with his eight-part, made-for-television video essay *Histoire(s) du Cinema* (1988–1998), along with *For Ever Mozart* (1996), and *In Praise of Love* (2001), in order to elucidate the composition and mastery of *Notre Musique.* Viewing these in succession reveals a progressive build-up or crescendo toward some breakthrough meditation about modern existence, fraught with ethnic strife, the physical and psychological ravages of war, poverty, underdevelopment, incurable diseases, and the inchoate mess of making sense of it all in everyday life. In a dialogue with Godard, art historian Youssef Ishaghpour elaborates succinctly on Godard's concern in his cinema of the past two decades:

> You position yourself below the vicissitudes, without avoiding them, and also

above them, in a synthetic perspective from which cinema stops being the entertaining spectacle it is generally held to be, or the specialist area it is for cinephiles, to appear as it really is, not just the major art form of the twentieth century, but the center of the twentieth century, embracing the human totality of that century from the horrors of its disasters to its efforts at redemption through art.[3]

This striving for "redemption through art," with its reference of a Judeo-Christian belief system lies at the heart of Henry Darger's inner struggle, which fueled his art. In the universe he constructed, the forces of dark and light and the real and imaginary fought each other for control. His *Realms of the Unreal* told the story of the Vivian Girls, a royal family of pubescent sisters strong of will and body, and how they became foot soldiers of God to redeem the Christian land of Anniennia from the evil, godless Glandelinians. Incorporating biographical details from the reality of his life with fiction culled from his favorite books, comic strips, and popular culture, Darger honed his skills as an image collagist and paved his legacy as a major figure of "outsider art."[4] Besides this volume of illustrations and accompanying text, he left behind an autobiography that has offered intertextual evidence and has functioned as a means for deciphering his *Realms.* Whether the two corroborate each other isn't clearly conveyed in Yu's film.

Was Darger a mad genius, as Yu's "version" posits, or perhaps, as art historian John MacGregor's alternative and unpopular view has it, did Darger possess a perverse and criminal mind, a kind of true madness?[5] Yu's decision to tell Darger's story as one of light over dark, in the documentary mode augmented by animated sequences, tableaux vivants of illustrations from the *Realms,* demonstrates a commitment to a celebration of the creative impulse as a force of life over death, an ultimate truth. In the interview included on the DVD, Yu speaks of her work as a "requiem" and as an imaginative retelling of Darger's life. She describes the exorbitant amount of material he left behind in the small room he occupied for most of his life (besides his novel, Darger had journals, paintings, and other collections). With the excep-

tion of three photos of Darger, the lack of physical evidence of his existence forced — or rather allowed — her license to "invent" him as she envisioned.[6] In this respect, intelligibility of the man and his art requires one to subscribe to a blind faith in the image and text as evidence.

Godard's project indulges in its enigmatic nature and symbolism in tandem. While Yu weaves three narrative strands (the autobiography of Henry Darger, the reception and perception of him by the outside world, and the fictive world of the Vivian Girls in his *Realms*) into one complete story, Godard employs a triptych structure reminiscent of Dante's *Divine Comedy* in his designation of "Hell," "Purgatory," and "Heaven," which, he explains, refer to "a past, a present, a future; one image, another image, and what comes between . . . the real image, the third person, as in the Trinity." For the main section, "Purgatory," he chose as his setting Sarajevo, a city still in midst of healing from political turmoil and civil war. The hell of war and his hope for heaven for the city as metonymy for the question of Europe in the twenty-first century occupies the heart of his cinematic essay.

Both Godard and Yu use narrative structures wherein multiple, contradictory perspectives coexist on equal terms and open the space to explore the work of memory and its relationship to personal and historical trauma. Creating his own cinematic language where the fundamental unit of shot–reverse shot is embedded in montage, Godard quips about destroying a way of using the written form that refuses to respect images, especially in a story centered on a fictional literary conference with its poets and writers serving as his Greek chorus.[7] Yu admits to the controversial inclusion of animated sequences of Darger's illustrations as both a means of bringing to life the artist, rather than focusing on the man's mental instability, and as a storyteller, using these images to impose "control" and "explanation of that world" in the eyes of that artist.[8] Only having three photos of Darger meant she could not rely on archival footage culled from home movies, family collections, and public information, as Darger's hermitlike existence kept him out of any limelight. Instead, his story is told primarily through the voiceovers of Larry Pine as stand-in for Darger relating biographical details in

semichronological order, and child-actress Dakota Fanning as representative of his youthful conscience and the characters in *Realms*. Further adding to his mystique, talking-head interviews of Kiyoko Lerner (his landlady and copyright holder of his works), Mary O'Donnell (daughter of his previous landlord), and neighbors Mark Waters and David Berglund confirm the view of him as an eccentric genius trapped in the shell of a nondescript, humble man.

Godard's asceticism in dividing his film into three distinct sections allows for more precision in analysis. The "Hell" and "Heaven" sections, both only ten minutes long, bookend the hour-long "Purgatory" center. As a prologue, "Hell" consists entirely of archival footage constructed as image collage recalling *Histoire(s) du Cinema*. He organizes "Hell" into four parts divided along units on wars, technology, victims of war, and images of Sarajevo during its civil war, but this is not easily apparent in his visual menagerie. Guided only by the strokes of a lone piano, documentary footage of gunfire, airplanes, tanks, battleships, executions, devastated countrysides, the holocaust, and the atomic bomb commingle with Hollywood film clips from *Apocalypse Now, Zulu,* and *Kiss Me Deadly*. He explains his method as "an Idea in the form of a constellation," an homage to Walter Benjamin's notion that stars, at a given moment, form constellations where resonance between the present and the past exist fluidly.[9]

Creating this space of contemplation remains Yu's goal, and she enlists an animation team headed by producer Kara Dallow to accomplish this. She intends the "progressive inclusion" of animated sequences not just as a means of filling the gaps in Darger's history but as what has been attributed to Godard's recent work as a "re-memorization" rather than history written in the indicative, a view from the outside. To be sure, Darger's life and art bear this out not only in his literal influence as a representative of "outsider art" (art created by self-taught and disenfranchised artists on the fringes of society) but in a symbolic sense, as his life was in his art as much as his art was in his life, and echoing Godard's proclamation in his prologue that "we consider death two ways: the impossible of the possible and the possible of the impossible." The compelling aspect of Darger's filmic story remains its

functioning as a moratorium of his life after death. In this manner, it reconciles both the impossibility of the possible and possibility of the impossible in that any ultimate truth about his life would most likely be found in an exploration of his art.

Meshing his ongoing dialogue on the cinema of history and history of cinema with a pointed critique of contemporary war and political conflict, *Notre Musique* reanimates history on a polyvalent canvas, conveying both an intellectual and sensorial experience. Our act of witnessing history in movement materializes in the intertwined, divergent trajectories of the two heroines, Judith Lerner (Sarah Adler), an Israeli journalist, and Olga Brodsky (Nade Dieu), a Jewish Israeli/Russian "student" and the niece to Godard's translator colleague, Ramos Garcia (Rony Kramer). Through their respective points of view, we see the impact of personal and historical trauma on contemporary European culture and identity politics, filtered through the prism of the legacy of the Holocaust, the repercussions of the ends of communism, and the ongoing Israeli–Palestinian conflict. Judith gravitates toward the light in her quest for reconciliation and healing of that trauma. As part of the European Literary Encounters entourage, she tells French Ambassador Naville (Simon Eine) of her family history and how he, in an act of resistance against the Nazi authorities, housed a young Jewish couple in Vichy, France, in 1943. Using her parents' story to inflect her understanding of the Israeli–Palestinian conflict and the French position on that subject, she seeks engagement in "just a conversation" over "not a just conversation" with him. Essentially a writer of historical events in movement, Judith takes a stand at the front lines.

Olga attends Godard's lecture on "The Text and the Image" and absorbs his words on film grammar. She learns that the shot–reverse shot form parts of the whole truth or the central conceit that "truth has two faces." In this scene, she channels her own malaise of personal and historical trauma through the cinematic syntax of text and image. Her epiphany, as lines of dialogue or quotations from the historical script, sets her on a path toward the dark. Olga sees no hope of reconciliation, and the weight of personal and historical trauma burdens her so much she chooses death. The symbolic movement from experience back to innocence, from death to life, emerges just as Godard is asked, "Can the new digital cameras save the cinema?" to which he remains absolutely silent, unable to respond or cast judgment. As Olga remains unconvinced of healing her trauma or about the question of Europe, she martyrs herself in a Jerusalem cinema. Like Christ, she views salvation in a life after death. The fact that her actions can be mistaken as that of a suicide bomber conjures immediacy, a sense of pathos for any contemporary audience. She leaves behind a DVD of a little digital film she made for Godard, a sympathetic spirit and someone who could make sense of her "story," just as Yu's apparent affinity for Darger's story exemplifies.

In this fluidity of text plus image as space of memory and its relationship to trauma, Godard and Yu's works comment on the archive as a theoretical and cultural concept. Cinema offers itself up as both site and sight of developing new regimes of knowledge and creates its archive. Historian Carolyn Steedman affirms this notion of the archive as a potential site/sight of knowledge and the idea of history as not just stuff but as process, as ideation, imagining, and remembering:

> It is a common desire — it has been so since at least the end of the nineteenth century — to use the Archive as metaphor or analogy, when memory is discussed . . . an Archive is not very much like human memory, and is not at all like the unconscious mind. An Archive may indeed take in stuff, heterogeneous, undifferentiated stuff . . . texts, documents, data . . . and order them by the principles of unification and classification. This stuff reordered, remade, then, emerges — some would say like a memory — when someone needs to find it or just simply needs it, for new and current purposes.[10]

In repurposing and recontextualizing various types of archival footage, Godard's audiovisual pastiche of Hollywood and popular culture with classical imagery of religious iconography and premodern, baroque allusions to aspects of European high culture, philosophical preoccupations, and fallacies simultaneously recalls the past and "projects" a future through its

soliciting questions rather than offering answers. As he indicates in his conversation with Ishaghpour, "an image is peaceable. An image of the Virgin and her baby on a donkey doesn't cause a war. Its interpretation by a text is what leads to war."[11] By remaining "silent" in favor of any solution, judgment, or criticism of either Judith or Olga's choices, he mines our collective archive as a common lexicon of a shared cultural memory to pose the vital questions of our time as a humanistic refrain to "our music."

Like a historian going to the archive to be at home as well as to be alone,[12] Yu enters Henry Darger's "archive," the small room he occupied at the Webster House in Chicago, for the selection process of visualizing the key themes of his *Realms of the Unreal* for her film. We learn Yu received full access to Darger's "archive" and his works through the cooperation of his landlady, Kiyoko Lerner, who, as owner of the "archive," we could conjecture has a vested interest in the romantic image of Darger as an eccentric genius rather than that of mentally ill degenerate. The latter has been suggested through an interpretation of his *Realms* as overtly bordering on child pornography, pedophilic fetishism, and sexual degeneracy. For instance, the Vivian Girls are depicted as little girls with penises, often in various states of undress, and, in Darger's universe, they can do anything full-grown men could do, such as fight in battle, and so forth. The Vivian Girls and their leadership of an army of children endure much physical violence inflicted upon their bodies. Graphic depictions of disemboweled, decapitated, and impaled naked children in the battlefield trenches and on crosses fill up much of Darger's illustrations. In the DVD interview and at a recent documentary salon, pressed for answers on the sexuality of his work, Yu quells the speculation by insisting that Darger was an innocent about matters of sex (one "acquaintance" interviewed quips that she didn't think he knew the difference between a boy and a girl) citing the lack of irony in his writing as evidence.[13] Whether he was one thing or another matters not in the film. The depiction of children as the fount of all things good confirms a worldview of Edenic innocence that never existed for Darger in his dreary, daily life. Steedman's thoughts on the archive as refuge carries some weight here:

"The Archive allowed the imagining of a particular and modern form of loneliness, which was analogous to the simultaneous conception of the Historian's relationship to the past as one of irretrievable dispossession."[14]

In this sense, perhaps, Darger's real-life loneliness and his turning inward allowed him access to construct his "archive" in the space of his habitat and provided the creative spark for his masterworks. Before it was dismantled in 2000, Darger's room remained virtually as he had left it before his death in 1973. It contained the manuscript and illustrations, a work that consumed sixty years of Darger's life, three hundred paintings, and a library of books (including the Wizard of Oz books, Dickens, *Uncle Tom's Cabin,* etc.), religious iconography, and various knickknacks. The illustrations looked like "elaborate montages that mimic the luminous quality of stained glass" and "were drawn in pencil and charcoal, traced from artwork that caught his fancy, and meticulously pieced together and watercolored." As a conservative interpretation of Darger's vision, Yu and a team of animators decided on a two-dimensional canvas and a deliberately low-tech "cut-out" look. Works from Darger's "collection" were scanned into a computer and widely available commercial graphic software Adobe After Effects and Flash were used in the animation process.[15] Additionally, Darger assembled a massive clipping file of images from magazine ads, comic strips, and children's books. Eventually, he photographically enlarged some of these clippings to make various-sized templates for inclusion in his *Realms.*[16] Yu's film spends a substantial amount of time recording the space of his "archive" as a "re-memorization" of Darger's life and art. His room, cluttered with these objects, becomes emblematic of the man himself. In remembering Darger's life and art through cinema, we possess the capability to redeem this man's past for the future. Since his death, his works have been exhibited widely and the American Folk Art Museum (where most of his work has been deposited) in New York has even opened up the Henry Darger Study Room.[17]

In Godard's epilogue, "Heaven," we follow Olga on her arrival in an afterlife. She walks through a forest and is greeted by a cacophony of animal sounds and nature in movement

(the splashing of water on rocks, the rustling of leaves in the trees). She eventually encounters other youths like her, a man reading a book with his dog, two couples in swimwear tossing a beach ball, and a man sitting next to the river eating an apple. She joins him and, in Edenic innocence, takes a bite out of his apple. She looks offscreen into the direction of the sunlight. As her story ends the film, Godard invites us to interpret our collective histories and memories as we gaze into the unknown future.

Wellspring Media has issued the Godard and Yu films on DVD in their original theatrical aspect ratios of 1.33:1, Dolby SRD, and 1.85:1 nonanamorphic, Dolby Digital 5.1 version, with a filmography and trailer gallery. The thirty-minute interview with filmmaker Yu is informative but the sound levels are uneven, making the interviewer's voice barely audible.

NOTES

1. *"Notre Musique" Press Book,* Wellspring Media, http://www.wellspring.com/movies/text.html?page=press_book&movie_id=59.
2. Colin MacCabe, *Godard: A Portrait of the Artist at Seventy* (New York: Farrar, Straus and Giroux, 2003), 299.
3. Jean-Luc Godard and Youssef Ishaghpour, *Cinema: The Archeology of a Film and the Memory of a Century,* trans. John Howe (Oxford: Berg, 2005), 4.
4. *"In the Realms of the Unreal" Press Book,* Wellspring Media, http://www.wellspring.com/movies/text.html?page=press_book&movie_id=60.
5. Russell Engebretson, review of *In the Realms of the Unreal: The Mystery of Henry Darger, DVD Verdict,* www.dvdverdict.com/printer/realmsunreal.php.
6. Jessica Yu confirms the likelihood of misinformation conveyed in Darger's autobiography, such as the existence of a missing sister and the mysterious death of his only friend (Q & A session at Academy/Contemporary Documentary Series, UCLA, Los Angeles, Calif., February 22, 2006).
7. *"Notre Musique" Press Book,* 11.
8. Director's comments, Q & A session, February 22, 2006.
9. Godard and Ishaghpour, *Cinema,* 7.
10. Carolyn Steedman, *Dust* (Manchester, U.K.: Manchester University Press, 2001), 68.
11. Godard and Ishaghpour, *Cinema,* 103.
12. This conceit comes from Steedman, *Dust,* 72.
13. Director's comments, Q & A session, February 22, 2006.
14. Steedman, *Dust,* 72.
15. Animation producer Kara Dallow's comments, Q & A session at Academy/Contemporary Documentary Series, UCLA, Los Angeles, Calif., February 22, 2006.
16. Engebretson review.
17. Director's comments, Q & A session February 22, 2006.

Contributors

Grace An is assistant professor of cinema studies and French at Oberlin College. She is at work on her manuscript "A Par-asian Imaginary: Franco-Asian Encounters since 1945." Her main interests are French literature and cinema, especially documentary, of the second half of the twentieth century, with a focus on the French interest in East Asia since World War II.

Kristen Anderson Wagner is a PhD candidate at the University of Southern California School of Cinema-Television. She is writing her dissertation on the work of female comedians in American silent film.

Andreas Busche has an MA in Film Archiving from the University of East Anglia, England, and is currently working for the Stiftung Deutsche Kinemathek.

Nathan Carroll is assistant professor in the department of Communication and Theatre Arts at the College of St. Scholastica in Duluth, Minnesota.

John L. Hochheimer is professor and chair of the department of Radio-Television at Southern Illinois University, Carbondale. From 1988 to 2006 he was on the faculty of the departments of Journalism and Television/Radio at Ithaca College. His recent work has focused on the linkages between spirituality, communication media, and human meaning. His work in these areas has been published in *Communications: The European Journal of Communications Research, Javnost/The Public, Journal of Communication Inquiry, Critical Arts: A South-North Journal of Cultural and Media Studies* (South Africa), *Media, Culture & Society, College Literature,* and *Nature,* among others.

Jan-Christopher Horak is a visiting professor in critical studies at UCLA and acting director of the Moving Image Archives Studies Program. Horak is author of numerous books and articles, including *Making Images Move: Photographers and Avant-Garde Cinema, Lovers of Cinema: The First American Film Avant-Garde,* and *The Dream Merchants: Making and Selling Films in Hollywood's Golden Age.*

Janna Jones is associate professor in the School of Communication at Northern Arizona University. She is also an advisor to Northeast Historic Film. She has published a number of articles about cinematic culture and cultural preservation. Her book *The Southern Movie Palace: Rise, Fall, and Resurrection* interprets the discursive and physical preservation of picture palaces. She is writing a book about the cultural significance of moving image archives in the United States.

Heidi Kenaga received her PhD in film from the University of Wisconsin–Madison. She is currently a research associate at the University of Memphis, where she teaches courses in film and literature. She has published essays on 1920s American cinema and culture in *Film History* and various U.S. and British anthologies and coedited (with Diane Carson) *Sayles Talk: New Perspectives on Independent Filmmaker John Sayles* (2005).

Jill Kozeluh lives in Chicago, where she is a community college instructor. She holds a Master of Arts degree in film studies from Ohio University.

Lindy Leong is a PhD candidate in the UCLA department of Film, Television, and Digital Media. She is working on a dissertation introducing and examining the politics and cultures of moving image archiving and preservation in Southeast Asia. Aside from her academic pursuits, she is an aspiring film archivist and currently works for the Academy Film Archive in Hollywood, California.

Joshua Mabe is a recent graduate of the Masters of Library Science program at the University of South Carolina in Columbia. As a student, he programmed several avant-garde film series at USC and Winthrop University.

Devin Orgeron is assistant professor of film studies at North Carolina State University. His book in progress, *Motion Studies*, traces the cinema's longstanding interest in the subject of automobility. His writing has appeared in *CineAction, COIL, Film Quarterly, Journal of Film and Video, College Literature,* and *Post Script.* He also collects, shows, and writes about home movies from the 1940s to the 1970s.

Rick Schmidlin produced the reedit of Orson Welles's *Touch Of Evil* (1958), which premiered at the Telluride Film Festival and Toronto Film Festivals in 1998. In 1999, he produced the reconstruction of Erich von Stroheim's 1924 classic *Greed* for Turner Entertainment and Turner Classic Movies. In 2000, he produced the restoration of the Edison/Dickson Sound Test for The Library Of Congress. He is currently guest curator of a new exhibition on Erich von Stroheim opening February 2007 at the Potsdam Film Museum, Germany.

Barbara Selznick is an associate professor in the department of Media Arts at the University of Arizona. Her book on art film exhibition, *Sure Seaters: The Emergence of Art House Cinema,* was published by the University of Minnesota Press in 2001. Dr. Selznick has written chapters for a number of anthologies and her work has been published in *Spectator* (USC), *Film History, Velvet Light Trap,* and *Quarterly Review of Film and Video.*

Anna Siomopoulos teaches cinema studies in the department of English at Bentley College. She has published articles on U.S. film and culture in many journals, including *Film History, Arizona Quarterly,* and *Cinema Journal.* She is completing a book entitled *Public Daydreams: Consumer Citizenship and Hollywood Cinema of the 1930s.*

Patricia Zimmermann is professor of cinema and photography in the Roy H. Park School of Communications at Ithaca College. She is the author of *Reel Families: A Social History of Amateur Film* and *States of Emergency: Documentaries, Wars, Democracies* (Minnesota, 2000). She is also codirector of the Finger Lakes Environmental Film Festival at Ithaca College.

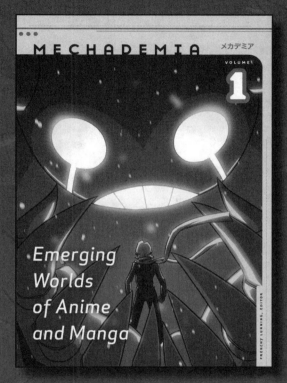

New Perspectives

Shimmering Screens
Making Media in an Aboriginal Community
Jennifer Deger

How does the introduction of modern media influence a community? How do reality and imagination converge in the creation of documentary? Jennifer Deger addresses these questions in her compelling study of one aboriginal community's relationship with media. *Shimmering Screens* explores the place of technology in this community through discussions about the influence of mainstream television, the changing role of photography in mortuary ceremonies, and the making of local radio and video.

$22.50 paper • $67.50 cloth • 256 pages
Visible Evidence Series, volume 19

Liberating Shahrazad
Feminism, Postcolonialism, and Islam
Suzanne Gauch

Shahrazad, the legendary fictional storyteller who spun the tales of the 1,001 Arabian Nights, has long been rendered as a silent exotic beauty by Western film and fiction adaptations. Now, she talks back to present a new image of Muslim women. In *Liberating Shahrazad*, Suzanne Gauch analyzes how postcolonial writers and filmmakers from Algeria, Morocco, and Tunisia have reclaimed the storyteller in order to portray Muslim women in ways that highlight their power to shape their own destinies.

$20.00 paper • $60.00 cloth • 224 pages

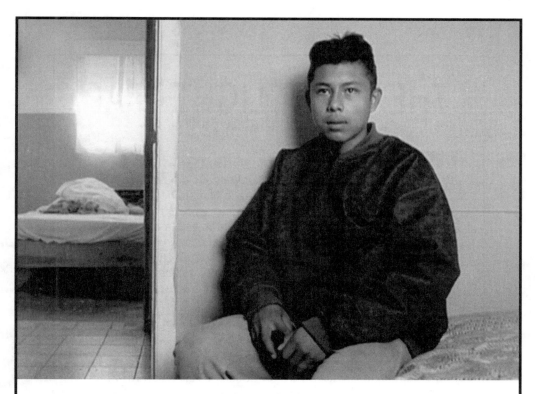

CANADIAN JOURNAL OF FILM STUDIES
REVUE CANADIENNE D'ÉTUDES CINÉMATOGRAPHIQUES

Scholarly articles in English and French on theory, history and criticism of film and television; book reviews; rare and archival research documents.

VOLUME 15 NO. 2 FALL • AUTOMNE 2006

Articles on
Geopolitical and filmic space
Joyce Wieland's "expanded cinema"
Generic discourses in *Mean Streets*
Sound, horror and Amenábar's *Tesis*
John Greyson's *Lilies*
The trailer for *Citizen Kane*

Review-Essays on
Film festivals

SUBSCRIPTIONS:
Individuals $35 (CAD) in Canada, $35 (US) in all other countries.
Institutions, $45 (CAD) in Canada and $45 (US) in all other countries. Payment to the
Canadian Journal of Film Studies,
Department of Film Studies
Queen's University
160 Stuart Street
Kingston, ON K7L 3N6
Canada
Fax: (613) 533-2063
E-Mail: cjfs@post.queensu.ca
Website: www.filmstudies.ca/cjfs.html

CJFS • RCEC
is published biannually by the
Film Studies Association of Canada
Association canadienne d'études cinématographiques